Freelance Photography

FREELANCE PHOTOGRAPHY

Advice from the Pros

•

CURTIS W. CASEWIT

Collier Books
Macmillan Publishing Company
NEW YORK

Collier Macmillan Publishers
LONDON

Macmillan Publishing Company
866 Third Avenue, New York, N.Y. 10022
Collier Macmillan Canada, Ltd.

Library of Congress Cataloging in Publication Data

Casewit, Curtis W
 Freelance photography.

 Bibliography: p.
 Includes index.
 1. Photography, Commercial. I. Title.
TR690.2.C37 658'.91'77 79-21077
ISBN 0-02-079310-3

Macmillan books are available at special discounts for
bulk purchases for sales promotions, premiums, fund-
raising, or educational use. Special editions or book ex-
cerpts can also be created to specification. For details,
contact:

Special Sales Director
Macmillan Publishing Company
866 Third Avenue
New York, New York 10022

10 9 8 7 6 5 4

First Collier Books Edition 1979

Printed in the United States of America

Contents

The Photographer as Book Author · Obtaining a Book
Contract · Self-publishing

Taking Stock: Where Do You Fit in? · The Advertising
Photographer · The Commercial Photographer · Architec-
tural/Industrial/Technical Photography · Commercial
Photography Schools · The Wilderness, Wildlife, and Agri-
cultural Specialist · Travel Photography · Photojournalism ·
The Photo Artist · Grants, Fellowships

A Morning with Francesco Scavullo · What You Can Learn
from Other Portraitists · Fashion Photography · Apprentice-
ships: The Value of Assisting Other Photographers · Glam-
our and the Nude · The High-class Big-city Portrait
Studio · The Small Photography Studio · Weddings, Babies,
and More · Part-time People Freelancers

Dealing with Art Directors · How to Remain Friends with
Magazine Editors · Should You Have a Rep? · Ethics ·
Expanding Your Livelihood: In the Corporate Vineyards ·
Branching Out—Book covers, Record album covers, Audio-
visual firms, Encyclopedia companies, Posters and greeting
cards, Calendars · Selling to Federal and State Government
Agencies · Business Matters: Written Assignments and Bill-
ings.

The Financial Rewards · Rights: Who Owns the Pictures? ·
Holding Fees · Lost or Damaged Photos · The ASMP
Policies · Collection Tactics That Work · The Law and the
Photographer: The Public's Right to Privacy · The Model
Release · Copyrights · Taxes for the Freelance Photogra-
pher · An Afterword

Preface

MY ADMIRATION has always gone to photographers, leaping from airplanes with their cameras, diving into our oceans; they even shoot pictures while racing on skis. I have worked with travel specialists who stalk far-flung countries. I have watched portraitists who squat or belly down for better shots. I have hiked with a photographer who dedicated herself to photographing nature; I was with her when she defied the zigzagging lightning atop Longs Peak, Colorado. One of her first pictures, a pond gleaming with aspen leaves, hangs in my house.

I learned to respect the medium itself, too. Some pictures remain engraved in my brain. A New York advertising pro captured two lovers looking into each other's eyes. And the eye of Suzanne Szasz's 35mm camera was there to record the high leap of a kitten. The same photo artist was able to immortalize the sensitive features of a child; years later, these photos still help the parents to visualize their youngsters as they were.

Then there are the great photojournalists. Some of their images stay with me: the black-and-white horizontals of an American president's mortal illness; the poverty of Mexican migrant workers; realistic pictures of war, with its grimy soldiers' faces; one young man's views of the Danube River; his colleague's special vision of

the jet set at a Swiss ski resort; Dan Guravich's photo series from aboard the S.S. *Manhattan*, as the icebreaker voyaged through the frozen Alaskan Northwest Passage. Documents all, and all evoking my admiration.

The amateur can learn from these experts. Even the newcomer can often harness the power of photography; it just takes luck and timing and a little practice. Click! Your one shot could make a stronger statement than an entire newspaper feature; it may go into the history books and earn you royalties for decades. Your picture may even bring about change. On one of his first assignments, a young California environmental specialist photographed the dead stump of an ancient lodgepole pine; the impact of his picture brought the destruction of these trees to national attention. Meanwhile, another photographer's wilderness coverage helped save Idaho's White Cloud Mountains from open-pit mining.

Even the newest part-time freelancer will earn not only money from photography—which is the purpose of this book—but may earn people's attention. If you are Duane Michals, you can surprise and shock people. *Playboy*'s Nicholas De Sciose captures the beauty of a woman's body. David Muench makes us understand the character of a landscape. A superb portraitist, like Francesco Scavullo, is perhaps as much a psychologist who gets into the minds of his subjects as he is an artist who depicts them for us. "I think photography really enriches your ability to understand life," says Suzanne Szasz. She is deeply imbued with humanity.

Your own private vision may be different from hers—sweet-sour, ironic, or biting. But you are more fortunate than many other people: Once fastened onto the film negative, your memories are meant to last. Think of a factory worker, for instance, who spends long hours on the assembly line with a product that is only partly his. By contrast, as a photographer, you stamp your personal imprint on the picture, whether it's of a face, or a wildflower, or a city scene. Even a farmer's labor—the growing of the food we eat—leaves no traces. But your camera's record remains. "Photography is the language of our time," says Nicholas Ducrot, a book editor who specializes in the medium.

The craft has become art for exhibition in galleries and museums. Collectors snap up the photos of old masters for tidy sums. And even novices now often succeed in exhibiting their surrealist or abstract pictures. What opportunities! Architects and designers decorate with mounted color prints. Photos now grace elegant townhouses and apartments as if they were paintings.

Photography has never boomed as it does now. One expert estimates that there are now ninety million photographers in America. They buy thirty-five million new cameras a year and shoot six billion pictures. (A Nikon executive told me that women now account for much of this wave.) According to Ken Poli, a well-known editor in the field, there are now greater opportunities for freelancers to work. The photo magazines themselves are healthy. *Popular Photography*, along with *Modern Photography*, steers toward a circulation of one million readers. Rohn Engh, who publishes a special newsletter on making money with a camera, states that some twenty-three thousand magazines await the new part-time freelancer. "The market is terrific for the newcomer," says Engh. H. T. Kellner, another contributor to this book, and also an insider, figures that there is a magazine, newspaper, and book market for at least fifty million pictures a year. Not to mention calendars, posters, and encyclopedia photos. Many of these are sold by part-time freelancers, some of whom derive a fair second income from this work. This book aims to help them increase their earnings.

Grants for serious photo artists are now common. In addition, all kinds of present-day specialists—in the scientific, medical, and architectural fields, for instance—make a good living. Young photographers are hired in droves by industry, the government, and our communications media. "Photography is exploding," the editor of a trade journal tells us, adding, "Interest in photography is at a peak unimaginable even a decade ago. It has become the second biggest hobby after stamp collecting."

Naturally, publishers offer a great number of books on the subject. The majority of the titles are technical, however. My own aim is a different one. I am interested in practical matters. How do you

approach an editor? How do you correspond with a magazine's art director? What is an appropriate portfolio? Does it take connections to get an assignment? Is it possible to sell a book? How do you make money from calendars? Few writers have dealt with these practicalities. I asked the big pros about how *they* got their start, about their day-to-day problems, about rights and finances. In my initial letters to the professionals, I spelled out my slant: The reader could get help with technique elsewhere. I did not want an intellectual approach; there are other books with lofty texts, some of them difficult to understand. I wanted to avoid the question-and-answer format. Instead, I decided to blend the comments of many people.

It was the true mark of greatness that such busy luminaries as Francesco Scavullo, David Muench, Phoebe Dunn, Duane Michals, and others should give me their time. Many of the personal interviews—of outdoor specialist Pete Czura; Tom Hollyman and J. Wesley Jones (both in advertising)—produced a marvelous insight into the photographer's livelihood and some fine anecdotes. Some of the top photographers in various fields were contacted in person, and then interviewed via a long questionnaire. Among others, I must thank Dean Conger, Jack Fields, Dave Bartruff, and Professor John Trimble for their replies.

There were many successful specialists whom I did not meet; they assisted with *Freelance Photography* by mail. One of my correspondents sent two tapes. He had taped a one-hour interview in a bar, over Irish coffee, with a lady by his side, and music playing in the background.

All the pros welcomed controversial questions. And some gave brutally honest answers. I gained prior experience with controversy when I researched my Macmillan book for freelance writers. What did the photographers have to say about their agents, for instance? Or how did the pros feel about their reps' commissions? What were the rackets and rip-offs the newcomer should avoid? Were the pros in favor of learning the craft by correspondence? How did the professionals deal with editors or art directors who

lost transparencies? How did they deal with clients who tried to evade payment for pictures? What kind of collection methods worked best?

Questions like these brought forth a fountain of information which not only proves useful to the novice but to other full-time freelancers as well. Ron Adams, a glamour and advertising specialist in San Francisco, was all in favor of realism. "As far as the concept of your book is concerned," Adams said, "you've surely got a winner. Especially if you don't repeat all that trite stuff I've read before. Do something that rattles the cages!"

My own cage was seldom rattled in writing *Freelance Photography*. The experts proved to be remarkably cooperative—with few exceptions. Why did one hallowed name beg off? I understood the reason when I visited him. He was terribly harried, hurried. He chain-smoked. He did too much. He was the only Name who seemed irritable and in ill humor. Some of the legendary names couldn't be part of this project for various reasons. The late W. Eugene Smith was already very ill. Richard Avedon was swamped with work. Elliott Erwitt did not reply to two letters. Irving Penn wrote simply: "Please excuse me. But good wishes." As luck would have it, other greats were eager to help.

I am grateful to them all. I salute their métier. Apart from the already mentioned individuals, my warm thanks go to Peter Gold, Lou Jacobs, Jr., Boyd Norton, Nicholas Durcot, Galen Rowell, Myron and Ann Sutton, Carl Iwasaki, Dick Durrance II, Bruce Pendleton, Nicholas De Sciose, Ursula Kreis, Ray Atkeson, C. W. Whitin, Kenneth Poli, Julia Scully, Grant Heilman, Jack Fields, Robert Farber, Victor Skrebneski, Herb Lubalin, Patricia Caulfield, Guy Cooper, Robert Wenkam, Peter Celliers, Dale Wilkins, James Milmoe, W. J. Muenstermann, Arlene Lewis, Pat Coffey, Paul Brock, Don Bower, Dick Burnell, James Alinder, Bill Penworthy, and to Esther McDowell, my typist, and to the Victor Hasselblad Company.

I also owe a debt to my editor Jeanne Fredericks, patient and gracious, as ever, and to the late Evelyn McElheny, who sowed the

seeds for this book. Photography was her be-all and end-all; she loved it more than life itself. May her enthusiasm—and the shared knowledge of her peers—inspire the reader.

Load your camera.

Focus. Shoot!

And get paid!

CURTIS CASEWIT
Denver, Colorado

Freelance Photography

1

The Occasional Freelancer

The Market

THERE ARE BASICALLY two kinds of photographers: those who take pictures for their own pleasure and those who do it to make money. Where do you belong? Is it possible, for instance, to *combine* the two? Would it be possible to share your talent, your personal vision, your feelings for a subject with not just the local camera club but with an even larger local audience? Wouldn't those pictures you took in Scotland—photos that almost breathe with a sense of the country—*deserve* to appear in print?

The questions are justified. A friend of mine, an alert, artistic woman who painted watercolors in college, did indeed go to Scotland, where she wandered with her 35mm Pentax among the lochs and glens. She and her camera spent four weeks in the highlands. She came back with almost five thousand transparencies. She shot superb photos of the mountains that swam in the mist, close-ups of the wet heather, blackberry bushes blazing in the sudden sun, with

peaks outlined faintly at a distance. She captured on film those Scottish children, the young girls with their milkmaid cheeks, the teenage boys strolling through chest-high ferns. She showed me her collection, casually, modestly, as if it were a mere travelogue.

It was more, of course.

That coverage was too good to be shown to just a few friends. The photos had to be published!

She was a nurse by profession; it had never occurred to her that a market existed. I taught her how to tap it, and she eventually did, placing some of her masterpieces with various travel periodicals.

Unfortunately, all too many amateur photographers tuck their best work into a trunk and forget about it. Some winners of the monthly contests of the nation's camera clubs do not bother submitting to publishers. Instead, they file away their transparencies. Rohn Engh, a longtime midwestern photographer, who also publishes a newsletter on marketing, exhorts the public—"housewife or salesman, amateur or pro"—to approach some of the twenty-three thousand existing United States markets with its output. Engh, who has done it himself while based on a Wisconsin farm, says it well:

The demand for photos today is endless. No sooner do the photo editors and art directors fill the need for this week's layout, they are off and searching for *more* photos for their next layout. The photos they need just might be in *your* files.

It is true that some people have good jobs and do not need the money. Others are too busy in their careers, with their families, or perhaps with picture-taking and developing. They invest time in photography, yet consider it a mere hobby. Many good amateurs, though, simply have an angst of offering their pictures for sale. Where should they begin? How can anyone tell what a magazine wants? Where do you get the addresses? What is the name of the art director or editor? And what if the photos should be turned down?

The fear of trying the marketplace often comes from not know-

ing the nuts and bolts: the right picture sizes; caption needs; packaging; how to mail submissions; how to present portfolios. After a few minor sales, the part-time freelancer may have to learn about writing letters to a publication, queries, and proposals, and about carrying out possible photo assignments.

How to Get Started

Most professionals only work with a market in mind. The top freelance photographers—the superlancers—will not release the shutter unless they know in advance who will buy the shots and for how much. They do not shoot willy-nilly. Such respected experts in their fields as Tom Hollyman (annual reports), Robert Farber (fashions), J. Wesley Jones (advertising), Nicholas De Sciose (sexy posters), Patricia Caulfield (wilderness) know who will buy their output. They seldom work on speculation.

A beginning, part-timer, or moonlighter is not so lucky. The new photographer must get his or her feet wet and "pay the dues."

At first, your best strategy might be to build up an inventory. "Shoot, shoot, shoot!" says Dan Guravich, a Mississippi photographer who nowadays works almost entirely on assignment. Yet when younger, Guravich systematically set out to accumulate a large photo file.

Using the camera initially to the hilt will pay off later on. One day Guravich traveled through Wyoming. As he drove for long hours, he became aware of the geometrical pattern made by the power lines zooming toward the horizon. Guravich got out of his car and aimed his camera at the power lines. Three years later, he told an oil magazine editor about his trip through the western state. "Listen!" the editor said suddenly. "Did you get a photo of power lines?" Did he! Guravich received four hundred dollars for his foresight.

Today, this pro advises beginners "to look and look and look for the absolutely irresistible story. Then shoot it and submit it to a market you think is made to measure for it. Even the most hard-

boiled editor will think twice before turning down an extra-strong story, even if done by an unknown."

On occasion, a new photo buff has such an overwhelming talent that he or she gains an immediate foothold. Suzanne Szasz, a short time after her arrival in New York from her native Hungary, set out to take pictures of what she loves best—children (she also loves cats and has done a superb job with them). She spoke little English when she turned up, fascinated, at an American summer camp. She had no idea about markets just then. But a friend suggested that she take the black-and-whites to *Life* magazine. To *Life* magazine? Really? She was timid and anxious, but she went, anyway. And a *Life* editor at once recognized this woman's deep humanity. She was, as Freud would say. a *mensch*. Her sheer warmth and understanding came through in the pictures. She had found a niche for her work.

A photographer usually fares better with more modest markets. It is uncommon to start at the top, as in Suzanne Szasz's case. The leading United States publications—from *Life to Smithsonian,* from *Travel & Leisure* to *Audubon* or *Playboy*, to the top women's monthlies—pay the kind of money that attracts massive competition. The newcomer can hardly buck the Big Names. And rejection can bring dejection and the urge to drop out of photography.

The alternative is to start at the bottom, and steadily, surely make your way up the ladder. The bottom? Why not? Ten dollars from a newspaper is better than a printed no-thank-you note from *Cosmopolitan* or *Esquire*. Fifteen dollars from an obscure religious magazine is preferable to a curt refusal by *People* or *Money* or *Ms.* Hundreds of trade journals (about every conceivable industry and occupation) seek to illustrate articles with black-and-white pictures because these publications have no staff photographers. (For a complete list and the requirements of the trade press, see the listings in the *Writer's Market*, available at any book store.) Indeed, never has the magazine business been healthier; new publications are born daily.

A start with low-paying markets does not occur to most begin-

ners because Americans are weaned on the idea of instant success. Nor do many people want to serve an apprenticeship. Pete Czura, the Nebraska outdoor photographer regularly sells *Field & Stream* and other outdoor publications. He gets excellent money for illustrating books. Yet he is convinced that a novice should not aim too high. One summer evening, Czura was invited to speak at a federal prison about photography. About one hundred convicts— all of them eager amateurs—gathered to listen to this pro. He told them at once about the opportunities to shoot for daily newspapers, weekly papers, specialized papers, trade magazines, and minor magazines. "Don't start too high!" Czura said wisely. "It's a million-to-one shot that you'll sell *Life*. You really don't have the capabilities yet. Go after the five- and ten-dollar markets!"

The convicts listened for a while until one of them got to his feet and said, "You're wrong, Czura." Others joined the prisoner to contradict a professional who earned a good living from his work. "They were indignant," Czura said later. "They never accepted what I told them. Yet they were completely out of their ballpark."

I often find the same situation in marketing classes for freelance writers at the University of Colorado in Denver. Novices first try *Reader's Digest, Harper's,* or *The New Yorker*. These students would be better off submitting to a small newspaper, a religious magazine, or an obscure political or woman's publication. Acceptance here is so much better than immediate rejection by the top markets.

Aim Locally and Regionally

A budding photographer can at first concentrate on the *local* scene. Shoot what interests you, and then approach your local Sunday supplement editor. He (or she) is likely to be interested in your first efforts because you live in the same community. Likewise, the daily newspaper in your city (or a suburban weekly) will probably be interested in your black-and-white pictures. After all, the paper's staff cannot cover every event. Use up several rolls of

film, print up contact sheets, and phone the editor. If he says no, try his competitor in the same city. New photographers who don't like to use the phone or visit an editor can write a brief letter. Simply tell the prospective buyer what you have, mention that you noticed similar pictures before, and that you would like to send yours in. Enclose a stamped self-addressed return envelope, or a self-addressed postcard for the other person's reply.

All this is fairly easy to do. Here is an illustration. When Evelyn McElheny, a Boulder, Colorado, amateur photographer drove to the supermarket one afternoon, an automobile in front of her rolled into a ditch. The driver crawled out, unhurt. It was a dramatic scene. She shot at once and immediately called a local weekly with the elegant name of *Town & Country*. Sale! Boulder's *Town & Country* published the picture for ten dollars.

The local scene need not include only newspapers and Sunday supplements.

A newcomer should also consider the burgeoning "city magazines." What are they? On the most successful scale, they are publications like *New York* magazine, *New West*, or *Texas Monthly*. These three have the highest standards, of course, along with a genuine interest in good photography. The trio is followed by many other important city magazines like *Los Angeles* magazine, *Cue*, and *Denver*. If you live in a major city—especially a less competitive one than Los Angeles or New York—you may have a good chance to make connections with an editor. (For addresses, see *Writer's Market*.)

In the same vein, regional magazines are flourishing. Consider one of the following ones in *your* region:

Alaska Magazine	*Oklahoma Today*
Texas Highways	*Palm Springs Life*
Montana Magazine	*Westworld*
The Nevadan	*New England Guide*
New Hampshire Profiles	*Gulfshore Life*
New Mexico Magazine	*Yankee*

There are many more, of course.

A young, talented photojournalist has an excellent chance with

regional editors. Example? A young Denverite-with-camera spent his summer on an Indian fishing vessel in Canada's "Inside Passage." While fishing for salmon with a crew of four Tlingit Indians, he was also smart enough to deploy his 35mm Canon on a daily basis. He returned with about thirty rolls of Kodacolor film. Some of the slides were magnificent. He had done it all: He had photographed the crew fighting a storm in their yellow slickers; tons of salmon wiggling in the nets; the many other vessels on the scene; the bright red of the fish on deck; the joint meals in the galley.

I suggested that he try a Canadian publication named *North/ Nord*. Happy ending; they bought the twenty-year-old's first photographs. His pay: three hundred dollars. Thinking regionally had brought immediate acceptance.

It goes without saying that you must *study* the paper's (or magazine's) published pictures with great care. Some beginners have sent color slides to newspapers that only use black-and-white. (Conversion would be too expensive.) Other tyros submit unpleasant, far-out still lifes to a market which uses only "nice" pictures.

Looking at pages in the Sunday supplements' (or magazines') recent issues will help you tremendously. You will not only be able to evaluate the preferred style but the favorite subjects as well. The published photos should become catalysts for your own camera work. Case in point: Suppose you notice a photo story about a local football player. Several pictures show him on the field; other shots tell about his family and home life.

If you like sports, this football feature should be a catalyst to cover similar scenes in a local baseball player's life. A published feature—providing a freelancer took the photos—of a ballet ought to make some new musically oriented photographers wonder: Could the editor use a story on opera? And if you are an eager skier who always schusses with a Leica in the day pack, you may be the logical candidate as a contributor to the ski magazines. The professional generally calls up first and then does the job. The beginner is better off trying it on speculation, learning something in

the process, and after some trial-and-error shooting, selling the ballet story somewhere.

The subjects must be close to those of your own inner needs and special interests and which eventually can be matched by a market. As you become more fluent and experienced in the medium, ideas will gush forth like geysers. Curiosity, an alert mind, compassion, personal convictions, travel, and reading—reading, reading, reading—should produce numerous ideas. You will soon be swept up by the magic of photography. In Henry Luce's famous words, you will set out "to see life; to see the world; to eyewitness great events; to watch the faces of the poor and the gestures of the proud; to see strange things—machines, armies, multitudes, shadows in the jungle and on the moon. . . ."

Analyzing the Market

The new part-time freelancer must acquire the skill to analyze a publication. After all, only complete understanding of editors' likes and dislikes, needs and format enable you to make sales. Do they use only one shot or complete stories? Do they like photo essays? Do they go in for humor? If so, what kind? Is it folky-corny? Sophisticated? Or are they always dead serious? (In which case, they are not the humorists' market.)

As you leaf through a periodical, ask yourself this important question: What is the quality of the photos? Will you be able to match it with your own output? Could you top the quality which you see? This applies to color transparencies as well. Keep in mind that you are new; you may be competing for space and money with established pros. A thorough analysis thus becomes a must. One new freelancer who did not check out the publication, received a letter from the editor which should make anyone pause. The editor wrote:

We need all slides to be sharply in focus—in your Slide No. 1, for example, the boy at left is a bit soft, but we'd be able to crop him out. Heavy shadow areas at critical places detract from the beauty of the

photo in newspaper reproduction. Shadows across faces can cost a sale. Unnatural color—like faces with a greenish, reddish, yellowish, etc. cast—is cause for immediate rejection.

We prefer sharp, vivid, contrasty colors. Soft, pastel shades do not reproduce well enough most of the time, so we try to avoid them.

The guidelines were invaluable, of course. But not every picture editor bothers sending a novice such a letter. The opposite is usually true: Your pictures will be stamped as those of an amateur and not taken seriously; worse, the editor will never tell you why your photos were returned.

A publication analysis should also include answers to such questions as: Did the photographer use special or expensive equipment? How much pictorial imagination is there? Am I competing against very imaginative peers? Could I have shot these pictures? Are the pictures commonplace? (The photography in trade magazines, for example, can be extremely dull, yet as you study it, you will notice that the pictures focus on the important things and truly illustrate a story.)

Most working professionals still keep checking the marketplace. Grant Heilman, the agricultural specialist, subscribes to more than forty publications. Every month, he looks at all of them, quickly, "searching for changes and approaches."

Almost every top superlancer who was queried for this book is in agreement with Heilman, and many pros came up with incisive questions. Galen Rowell, the mountaineering photographer, for instance, wrote, "I can tell about the magazine's style. How do they use people in their pictures? Are they posed or candid? Small against a big world or large against a small world? Indoors or out? Big format camera or 35mm? Action or still? Stuffy or innovative? Sandwiched, retouched, airbrushed, or clearly true to the original photo?"

Myron Sutton, a well-known nature photographer says he evaluates "whether the picture has meaning (or is just intended to be pretty and win awards) and has integrity, whether it has been

faked or forced in any way, and how much it tells of the photographer's ingenuity."

Lou Jacobs, Jr., a veteran California photojournalist, lecturer, and writer on the topic says: "You try to determine if the photography is visually stimulating, illustrative, functional, or whatever it aims to be. Is it dull? Provocative? You can only analyze their approach when you know the audience and purpose of the magazine."

H. T. Kellner, publisher of *Moneygram* and the superexpert who coined the term "superlancer" puts it this way:

Analysis is one of the keys to success in freelancing. No photographer should ever submit photos for publication unless he/she first studies the publication. Are the pictures vertical, horizontal, or square? Study the publication to see which format is most often used on the cover. Ninety-nine percent are vertical, but others do pop up from time to time. Determine the position of the magazine's logo and be sure that your submissions provide space for them.

Study the inside photos for mood, style, lighting, grain, special effects. Direct flash is out: Natural lighting or bounced flash is in. Are the photos spontaneous? What about styles in clothing and hair? Are the subjects clean-cut, fresh? This is especially important when submitting to religious publications. To what extent are photos of minorities included? Do the photos stand alone, or are they used to support stories, articles, or poems? Do the editors prefer "special effects" achieved through the use of different lenses? Filters? Darkroom manipulation? Grain? Solarization? What percentage of the photos in a given publication are nature, people, scenic, travel, promotional?

It may also be smart to compare the names of the photographers with those listed on the publication's masthead. Are they the same people? Do the *editors* furnish the pix? Are there staff photographers listed? Knowing the answer will save you postage. There is no point in approaching a staff-produced publication.

The art directors, editors, ad people, or circulation managers will supply a sample of their product; simply request it and enclose postage. (Some magazines—in the religious field, for instance—will surprise you by sending you *several* publications put out by their

company.) An ambitious freelancer should also spend time at major public and university libraries and look through the magazine racks in the various departments. (Business sections of major libraries have their own periodicals.) Newsstands are also a good source for leads.

Fortunately, the publishers themselves can tell you what they want or do not want. Most of them put out a sheet for "editorial contributors." It includes not just writers but photographers as well. The data may be brief, such as that from *Yankee Magazine*:

Current New England seasonal scenics, black-and-white, verticals, glossy only (8×10); also, unusual old-time photographs. Occasionally we use color transparencies (4×5). We also use 2¼″ and sometimes 35mm color transparencies to illustrate features. Please include captions with all photos submitted.

Despite this information, tyros have submitted Pennsylvania or New York State backgrounds. *New Hampshire Profiles,* in the same New England neighborhood, tells on its contributors' information sheet what the editors do *not* want:

Generally we have no use for single unrelated photographs. We prefer to see photo-essay treatment of subjects. Captions should be on a separate sheet numbered to correspond to the photographs. Black-and-white photographs make up about 90 percent of illustrations used. We do run some inside color for which we require 35mm or larger transparencies.

Such details sent upon request prove especially important for new publications still in the making or on the stands for the first time.

You can also learn something about the area a publication is interested in. An outdoors magazine informs you, "We cover the eleven Western states plus Alaska, Hawaii, Western Canada, the west coast of Mexico, and Baja California. We *do not* consider material dealing with any other areas."

This intelligence is followed by what they want: "Our needs call for an assortment of both color and black-and-white photos in each issue. Therefore, if we have the choice of selecting one or the

other, your chances of selling are much better. In black-and-white submissions, we are looking for sharp, crisp black-and-white displaying good contrasts. We can work with 35mm transparencies for color artwork, but larger transparencies are preferred. Send us a dozen or more photos, if you have them. Occasionally we will buy a series of photos to be used as a one- or two-page picture layout. If you have this in mind, the caption material must tell the story. We prefer action or information-type photos that clearly illustrate the written text. We have an aversion to 'fish slaughter' photos or hunting pictures which show an undue amount of gore. Photos which give the impression of being posed are unappealing."

The above info should be worth its weight in new tripods, lenses, and film, if not in gold.

You will also learn what kind of a check you can expect. Some photography instructors feel, as does this writer, that money should not matter at first. Give a few pictures away. Make placements. Get your work *into print*. Consider the medium: A good picture you shot for an important philanthropic organization—or the local symphony society—can give you visibility in an important newspaper or your city magazine. It also proves useful for your portfolio. So why not take a chance if people read your name as the photographer? Likewise, a stunning black-and-white composition printed in an illustrated photographic newsletter like *Moneygram* will be seen by editors.

Always insist on a byline, of course. If the photo is especially good, your name will be noticed. Editors have excellent memories. When you finally submit to the paying market, they will remember these shots of yours which they saw previously. It is true that some pros disagree. "Never—never!—give your photos away," says Robert Wenkam, a successful photo book author in Hawaii.

Where to Obtain Addresses of Editors

The new part-time freelancer may need some help in ferreting out the names, titles, and addresses of prospective buyers. How do

you go about this? First of all, you can check the publications' mastheads. These tell you who is in charge. Look for the name of the art director (if any), or editor (more common), on the contributors' sheet which was just mentioned. Two other excellent sources are:

- *The Photography Market Place*, published by Bowker, lists thousands of names, titles, and addresses (see bibliography for details).
- The *Photographers' Market* comes out every year, via Writer's Digest Books.

These yearly reference books are available at major libraries, or can be bought at bookstores.

A photographic newsletter is another excellent tool for the more aggressive newcomer. Such newsletters contain four or more pages chock-full of marketing information. Newsletters come out monthly or bimonthly. They are by no means cheap. But one or two small sales should pay for your year's subscription, which is tax deductible if you derive income from it. Here they are:

- Kellner's *Moneygram: A Market for Every Photo*, is published at 1768 Rockville Drive, Baldwin, New York 11510.
- *The Photoletter* is published by Photosearch International, Osceola, Wisconsin 54020.

Some other newsletters, although mostly for writers, can also be helpful. Why? You get advance information about magazines that will hit the stands shortly. And each editor of these Kiplinger-type enterprises has his or her own information sources. So you will often get data from one which the other does not have. Write to:

- The *Freelancer's Newsletter*, P.O. Box 89, Skaneateles, New York 13152.
- Jessyca Russell Gaver's *Newsletter*, P.O. Box 15891, San Diego, California 92115.
- *Freelancer's Market*, 20 Waterside Plaza, New York, New York 10010.

Among the magazines, you can obtain good marketing leads from *Writer's Digest*, 9933 Alliance Road, Cincinnati, Ohio 45242. Many of its market listings pertain to photography.

Lastly, consider the editorial news published for the benefit of members by some worthwhile organizations. Among them are:

- ASMP, 205 Lexington Avenue, New York, New York 10016.
- Society of American Travel Writers, 1120 Connecticut Avenue, N.W. Washington, D.C. 20036.
- The National Writers Club, 1450 South Havana, Aurora, Colorado 80012.

Rohn Engh, who publishes *The Photoletter*, offers some excellent advice to newcomers on how to get the most mileage out of a writer's magazine or a newsletter. Engh writes: "Never submit inappropriate or off-target photos to editors, or pictures after an editorial deadline!" Apparently, many people make these mistakes; as a result, they wind up, Engh says, on a "list."

H. T. Kellner agrees. "Don't waste the editor's time (and yours) by submitting work that he obviously can't use," he says.

Editors have contempt for novices who do not pay attention to a magazine's seasonal editorial cutoff dates. If the newsletter quotes the prospective buyer as saying, "No spring pix after Dec. 31st," any such pictures he gets on January 2 will cause irritation. It might be good to find out a market's publication schedule in advance. The lead time from submission to publication varies greatly.

Inappropriate or off-target photos? You would be disqualified for submitting pictures of two puppies when the editor requested older dogs, or midwestern hills when the request read "mountain scenes of peaks over 14,000 feet." In the same sense, an amateur wears out his or her welcome by supplying obsolete material. Illustration? Watch the hairstyles, clothes, and automobiles. Make sure that the picture is up to date unless the periodical asked for a crew cut of the 1940s, a miniskirt of the 1960s, or a prewar Mercedes-Benz. Editors will bear with you once or twice. But if you continue to send the wrong things, you will get a bad reputation that cannot be easily erased.

Do it right the first time. This includes the right number of photos. Some novices supply too few; others inundate the editor. It all depends on your topic and whether you are submitting a photo essay or some unrelated photographs. (Those who make their living in the business insist that whatever you send cannot be mediocre. Give them your best shots at all times.)

In case of a complete photo feature, you will need at least a dozen selections. If the material is complex and varied, editors may expect even more. Here is what one regional southern magazine wants:

For major features, we require a minimum of twenty-five professional-quality color transparencies (fifty are better) showing an assortment of scenes taken from a variety of angles and distances. At least eight separate photos are necessary to adequately lay out a major feature, so please don't sent us twenty-five shots of the same thing taken from a different view. Do, however, include verticals as well as horizontals.

The editor goes one step further. He gives you details on how to photograph people for his publication: "A person or persons should be the focal point in most photographs. Certainly, a picture of a snow-capped mountain peak is beautiful, but without a person clearly in it, you'd be better off sending the shot to a Christmas-card company. We need people-in-action photos and expressional close-ups of faces. In your pictures, show us many moods. And when appropriate to your story, provide us with an ample supply of imaginative wildlife or fish shots, the kind and quality today's readers expect from superior magazines!"

This particular market not only furnishes a sheet for contributors. Here you receive a complete *booklet* with information.

A careful reading should lead to a sale.

How to Submit and Ship Photographs for Publication

An editor can tell almost at once whether a shipment of black-and-white photos comes from an inexperienced newcomer or from a pro. For instance, a beginner will often send snapshots or 5×7s.

Both happen to be incorrect sizes. The right one for all newspapers and magazines is 8×10. The printing should be glossy. Seasoned photographers never give their black-and-white printing business to drugstores but to custom labs instead. Or they have their own black-and-white darkroom.

Pros may supply the editor with a few samples of 8×10s and illustrate the rest of their photo story or pix on *one* subject with contact sheets. Such sheets are simply miniexposures of your many negatives. With the help of a magnifying glass, the editor can pick out the best ones. Contacts show professionalism; they save you time and money for developing more 8×10s than you need.

An inexperienced photographer may let the prospective client do some guessing about the scenes in a series of pictures. A *pro supplies captions*. In addition, if you send in a short picture feature, you will need at least a few paragraphs of explanatory text. Always keep a carbon of both text and captions (you are never sure about postal deliveries). Details on caption-writing and short photo features can be found in chapter four.

It is not a good idea to mail your black-and-white negatives unless the editor asked for them, or you were on an assignment for the publication. Naturally, black-and-white glossies must be well packaged. Use a strong cardboard for this purpose. Write or stamp DO NOT BEND on the envelope. And always make a note to yourself on how many photos you sent, when you did it, and to whom.

Some of your submissions may be in color, which usually means 35mm transparencies or 2¼″ transparencies. Color *prints* are not used except in fashion/glamour or commercial photography, in portfolios, or in exhibits. Transparencies may be originals (which many editors prefer), or "dupes"; the latter do not always reflect the quality of your shot. But they show the other person what you can do, plus such telltale things as composition, imagination, and sharpness. Instead of dupes you can also ask a photo store about "internegatives." Color film is adequately processed by large labs that take care of photo shops, supermarkets, and even drugstores. As your career progresses, you can look for better color processing sources.

Always submit your 35mm transparencies in plastic sleeve pages known as "Vis-files." These usually have space for exactly twenty slides. The translucent sheets are available at good photo stores, stationery stores, or at coin shops.

Should you send a note with your photo shipment? It is useful to enclose at least a piece of paper listing the number of pictures, your name and address, and the recipient's name and address. You can also explain briefly who you are: camera club contest winner? photo assistant? PR person? first-time photographer? school annual producer? Tell the editor what prompted you to submit your work. Were you inspired by a similar photo story in the publication, for instance? Or did you read about the market needs in a writer's magazine or a newsletter? Did a well-known pro suggest that you send the pictures? If you have more pix on file, say so.

Good packaging is a must; it separates the sloppy person from the professional who knows the importance of a good appearance. This includes a typed address, an SASE (self-addressed stamped envelope, with insurance, if necessary), and corrugated cardboard. A few people even use Masonite for protection.

United States postal rates have doubled in just a few years, and the pummeling of photo packages by new machinery and the postal bureaucracy slow down the mails more than ever. You have little choice except to use the post office. Parcel services are hardly better; United Parcel, for example, makes you come for pickups to faraway warehouses and refuses to deliver to a post office box. Worse, UPS is hard to reach on the chronically busy phones. In New York City, some well-heeled photographers use courier services; others hand-carry important photo shipments to an editorial office.

Top professionals like Grant Heilman, who employs an office staff for packaging and shipping, reduce damage and make delivery faster by paying the premium price for postage. Heilman explains: "All pictures are sent by priority mail. We find this method not only faster but less damaging. When pictures are returned to us we again suggest priority (air) mail, and the use of certified mail

as proof the pictures have left your possession." For valuable color, registered mail is safer than certified mail.

First-class "priority" mailing impresses a few recipients because you paid a fortune to send your pictures. Unless you received a publication's request, however, the "priority" expense is not always necessary. For a beginner, or for speculative black-and-white ventures, a cheaper system might be preferable. Mail black-and-whites via the slower but less expensive Third or Fourth Class. (Special Handling can speed things up.) If your *photography* is good, you will get a check, anyway. On the other hand, your first attempts may be returned. Keep your head up and try again. Consider Diana Ross's words: "Life is a struggle, moving to the next thing."

"On Spec" Versus Assignment

You can also use the mails for a general inquiry, to obtain sales leads, or to prepare the editor for your future contributions. One of the champions of this practical use of a letter method is H. T. Kellner, a Baldwin, New York, photographer, author, and teacher.

Kellner, who has been an inspiration to many freelance photographers through his *Moneygram* newsletter, regularly gets in touch with editors through the mails. He preprints an $8\frac{1}{2} \times 5\frac{1}{2}$ sized sheet which can be returned to him with checkmarked answers.

Dear Mr. Jones:

I am interested in submitting photographs for your consideration. Please take a moment to complete the checklist below. A stamped, self-addressed envelope is enclosed.

Sincerely,
H.T.K.

☐ We are not in the market.
☐ We are sending a sample copy.
☐ We are placing you on our mailing list.
☐ We purchase B/W ☐ Color ☐ Both ☐
☐ We are overstocked. Try us in _____ months.

☐ Send a list of photos you have in your stock file.
☐ We would like to see some samples of your work.
☐ We have listed our current needs on the reverse side of this page.

Kellner has simplified everything for the prospective buyer. The busy editor need only check one or more of the items and return it in the SASE. As a result, the Baldwin man winds up on numerous editorial mailing lists. At times, he is hard-pressed to keep up with the demand for his photographs.

In fact, it is the editor who often solicits his contribution. Once you are known to a publication, you will receive mimeographed "Dear Contributing Photographer" letters with specific requests. A sports magazine may ask you to supply quickly pix of:

Jim Rick, Boston Red Sox. He's our poster personality for this issue, so we'll want only 35mm color transparencies on Jim. I'd like to see a good range of shots on this athlete: some game action shots; shots of him hitting the ball; of him on the bases; perhaps some dugout shots; and a good variety of portraits, tight, full-frame facial shots with good expressions. He's a possible for our cover, as well.

And the publication's upcoming issues are outlined for you in advance.

We'll soon need photos of: Greg Louganis, champion diver; Broc Glover, motocross champion; Tom Ferguson, rodeo champion; Ric Barry, pro basketball; Rogie Vachon, pro hockey; also "New Sport" pictorials on: spelunking, racquetball, baton twirling, boomerangs, and dog sledding. Thanks for working with us.

Needless to say, such request sheets can reach you from all types of publications.

Some of these sales should get you ready to write an editor about a specific photo story which *you* have in mind.

The editor may respond that "The idea sounds interesting. Why don't you go ahead on spec?" It means "on speculation," of course. This signifies interest but no assurance that your pictures will be

accepted. You stand a good chance, though; most editors will decline instead of encouraging you with an on-spec offer.

Just as writers presell an article by first writing editors about the idea, so does the freelance photographer. The inquiry method is called "a query."

All good publications expect it from you. Not too long ago, the editor of the prestigious *Travel & Leisure* magazine spoke to a group of new photographers. A question came from the floor. "What's the easiest way to sell you?" The editor's answer: "Ask first!"

"Asking first" can be a simple, one-paragraph note. "Dear Mr. X: Would you be interested in picture coverage of this year's Calgary Stampede in Alberta? As you know, it's one of the most important rodeos in the world. As a Canadian rancher, avid rider, and part-time photographer, I'm extremely interested in the topic. I'll be in Calgary for the event. I'd be happy to shoot on spec for you. Looking forward to your reply."

As a newcomer, it would be unwise to discuss expenses, or picture rates. Blow your horn but don't brag too hard. "Be aggressive without overdoing it!" writes Robert Farber, the successful fashion photographer. One important point: Always write your query on a letterhead.

A professional typist can be important; editors are sticklers for good spelling and punctuation, and they look down on photographers with poor grammar. Always address your letter to the right person, and make sure that the individual's name is spelled correctly.

Querying a publication saves time for everyone. The editor will not need to open a package, screen your pictures, and then ship them back. (Besides, similar pictures may be on inventory at the magazine.) As for you, there would be no point in shooting a story which is later turned down by all the editors.

A pro with many contacts like Pete Czura generally inquires before he shoots. But as an established outdoor photographer, he also has a sense that a subject will be a good one for a number of

publications. So he sometimes shoots it, anyway, and *then* pens an enthusiastic, concise letter like this one:

Dear Ed B:

The cover on the July issue triggered an idea which may appeal to you.

You've seen the antics of the hot-doggers on snow skis. There is a new group of hot-doggers performing incredible feats on water skis. I was lucky and managed to obtain some exciting b/w pix plus some color action scenes of one of the world's most famous water skiing hot-doggers, Ricky McCormick, performing free-style maneuvers. I managed to obtain his cooperation and photographed various action scenes of him at Cypress Gardens. He is doing the mule kicks, helicopter skip; 110° back flip, full gainer (somersault), plus some other stunts.

Shall I send you the batch of outstanding b/w pix? These can be used either as a picture story or for color illustration purposes. Please advise. Take care.

Cordially,
Pete Czura

A letter such as the above proves especially useful when the photographer lives in Nebraska, like Czura, and the magazine is in New York.

The query should be long enough to give the prospective buyer facts about the material and to tell him or her whether or not you will write the text yourself. On the other hand, extreme length is unnecessary; don't exceed one page with your query.

Make sure that the query gives the flavor of your proposed photo story. An American music critic who takes pictures showed his understanding of the subject—as well as of his subject's ambiance—by writing to a specialized publication as follows:

It was my good fortune to recently travel for thirteen days with the English Chamber Orchestra, the Tashi Quartet, trumpet soloist Maurice Andre, Soprano Jessye Norman (an American-born British national), Russian ballet dancers Galina and Valery Panov, and many others.

We were on a music cruise. A unique one: the performances alternately took place aboard our ship and ashore. The Panovs, for instance, danced on the floodlit decks while we docked at Pointe à Pitre, Guadeloupe. Miss Norman sang Purcell in an open, country church on St. Croix. There was a musical gala al fresco on a banker's estate among the hillsides of Caracas. Pianists Pierre Barbizet, Arnaldo Cohen, Ruth Laredo played in the ship's Grand Salon while we were at sea. (The vessel rolled so much one evening that the piano had to be tied down.)

I photographed Peter Serkin, pianist son of Rudolph. I shot Herr Mohr, the much-needed piano tuner aboard. I followed the *croisière's* Hungarian impresario around. Some of the artists' names—Stoyka Nilanova, Aaron Rosand, Pinchas Zukerman—will be of interest to their fellow musicians on both sides of the Atlantic. Isaac Stern and Nureyev have made the cruise; the next one will include Jean-Pierre Rampal and Rostropovich, among many others.

You'll agree that THE MUSIC CRUISE makes for an interesting photographic concept. Some of your readers may have been past passengers; others may plan to go but would like to learn more. Still others could simply find a vicarious pleasure in such a photo article.

The critic received a favorable "let's see your pictures" letter. And he eventually sold a short article as well.

It is now generally accepted among professionals that you can query several publications at the same time. But it would not be proper to offer your story to two *competing* magazines, to *Modern Bride* and *Bride*, for instance. What if *both* accepted the same proposal? On the other hand, there is nothing wrong with mentioning the Calgary Stampede to an American travel magazine, to a Canadian regional magazine, to a ranchers' publication, and so on. Each editor would purchase different material from you. Nor do you always have to go far afield. Dan Guravich writes: "There is a market for the right kind of story and there is the right kind of story in your own backyard if you will look for it."

Guravich himself confesses that he often photographs for (and sells to) "publications which no one else ever thinks of." Some of them, like certain corporate magazines, pay very well indeed.

Guravich, like every superlancer, insists that assignments must be in writing, with all the details spelled out.

For a newer photographer, even a written on-spec okay will set the lenses into motion. An editor's brief on-spec offer can be a fine incentive to do the best possible job and perhaps get a foot into the door. Likewise, an assignment (even by a twenty-five-dollars-a-picture market) should send you into a photographic orbit. A success-bound type will deliver more than required. Needless to say, the photographer's approach and style must be based on a study of the magazine's recent issues.

Whether on spec or assignment, a courteous note is in order.

Dear Ms. Smith:
 Thanks for okaying our query on photo coverage of the New England orchard harvest for a late autumn issue. We'll go to work at once and assure you that the black-and-whites will reach you before the deadline.
 Sincerely . . .

Editors appreciate freelancers who keep their promises and follow through.

Unless you're shooting for a photo magazine which might expect experimental and far-out work—or at least very innovative pictures—you had better stick closely to your buyer's style. "The mission of my art is to say what I think, to be my own declaration," wrote Ben Shahn, the artist. A new photographer should always consider the *editor's* mission. Shoot for the market. The reward will come: An acceptance! A byline! Credits!

The Freelance Photographer

Obtaining Assignments in Person

AFTER YOU HAVE MADE A FEW SALES to magazines by mail, you may want to do so in person. Visit an editor! "It creates persons out of titles," says Ken Poli, an editor, "and provides a chance for a give-and-take conversation."

It is much easier to discuss a photo story across a desk than to correspond about it. And a newcomer in the field or a part-time freelancer is as welcome in magazine offices as an old pro. Your ideas are the lifeblood of the industry. Publications are always looking for new talent. The editors (or art directors) don't sit on lofty thrones. They are approachable. They *will* see you, if perhaps only briefly at first. One caveat, though: You need a professional attitude.

It begins with your approach. Never arrive unannounced. Write the editor a brief note that you will be in his or her city during such and such a week. Supply several possible dates. Enclose a self-

addressed postcard so that the busy photo buyer can jot down the best day and most convenient time.

You can also telephone your contact. Again, respect for the other person's schedule is important. Keep your dialogue brief. And listen carefully to the photo editor.

Lisl Dennis, a well-known travel specialist, managed to sell to *Life* magazine and many other topflight publications by first making an approach by phone. She has a charming voice and a good personality which come through at once. "I'm Lisl Dennis," she says simply. "I'm a professional photographer here in New York. I'd like to discuss some ideas with you."

To be sure before you even lift the receiver, you ought to know exactly what you hope to sell to the photo buyer. It's a taboo to call for a casual conversation. And editors consider it a cardinal sin if you waste their time.

The art director or editor may actually ask you point-blank about your ideas. Should you reveal these over the phone? That depends on you. Many photographers prefer to wangle an appointment and then make their presentation across a desk. So there is nothing wrong with your counter question: "Would you mind very much if I saw you in person? I promise to stay only a few minutes. What would be the best date for you? And the best time?"

If you've regularly sold the publication, the art director may invite you to lunch. "It is a delightful message!" says one pro. "But better not fish for the invitation. Let it come from the buyer."

You could ruin the opportunity by not preparing yourself. Read up on your host's company. If it is a publication, race to the library and study many previous issues. Note the names of your colleagues and the rest of the staff. Study the magazine's slant. Do some extra research on policies, circulation, and ad revenue.

Remember the photo stories they have used and which you liked. Will your ideas and style live up to their standards? Or are you trying to sell run-of-the-mill work? Be honest with yourself. One freelancer says: "You have to come in with an idea that is so exciting they can't turn you down, because if it's not that exciting,

they're not going to take a chance on you. To break in, you have to be better than the pros who've been doing it for twenty years. It's sometimes possible."

It is now two hours prior to your visit. Concentrate for a moment. Do you know what you want to pitch to the editor? Is everything clearly formulated in your mind? Some freelancers actually write down their specific photo ideas on file cards that can be consulted during the interview or lunch. And they rehearse their proposals at least mentally before meeting the other person. Stuttering or lack of self-assurance won't go over very well with a photo buyer. Instead, you must sound like an authority on the topic you propose. You should give the impression of being an insider. This takes preparation.

Articulate and personable photographers have the edge on people who cannot express themselves or are too shy. The latter will be more effective using the mails.

While all the professionals queried for this chapter agreed that a personal contact proves useful, every pro also stated that you had better leave your camera equipment at home. Dean Conger, of the *National Geographic* considers visiting with cameras "an affectation." Boyd Norton, the nature photographer, asks these fair questions:

Does a writer carry a typewriter in to see an editor? Or would an artist carry in palette, paint, and canvas? I don't understand why any photographer would want to carry a bunch of cameras around while visiting editors. What does it prove? That you own some very nice equipment? Leave your cameras home!

Pete Czura considers this approach, "Dumb! Dumb! Take in examples of your output instead," he says. "Editors don't care if you use a pin-hole camera. It's the final result that counts."

The professionals agree that pressure tactics are unnecessary to get an assignment. Present several ideas. Pay attention to the editor's reaction.

The photo buyer also expects that you are enthusiastic about

your story suggestions. An art director (or editor) can hardly be expected to warm up to a project if you are lukewarm about it yourself. I once called on a famous magazine editor, a woman who was chronically besieged by story offers. "How do you know which ideas to pick?" I asked her.

The editor's reply remains memorable: "I look for the gleam in the eye!" she told me. "The gleam in the eye tells me all."

If the shoe is on the other foot—the buyer offers you an assignment that originated in the house—you should accept it only if you like the idea. One freelancer advises tyros: "Never take an assignment about something you don't care about, because if you do, you're stuck for two or three weeks with something that you hate —and you don't do it that well, and it shows."

Carl Iwasaki, longtime contributor to *Sports Illustrated* and to *People* feels that many newcomers attempt to try too many things. "Then they get into trouble. They would've been better off by being honest. It's okay to say that you *can't* handle a certain assignment."

Naturally, to obtain an editorial go-ahead, your timing will be vital. It would be foolish to propose a winter sports story to a major travel market in November. Such coverage was already planned ten or even twelve months earlier. Likewise, a new invention, a political event, a medical discovery all need timing.

What if the editor goes for your idea? What is the next step? Two possibilities: one, on spec; or two, on assignment.

"On spec" means that the photo editor may—or may not— accept your final product. Should you do it? It means taking a chance. But it also gives *you* a chance to prove yourself. The superlancers only work on assignment. They'll get paid even if the project doesn't pan out in the end. On the plus side, the rejected on-spec photos can be sold to a lesser publication or as stock.

In either case, you must predetermine your working conditions. How many photos are expected? Color only? Or black-and-white, too? Contacts? Prints? What is the deadline? How about captions? How much text, if any? Will the publisher pay expenses? Prior to a

job, pros always discuss their pay and the rights to be sold (see chapters seven and eight in this book). Professionals also go into great detail about the editor's expectations; this prevents misunderstandings.

A beginning freelancer cannot take a backseat when it comes to these details. You are entitled to ask the other person to put everything in writing.

All these personal dealings can be handled with tact. "Be sincere, honest, friendly," advises San Francisco photographer Dave Bartruff. "And you *will* succeed."

The Portfolio

The in-person approach also applies to showing your portfolio. Instead of mailing it, try to wangle an appointment and show it personally.

Many pros consider their early portfolios a route to their success. After all, it is a record of your achievements and the path to your future.

Nothing sells the photo editor faster on your ability than to see some samples of your work. A person can con someone with words and promises, but a good selection of pictures tells the prospective buyer more about your vision, skills, imagination, and originality than two hours of self-praise. Here's the chance to show the photo editor that you understand his or her needs, and that you will do a good job on the assignment. Here is a chance to make a visual impact on a prospective buyer.

Advertising publications and PR (public relations) agencies may give you in-house assignments months after your visit. The prospective buyer still remembers you and the job goes your way. Likewise, a portfolio is one possible avenue to an apprenticeship with another photographer.

How much material should you bring along? What kind? And how do you present it? That depends on the specific magazine or client. Do they use only color? Or just black-and-white? Color

slides can be shown in plastic envelopes that can be put on a lighted slide table or light box. Many photo agents and some photographers carry their own projectors or carousels. (You can discreetly phone the secretary ahead of time and inquire. Ask if you should bring a projector or is there one in the house?) Black-and-white pictures (8×10, of course) look good in protective see-through plastic sheets; display them in a ring binder.

Originality counts here, too. When Duane Michals, the well-known experimental photographer, still made the rounds of offices, he carried his black-and-white pictures in black slipcases. Each contained a different subject and came with identifying labels. "Editors and art directors see hundreds of presentations," says Michals. "Make yours more interesting!"

One way to build up interest: Choose only the most creative and unique shots from your arsenal. Leave the more commonplace work samples at home. Aim for technical quality. "Never take *schlock*," says one insider. "Be fiercely selective; pick out only your best pictures." Herb Lubalin, one of the most respected art buyers in the United States, and the president of his own design firm, minces no words about some freelancers.

I have been buying photography and illustration for over thirty years. I'm constantly amazed at the lack of sensitivity shown in the selection of work for promotional purposes and in portfolios. One good picture is worth a hell of a lot more than a half-dozen mediocre ones.

One of Lubalin's colleagues echoes these sentiments. He says: "I ask that people show only what they consider their very best work. Even though they may include work *they know* is not their best for other reasons, *I don't know* and can hardly feel that we start out with a common definition of excellence."

Guy Cooper, a photo editor, also points out some newcomers' miscalculations. "Let's say you have been shooting for three or four years. Your technique has improved both technically and graphically and you have five or six different photo features in

your portfolio. It may be a temptation to include your *earlier* work in order to show how proficient you've become. Don't! Just let it be the best you have. If something is weaker than the rest, forget about it," says Cooper.

Apart from editing your work ruthlessly, your portfolio should also reflect some understanding of the particular editor's needs. Tailor it to the person and company you visit. Example? Suppose you call on one of those slick travel magazines that ooze with luscious romantic ads for cruise lines, airlines, and national tourist offices. It goes without saying that the art director of *Travel & Leisure* would take a dim view of travel coverage that depicts the seamy side of a passenger liner (interesting as it may be). An imprudent photojournalist actually presented shots of a crashing jet to the art director of an ad agency that had two fat-cat airline clients.

If you have traveled in South America and want to cram your portfolio with exposés of a country's poverty and misery, you had better think twice. Because of the nature of its advertisers, the art director of a sleek travel magazine would naturally shun such pictures (and recoil from the person who brought them). When calling on *Glamour, Mademoiselle,* or *Harper's Bazaar* your dossier should not contain your ironical masterpieces about America's polluted cities or streets with shabby porno shops. Incredible? According to many buyers, novice photographers arrive every day with inappropriate samples.

Ad agencies pay well and deserve that you use your brains beforehand. Do some research and select your samples with particular care. Show the kind of art they would choose for *their* clients. Some enterprising newcomers shoot some specials for a particular visit.

Longtime practitioners in the business have also learned the importance of a portfolio's right "image." It must not only speak to the buyer's needs but also highlight your own photographic niche. Here's an opportunity to show your style. It should tie in with *your* interests as well. Hopefully, the latter matches the prospect's.

Never confuse the other person. Grant Heilman recalls a visit from a young photographer who wanted to find a job in newspaper sports photography. His portfolio? A nude, drops of water on a leaf, and an old house!

Versatility is good. But there can be too much of a good thing. Avoid bringing a Kodak Carousel with dozens of pictures about several dozen topics. Concentrate on just a few specialties and show what you can do with these, and, in Dean Conger's words, show "your mastery of the medium."

Editors may distrust a photographer who claims that he or she can do justice to *any* topic. "A jack-of-all-trades gets few assignments," says one big-city insider. A top New York buyer puts it this way: "I am not interested in general portfolios. There are enough of the 'very best' people around who show specialized work handled superbly and innovatively. Sadly, the generalist, or renaissance man or woman, has little place in the complex, fast-moving 8os. It is very rare indeed that I see a mixed folio in which all categories are equally excellent." Naturally, the smaller a city, the broader the range of your pictures.

You may also keep in mind that your pictures should speak for themselves. You do not need to give a running commentary. The photo buyer welcomes silence. As he or she turns the pages (or while you flash the slides on a screen) the buyer must concentrate.

Talk about your shots only if you're asked. And don't make the faux pas of swamping your host with technical details. "Oh, I shot this with my Nikon F2 Motor Drive, 28mm, f3.5 Nikkor Lens at $\frac{1}{125}$ of second, f22."

The buyer is mostly interested in the picture (and whether your style suits the medium) and not in your technical prowess. In the same sense, you need not explain the background, the circumstances, or the whys or wherefores until you're asked.

It is true that a few art directors may listen to a photographer's gab, probably because they want to be polite. And some photo editors may even discuss and evaluate some of your precious creations. If so, you would be wise to lend an ear. Learn from these experts! Accept their opinions, even if they discover some flaws in

one of your favorite prize winners. "I don't want criticism! I want praise!" Joseph Conrad, the author, allegedly shouted at an editor. It makes little sense to copy Conrad's stance. On the contrary: you can only learn from the experienced photo buyer.

What else should you know about your presentation?

A few final bits of advice:

• Top commercial photographers like Ron Adams of San Francisco, say that it is gauche to bring a lot of black-and-white blow-ups with big white margins. "Take along a dozen pix without borders," advises Adams.

• Apart from slides, bring some published material. These tearsheets should aim for the particular magazine or ad agency's level of excellence. A fuzzy newsphoto, published in the *National Enquirer*, will not impress a *Life* magazine editor. And the art director of *Scientific American* will not be exactly swayed by your black-and-white story from a hardware magazine.

• Ask at the beginning about your host's next appointment. Don't overstay your time. It's precious for the other person as well.

• Forgive the photo editor's impatience. Let him or her set the pace for the slide show; don't linger on pictures until he asks you to. And don't look disappointed if he moves too rapidly for your taste. There may be several reasons for this: (1) the buyer is under deadline pressures; (2) your material is not up to the firm's standards; or (3) he is so experienced that only a few shots are needed to prove your photographic skills. The experienced art director spots things quickly. And you do not need to impress the editor with huge board mountings. (Don't come with dog-eared pictures, however.) Likewise, the buyer will be impressed by your published material; bring magazine ads, brochures, and editorial illustrations if you have some.

• The transitions should be smooth from one subject to the next. *Plan* your presentation. Leave nothing to chance. Radiate confidence in your field.

• Before going, give the person a business card or a résumé or

both. And after you get home, a brief thank-you-for-your-time letter is in order. Buyers appreciate such courtesies because they are rare in today's rude times.

Entering Contests

Should you enter a photo contest? After all, an art director has looked at your pictures with genuine admiration, and you have made some sales, too. You may have already won your camera club's first prize. (It was a ribbon which now dangles proudly from your kitchen pegboard). Almost every time you open a magazine, you notice a new contest. Prizes? Not just a ribbon, a trophy, or a medal, but often expensive photo equipment (a new Nikon f2, no less). Or money. Good money. A grand prize can amount to fifteen hundred dollars (and up). Totals at a single contest can add up to ten thousand dollars. Kodak runs one with fifty thousand dollars worth of prizes.

According to *Photo Insight*, a special newsletter (published at 169-15 Jamaica Avenue, Jamaica, New York 11432), there are contests for almost everyone: for high schoolers, for college students, for women only, for bowlers. Most of these contests specify that you must be an amateur: someone who gets less than 50 percent of his or her income from photography. Some big contests —the yearly National Press Photographers "Pictures of the Year" Competition, for instance—are for professionals.

Should you enter one of these events? Only *you* can decide. Consider the cons. First of all, even the National Bowling Council Photo Contest gobbles up some of your time. You need to select. pack, label, and mail the pictures. You need model releases. You must make up a return envelope, then take a trip to the post office. It is time-consuming.

Secondly, you are not alone. Competition for prizes can be fierce. The National Press Photographers contest will fetch up to ten thousand entries from as many as nine hundred photographers. The yearly Nikon bash gets from sixty thousand to one hundred

thousand entries by some twelve hundred individuals. Even a minor Michigan AAA magazine travel photography event fetches three thousand pictures (many of them of sunsets, by the way).

Do you really have a chance? Should you tie up your valuable slides and feed the greedy cashboxes of the US Post Office? Should you lay out the horrendous sums for postal insurance or registration, and in the end not win a thing and set yourself up for a disappointment?

On the other hand, you *could* luck out and get one of the five $1,000 prizes. Or you could bring honor to your local camera club or get your picture into the *Saturday Review* and even gain accolades from your peers.

Peter Gold, of the Lightworks Photography Workshops, feels that it might be worth the gamble under some circumstances. "If you need the money or the recognition, it might not be such a bad exchange to win a contest and be discovered," Gold writes.

Editors of photo magazines and freelancers alike, however, suggest that you read the ground rules. "Study the fine print," counsels Ken Poli, longtime editor of *Popular Photography*. According to Poli, some commercial enterprises "manage to acquire a free picture file via contests." How so? Some contest rules state that "the pictures become the property of the sponsor." It may be a state tourist office, attempting to obtain a fat file of valuable 35mm transparencies at little cost. Or it may be a prosperous airline.

Rohn Engh, publisher of *The Photoletter*, is one of the fighters on behalf of the clipped freelancers. Engh explains:

More and more, we are learning of photo contests in which the *sponsor* is the real winner. We refer to the practice in which a company sponsors a photo contest in which all the entries become the property of the sponsor. Only the top prizewinners receive any cash or prizes—the rest of the submitted pictures (sometimes by the thousands) become the property of the sponsor for use in promotion, advertising, or whatever. Even the top prizewinners surrender their copyrights because the "winning entries become the property of such and such, inc."

Engh suggests that you only "lease" the right to your pictures. Under no circumstances should you enter a contest where the prizewinners' photos "become the sponsor's property," that is, *your* photos suddenly belong to someone else. The "entries cannot be returned" clause may appear in fine print on the entry form. Read it with care. It spells exploitation.

Selling Stock

Duped pictures from your bulging files will also prove useful for stock sales. The latter can lead to assignments as well; after all, if an editor discovers that you are the owner of five thousand medical slides, for instance, the next medical story may go your way. (This applies to any field, from a collection of wildflower close-ups to children or cats in action to industrial, architectural, or scientific pictures.)

There are not many freelancers with a camera who do not shoot and sell stock, or are unwilling to supply specialized material to a client for pay. David Muench, one of America's most prominent landscape photographers, writes that he has a "very large active stock file." He suggests that beginners find it "beneficial to photograph as much as possible, even without an assignment, to tune in, stay alert, and to build a stock file."

For some people stock sales make up a good portion of the business. Grant Heilman, who has long carved a name for himself in the agricultural field, says: "My entire efforts go into pictures for the files. For a number of years I have accepted no assignment work, so that my own files could grow more rapidly. I enjoy the independence and the efficiency of this working method."

Many other pros support Heilman's approach. One of them is H. T. Kellner, the high school teacher–newsletter publisher who operates a profitable stock sale business in his spare time. Kellner says:

It's amazing how many requests for apparently mundane subjects cross my desk every day: a stack of newspapers, a stock shot of Niagara

Falls, New York, sunset with seagull, kids watching TV. In fact, there are many freelancers who do not accept assignments: They simply sell from a stock file they have developed over the years. And they add to their stock constantly because they know that there is indeed a market for every photo.

Luckily, stock sales will not require that you make personal calls on prospective buyers. This saves time and expenses. Heilman says: "I suspect that photographers looking for assignments need personal contact, stock photographers need less. I have always felt that people who buy my stock pictures are buying my pictures and not me."

You are not on immediate financial easy street by selling stock shots as Kellner does; nor are you in Heilman's big style. At first, your return will be small (along with a large investment in film, developing, and file systems). "It gets easier after seven to eight years' effort," Heilman insists.

The more pictures you accumulate, the more sales. As your inventory grows—from shooting with or without assignments—so does your opportunity to own the right picture when needed. Eventually, more and more editors will beat a path to your door.

Reminding Prospective Buyers of Your Inventory

One way to arouse a buyer's attention is to send out a circular about your stock files. Some photographers do this at least once a year. For instance, one typical circular, mimeographed on meadow-green paper, goes out from the San Francisco headquarters of Dave Bartruff. The large headline cannot be overlooked:

100,000+

One Hundred Thousand ORIGINAL 35mm COLOR TRANS-PARENCIES shot by an award-winning photographer who specializes in international travel and industrial assignments. Landmarks, facilities, cuisine, shopping, personal vignettes from everyday life—all done in a fresh, exciting way.

There follows a detailed list of picture subjects that include European countries, Latin America, the Middle East and India, the South Pacific. Under "Orient," Bartruff lists Japan, one of this photographer's special world areas that includes Okinawa, plus Korea, Taiwan, Hong Kong and Macao, Malaysia (east and west) and many other lands. "Important!" reads a footnote. "New destinations constantly being added. Call for update."

The list is impressive enough to be remembered by an editor who may in time ask for a Macao, Taiwan, or Okinawa scene. In fact, this photographer's 100,000+ file yields him about twenty-five thousand dollars a year.

Bartruff cautions newcomers not to shoot from the hip, however. "Try to make each a saleable shot!" he warns. One of his colleagues agrees. "A stock shot must be something of value," says Boyd Norton.

The picture requests will come as surely as returning homing pigeons if you mail your subject list to a sufficient number of prospective buyers. Among them might be the art directors of major and minor magazines, book publishers, encyclopedia companies, corporations, and ad agencies. Eventually, you will get a little mimeographed announcement in return. Like this one from an airline house organ:

DO YOU HAVE A COVER PHOTO
FOR OUR TRAVEL GUIDE?

Enclosed is a sample of the TRAVEL GUIDE cover. We are looking for four-color photos of travel destinations which we might use on our cover. We'd like to consider yours. Specifically, we're interested in:

1. Vertical photos. The cover size is $5\frac{1}{4}'' \times 8\frac{1}{4}''$.
2. Four-color slides, transparencies or color separations which make good use of the color.
3. Photos with lots of sky or space at the top where we can drop in the logo.
4. Photos of vacation spots with a foreign flavor that makes them distinguishable from other countries.

If you have a photo you'd like us to consider, please send it. If we don't use it, we'll be sure to return it to you.

All the pros agree that, if nothing else, stock shooting helps you gain experience and sharpens your photo senses. Don't worry about the cost of film. Galen Rowell, a mountain climber and runner adds these wise words: "You can't run a four-minute mile without practicing sub-sixty-second quarter miles. Photographers have a natural aversion to shooting too much film for themselves. Shooting stock is good practice for the time when you must suddenly pump fifty rolls a day through your camera."

Using a Stock Agent

Some professionals prefer to dump their thousands of pictures into the lap of a stock agency and let the agent do the rest. This frees them to go back to their creative work and eliminates a lot of bookkeeping as well. Besides, some photographers do not like to do a lot of soliciting or marketing. They are too busy shooting. For these people, a stock agent comes in handy. Disadvantages? The photographers pay a steep price for the agent's service; a 50 percent commission is customary.

Some stock outfits are giants. One agency may handle the output of photographers by the hundreds and may have more than ten million pictures on file. For this reason, the agent may attract photo requests from book publishers, poster firms, newspapers, magazines, PR and ad agencies, and audiovisual firms in fifteen countries.

H. T. Kellner, a leading American expert on photo markets, admits that 50 percent *is* a hefty bite.

But he tells you not to complain. "The commission is well worth it when you realize that your photos will get more exposure than if you were to handle them yourself. Consider, for example, how many more editors the agent knows than you do. Besides, the agent is an expert in opening up new markets for your work."

Also bear in mind that the larger agencies are generalists. They are interested in almost everything. A new photographer is therefore likely to fit in. Read the request sheet of Globe Photos, for instance. It states:

Subjects range from general human interest to color glamour, sports, outdoor action and life, travel, animals, famous personalities, unusual inventions and occupations, oddities, interesting people, nude girl layouts, background stories relating to important news events, and many others. We also handle material of special interest to specific markets (such as children) or to specific countries (such as a story on a Japanese movie star visiting Paris).

We need picture stories, illustrated articles, story suggestions, girl layouts, glamour covers, celebrity pictures, color on family situations and stock photos on all subjects.

Lisl Dennis is fond of *her* stock house because it "is influential and handles every conceivable subject." She considers her agent a "source of bread-and-butter income. Because she roams the world, New York-based Lisl Dennis has as many as ten thousand pictures on file with her agent. Her peers agree that only large volume pays off. "You're ignored unless you send in about five hundred quality pictures to start with," says Grant Heilman. "With five hundred outstanding ones they notice you."

Naturally, you need some patience. An extremely talented travel photographer supplied Globe Photos with several hundred of her best international slides. Six months went by. No sales. A year passed. Not a penny. Two years. Then three. Nothing. Guy Cooper, who once ran Contact Press Images—an agency with only a dozen photographers—explains some of the inner workings of the business. Writes Cooper:

A number of stock agencies hold in their files millions of images suitable for a wide variety of clients often outside the publications market. Cross-indexed and stashed away in drawers, your pictures of the rodeo may stay there for years until one day an advertising agency calls needing a "typically American scene" or a book publisher needs an illustration for a text book or a riding school wants to put together a publicity pamphlet. Out comes your picture. And you eventually get a check.

It is easier to become a client of a big stock agency than to withdraw from one. Stock pictures are usually held for five years, and photo features for two years, which means that you cannot

get photos back from the agency. (One agent actually charges *you* a fee for each requested picture.)

Guy Cooper tells about some of the reasons: "You can't say, 'I changed my mind, let me have my photos back!' Some of the originals may have been sent overseas. Others may still be under consideration with clients, so the commitment factor is very much a two-way street."

Holding your transparencies for five years can result in your work becoming obsolete and unsalable, of course. And transparencies may fade and become worthless to you.

Some newcomers are also unaware that stock agencies do not *buy* pictures. They sell them for you and keep their split. (Some people claim that a few of the houses keep *all* the proceeds, especially from overseas clients where a sale cannot be traced.) "I found them unreliable," writes Bartruff. "A nine-month wait to get paid!" At the same time, some agents insist on exclusivity. They make you sign a tricky contract to that effect.

Some other items:

• These photo warehouses do not return unsuitable photos to you unless you supply a stamped, self-addressed envelope.

• Agents often demand that you write a caption with each of your submissions. (And if you only make a dent with a minimum of five hundred photos, this means five hundred captions.)

• Agents need the negatives for all your black-and-white shots, plus contact sheets.

The firms vary widely in stock and intent. Some of them, for instance, prefer picture stories instead of just single, unrelated shots. Others are only interested in the outstanding, sensational, paparazzi-type wide-appeal picture. A few agents mainly handle nudes or entertainment personalities. And some slightly smaller (and more personalized) houses try to find assignments for a photographer. But it is hard to come aboard. Do not count on anything. (The photo representative, or rep, who handles only a few

top pros, is a different story altogether, and is discussed in another chapter.)

While varying in their approach, stock agencies do have something in common, however. Elliot Stern, who runs Globe Photos, makes no bones about it. "We're interested in the subject," Stern says, "not in the photographer." Some pros like Myron Sutton, who specializes in magnificent photo books and has a long track record in his field, says it succinctly, too:

Agents are both helpful and unnecessary. If a photographer has great pictures but no time to sell them, the agent can help. But agents sell photographs, not photographers. So the work must be first class, consistent, and professional. Young photographers have as good a chance as anyone to make and sell outstanding pictures.

Sutton's colleague Grant Heilman points out that "the agency invests little money in his work, just file space, and that they are inclined to be optimistic about sales—it doesn't cost them anything."

Indeed, the consensus among the superlancers is that a young photographer would be better off at first to do his or her "own thing." This way, you control your sales and save the commission as well. (After all, you leave your valuable material with an agent on consignment, and you never know what happens to your work.) Lisl Dennis, the New York travel pro, says justly, "You should know what it's like to represent yourself. Helps you to develop the needed qualities. Then, when you get too busy, an agent may be the next step in your professional growth pattern."

Photographers are actually much like writers who either praise or "fry" their literary agents. Boyd Norton, highly successful with photo books and as a workshop leader, probably comes up with the most interesting viewpoint. He writes:

My attitude toward photo agents varies enormously, depending on the time of year, the day, the phase of the moon. On Mondays, Wednesdays, and Fridays I wonder if I should have an agent handle my work. On Tuesdays, Thursdays, and Saturdays I conclude that I

have gotten along very well without an agent. On Sundays I get drunk and watch the Denver Broncos. It's a tough question. There is no doubt that agents can be useful. Right now I feel that I don't need one because I have enough work and enough contacts in the publishing field to keep me very busy. For a while I had a literary agent handle my work, but I discovered that for my specialty—picture books—I had better contacts with publishers than she did. The time when a photographer—or writer—needs an agent most is when they are new to the field and need an old hand at dealing with publishers. However, most agents don't want to handle young newcomers—they want to represent the established, well-known people who are known to produce consistently high-quality work. As I said, a tough question.

And Pete Czura says: "Bad! Got shafted by two agencies who went out of business and lost over three hundred transparencies. Never recovered my pix!"

Ray Atkeson, an outdoor photographer from the Pacific northwest says: "I've had considerable experience with agents. Few, if any, individual photographers benefit from agency representation. Agencies represent so many thousands of photographers and operate tremendous libraries of millions of pictures which eliminates any possibility of individuals benefiting greatly."

Now, H. T. Kellner, himself a marketing genius, says:

Three photo agents handled my work. I have done much better by selling on my own. I suppose that if a photographer has ten thousand or so photos on file with an agent, he'll eventually make money. But he could probably do better by developing his own contacts and eliminating commissions. Give the commissions (or part of them) to a secretary and you'll probably be better off in the long run. To each his own.

And finally, a photographer who wants to remain anonymous says: "Stock agents? *Oi weh!* But a juicy subject, anyway. My first one kept my 8×10 prints for two years until my story was stale. Then returned everything. His rubber stamp had practically burned through the paper. I next wrote to a prominent outfit. Wow! They demanded a fee to look at my things! A racket. While

I was selling on my own, I approached two more heavyweight agencies. Both of them rude. They never replied to my letters. Would have taken a name like David Muench to get an answer from them. My last try with a fellow who, it turned out, created the agency name mostly as a 'front' to peddle his own work. Never took on other photographers. Am now fending for myself, and doing fine, thank you."

If the stories don't discourage you, then how do you get on? If you are in New York, call on agents with a portfolio or mail it to them (with return postage for registered return mail). Out of town photographers can write a polite letter, enclosing an SASE for reply. Tell them about yourself.

What does the agent expect from you? And vice versa? Guy Cooper is an insider who can tell you.

When you write or telephone be sure not only to give your name, location, telephone numbers, etc., but also an idea of what you've been covering, how you think it might appeal to them, what you plan to do in the future. This last item is of paramount importance. Often young photographers are too wrapped up in what they *have* done. Ideas count along with future plans.

So you have called up a lot of different picture agencies. Some have said no straight out, others have said "maybe in three months," and finally one has agreed to let you leave your portfolio. How long should you await a reaction? It varies. So they have it and nothing happens? Call them and ask! Badger them for an opinion, a commitment. Write to them, but above all maintain a discreet pressure. Once you have been accepted it's a different story.

Ideally, the agency should give you a quick answer on whether it wants to handle your work or not. If the response is positive the agency should then edit and print up your photo-reportage to its best possible advantage, should push it hard for you to clients in their domestic marketplace, and should syndicate it overseas for sales through foreign agents. Having printed up sufficient quanti-

ties of prints for their files, they should then return the contact sheets and negatives to you and should keep you informed and paid on a monthly basis thereafter. *Caveat emptor!*

The names and addresses of some large agencies are:

Black Star
450 Park Avenue South
New York, New York 10016

Photo Researchers, Inc.
60 East 56th Street
New York, New York 10022

Culver Pictures
660 First Avenue
New York, New York 10016

Shostal Associates
60 East 42nd Street
New York, New York 10017

Globe Photos, Inc.
404 Park Avenue South
New York, New York 10016

Underwood & Underwood
3 West 46th Street
New York, New York 10036

Keystone Press Agency, Inc.
170 Fifth Avenue
New York, New York 10010

Exhibits

A part-time or full-time freelancer can also garner a little extra income—or prestige—by exhibiting photographs. In fact, the careers of numerous Big Names were launched by means of a gallery exhibit. Robert Farber, now considered an important American fashion photographer received his first exposure via a fine art gallery, and not through commercial channels.

Collectors lay in wait for famous names. Ansel Adams receives $1,000 for black-and-white scenes which a malicious critic compared to "postcard pictures." When he started, he was glad to get $150. After his retirement, and at the age of seventy-eight, Philip Halsman still derived much income from a traveling show; each picture yielded from $300 to $900. And collectors have snapped up the oeuvres of the late Edward Weston at $3,000 each.

A newcomer should have no illusions about such moneys. But the Farber story might at least inspire them to *consider* galleries. In San Francisco, for example, the Focus Gallery sells pictures by

new names for one hundred dollars, as do galleries elsewhere in the country. You can begin by checking the Yellow Pages of the phone book in your (or the nearest) city. Do they have a group show? See it. Do you happen to know one of the other photographers? Could that person recommend you? You also can ask for an appointment with the owner-manager to unfurl your portfolio.

There are other possibilities. Almost every major American city now has a photographic center. Some centers may be cooperatives and charge you a modest hanging fee. You may also be able to wangle a solo exhibit at your local bank, which can lead to an assignment from a corporation. Photos can be hung at a public library, a college, at a photo shop, and even at a gourmet restaurant. All this exposure can bring you some commercial referrals, of course.

In Denver, Colorado, a part-time outdoor photographer named Dale Wilkins had the good sense to contact the "Theater Under Glass." It's a local little theater, where the foyer walls seem ideal for a display of his appealing pastoral photo scenes. Wilkins framed his color prints with barnwood. The theater's gallery people sell to the patrons at a modest thirty to ninety dollars per picture. On another occasion, the versatile Wilkins exhibited twelve laser-image photographs; the photos considered of jewellike colored lines against a black background, with black framing and careful black matting to complement the laser images. Wilkins says:

I wanted somehow to share with the viewer my feelings about the images in an enduring way. I decided on a back-of-photograph statement, which I composed, had typeset in a distinctive modern face of my choosing, and had printed on a special paper. This statement provided spaces for the photograph title and size, and was mounted on the back of each photo, and signed by me.

So, I ended up turning out a multifaceted object, all done by me or to my specifications, not just a photograph. It was a real learning experience. I am delighted to report that seven of my works sold on opening night.

The gallery takes a 30 percent commission; but commissions can go to 60 percent.

Retailing

You can also call on local stationery or giftware stores and make arrangements for the sale of your pictures. In general, retailers take your work on a consignment basis. What should you know about the business aspects? According to the SBA (Small Business Administration), "Consignment sales can serve a photographer's purpose. Your pictures make for attractive stock at a shop."

A few minuses, though:

• While your pictures hang on display, you get no money until and unless they sell. You meanwhile tie up your own money for film, paper, matting, and frames.

• As a photographer, you must have enough cash on hand to wait extended periods for payment. Since the goods are out of your physical control, you can't do anything about damage or shopper abuse, either.

Some photographers prefer other marketing methods. They may exhibit locally for prestige reasons but sell to the public directly at some of the hundreds of summer country fairs or crafts fairs. (A complete list is available from the *Photographer's Market*, published by Writer's Digest Books). You can also advertise for commission salesmen who offer your framed pictures to retail stores, or contact a local giftware distributor to do the same thing. For an enterprising, commercially minded type, the market is immense. One of the best examples is Kenneth Townsend, a Canadian, who has sold $330,000 worth of his pictures in just a few years, all via salesmen, distributors, or gift shows. He holds out hope for almost every photographer. Townsend puts it this way: "Based on my experience, I believe it is possible for anyone to succeed, but there are certain qualifications. You must, of course, be an excellent darkroom printer; you must be able to provide the type of photograph the public will buy; and you must be willing to work at it."

How to Break into Full-time Freelancing

Knowing When You Are Ready

SOME OF AMERICA'S FINEST PHOTOGRAPHIC CAREERS began as switches from other careers. Boyd Norton, for instance, was a physicist interested in the wilderness. He eventually switched to his new métier and did photo books. Bruce Pendleton, the advertising pro, started as an art director for an agency. He took his first pictures on a part-time basis. Dave Bartuff, now successful near San Francisco, discovered his true calling almost by accident. Bartruff went to the University of Illinois for a journalism degree, then joined the army. He found himself stationed in the Korean boondocks. His mother had given him a camera, so he spent his free time roaming the Korean countryside and snapping shots of oriental farm life. The hobby soon developed into a craft. Once home, he began to study photography and worked at a number of related

jobs which often took him back to Japan. Eventually, all this led to a career as a full-time freelancer. He now specializes in international travel.

There are many such stories, of course. All these and other people knew just when they were ready for full-time freelancing. Whatever your photographic specialty, it would be unwise to burn your other income bridges behind you. Wait until you are certain about your earnings from photography. Make sure that you have enough savings to support you for six months or longer. And you should have *some* assignments, or steady clients in advertising/PR, or book contracts lined up. This goes for the photojournalist and the science photographer as well. (Studio work is discussed in chapter six.) In any case, it is best to break into a full-time career only when you have some contacts and bread-and-butter clients.

Tom Hollyman, who has long made a mark for himself in New York advertising, outlines more steps for the transition. "This is the time," says Hollyman, "to shoot lots and lots of pictures. Film is cheap! This is the time for experimentation. Try different lenses, filters, equipment, and learn what you can get out of film. Practice "taking pictures" with your eye—without camera and film—as you go about the day. Show your work to others who are better than you are. Listen to their criticism. If you feel that the critiques are valid, improve your work."

The willingness to accept criticism is important. It starts with being tough on oneself, of course, and demands ruthlessly discarding technically flawed pictures, even if they happen to be your favorites. The process continues as editors or art directors tear your work to pieces.

Dick Durrance II was a mere college junior when he had an opportunity to do a photo story for the *National Geographic*. To Durrance's surprise, his editor sent a blistering point by point letter on where the young free-lancer had failed. The critique might have discouraged some people, but not young Durrance, who'd heard of such things at home as the son of motion picture maker Dick Durrance I and of Margaret Durrance, a photojournalist. Junior

gladly accepted the editor's suggestions; as a result he was later sent on juicy assignments around the world. He now makes an even better living as a photographer for annual reports.

His tale is not unusual. While still new at the *National Geographic*, Dean Conger was sent to Cape Cod. Here, Conger saw some fishermen unloading their nets. He thought he had a great shot. But the picture editor's response was: "I've seen net shots from all over the world and this is pretty routine." It wasn't published. Conger's reaction was: "Right then I realized the difference in what I *had* been shooting. And in what was *now* expected of me." In short, the photographer suddenly understood the magazine's views of professionalism. "A good photographer wants to grow, to improve," says Ursula Kreis, an agent to some pros who make two thousand dollars a day and up.

The getting-ready phase can take a long time. Perhaps it should. *Vogue*'s Duane Michals, a former graphic designer, puts it this way: "Don't expect instant fame! Talent needs time to evolve. Be patient."

One of the best examples of patience is Nicholas De Sciose, now one of the Big Names in the glamour field. De Sciose shot for two full years before getting a magazine acceptance. He invested his own money in models, committed the time, and submitted six picture stories to *Playboy* until he sold the first one. When he finally did, he was at last ready for full-time freelancing. His income is now in the hundred-thousand-a-year range. De Sciose points out that part of your growth can also come through photo books and publications. This would be a good period for subscribing to photo magazines. Study the annuals. Look at loads of photos. Visit galleries. And make friends with a top pro so that you can get some advice.

Boyd Norton recalls his own learning period: "I began to work hard at studying the art of photography. I spent a lot of time analyzing pictures, studying the dynamics of picture space to find out what elements of line, form, texture, lighting, and arrangement could create something visually exciting."

Getting Better via a Workshop

Many well-known photographers are almost entirely self-taught; others are the product of art and design departments of colleges, or of university photo courses, or they went to a commercial photo school. But photographers of all kinds can also learn much by attending one of the many available photo workshops. These may range from some luncheon roundtables to a series of evening lectures, or from two tightly filled days to a full live-in week and longer. According to Dick Durrance, "such workshops can provide a broadened perspective and many technical ideas."

A longtime midwestern photo teacher elaborates. "Who should come to a workshop?" he asks. "Well, anyone who wants to learn as much as possible in as short a time as possible. Anyone who can keep going at full intensity for a week. Anyone who thinks that photography is more than just a sharp, clear picture. A workshop is for anyone who thinks he/she has a special way of seeing the world and wants to find ways to get that special way of seeing onto film and into prints."

Fortunately, you will now find dozens of workshops in North America. Name a specialty, and there will probably be a week-long expert teacher-cum-students rendezvous somewhere in the country. Indeed, each summer sees a workshop dedicated to "photographing the nude in nature." Another one zeros in on landscape architecture. You can attend Galen Rowell's outdoor photo sessions at Yosemite, complete with rock climbing instruction. Boyd Norton has made a name for himself with his "Wilderness Photography Workshops" in Wyoming, Idaho, and Alaska. "I love teaching," he says. "I enjoy the process of involving people in the art of photography, in watching them develop their creative potential."

Norton favors remote locations such as the T-Cross Ranch, close to the Yellowstone and Grand Teton national parks. The wildlife in the region includes bighorn sheep, mountain lions,

numerous smaller species, and moose, elk, deer, coyotes, and eagles are often seen from the porch of the lodge—the perfect setting for wilderness photography.

Many universities run field trips and lab sessions through their extension departments. And photographic centers in major cities—especially in New York and Los Angeles—feature well-known speakers.

Most summer workshops are eye-opening, stimulating, and inspiring. You might compare the learning experience with the summer writers' seminars described in *Freelance Writing: Advice from the Pros* (Macmillan). Lectures, discussions, critiques. No credits. Informality. Accommodations range from the spartan to the primitive to the plush. And, whether the organizers admit it or not, such get-togethers also fulfill a need for companionship and make a fine vacation. That's why some people actually follow the circuit from coast-to-coast.

The photo workshop proves much more helpful than the overly touted (and always overpriced) home-study course. A book can give you the kind of technical data you get from correspondence schools. By contrast, a summer workshop propels you into close quarters with a professional photographer (in some cases, a Big Name).

Peter Gold, who has for many years directed a workshop which began in Wisconsin and is now in Minnesota, explains the person-to-person attraction. "The 'teacher-at-the-elbows' situation is of the greatest value in those cases where the student wants to learn about *being* a photographer in all possible senses. A workshop intensifies things. Being so brief, all participants and the staff must speed up the questions, actions, attitudes, changes, accessibility, criticism, response to same, and so on."

Gold's week-long Lightworks Photography Workshop in Minneapolis is fairly typical of the focused, cram-type of experience. He sees it as a vehicle that allows you to rise "to new levels of concentration, production, effort, and learning." After all, you are

separated from your normal daily routine. The workshop can thus accomplish much good.

Naturally, the approaches and hours vary from one workshop to another. "Lightworks" happens to be an intense affair, with plenty of lab instruction. Students may be up at dawn and work with their instructors for ten to fourteen hours each day.

An instructor explains the focus and some of the curriculum. "We emphasize the development of one's critical ability and the craftsmanship necessary for creating fine expressive photographs— evaluating the negative; reading test strips; test, trial, and final prints; printing controls; straight and interpretive printing; chemicals, paper, contrast, toning; producing limited-edition portfolios and photography books: platinum printing and making enlarged negatives; mounting and print finishing."

Since printing can be so important in a photographer's life, workshops such as Gold's shouldn't be underestimated. One student explains the aftermath:

I have four prints on my wall, now museum-framed. I'm proud of them and I had intelligent, sensitive feedback on them. So I know *there's* something that happened for me. Ordinarily I do a print, mutter over it, think it's great, then decide that couldn't possibly be true and toss it in the stack of other dusty prints. I gained self-confidence from working with the group and talking lots.

Another alumnus speaks of a "rewarding week, full of elation."

You can also improve your photographic knowledge at two-day seminars held around the country. Among the most popular ones is the "New Nikon School of Photography. (You don't need to use Nikon equipment to attend.) The advanced 35mm camera course covers some useful technical subjects like multiple exposures, uses of infrared films, advanced filtration, motor drives, and so on. No serious proefssional should be without such knowledge, even if it is never applied.

It is true that short or long photo workshops are no magic

carpets. Don't expect to become an instant genius. Peter Gold realistically points this out when he says:

We don't expect to see great changes happen in the week people are here; that is, the work doesn't suddenly look like a fairy godmother hit it with a magic jolt of lightning. But with the daily cycles of assignment-processing-critique-response, one can spot some changes. New approaches are being tested. One does not leave as a new person, but as a person working with previously ignored or unknown parts of himself being explored and tapped.

Gold stresses that a one-week workshop isn't a "get-rich pathway to success." West Coast instructor/photographer Lou Jacobs, Jr., agrees. He warns that instructors should not promise that "a workshop and selling fine art photographs lead to prosperity."

Boyd Norton doesn't promise any immediate riches, either. In fact, his Wilderness Photography Workshops play down the money aspects and play up the techniques of photography. "These can be mastered in a matter of weeks," Norton says. "The art of photography, the development of the ability to 'see' exciting picture possibilities, takes considerably longer and it is here that the student can benefit best from a photographic education."

The addresses of some major workshops are:

Arizona Photographic
Workshop
4309 Winfield Scott Plaza
Scottsdale, Arizona 85251

Friends of Photography
P. O. Box 239
Carmel, California 93921

International Center for
Photography
1130 5th Avenue
New York, New York 10028

Lightworks Photo Workshop
25-FL University Avenue
Southeast
Minneapolis, Minn. 55414

New School for Social
Research
66 West 12th Street
New York, New York 10011

The Nikon School
623 Stewart Avenue
Garden City, New York 11530

Boyd Norton's
Wilderness Photo Workshops
P.O. Box 2605
Evergreen, Colorado 80439

Photo Graphics Workshops
212 Elm Street
New Canaan, Connecticut
16804

The Eye

Some beginners shun teaching situations. They feel that owner-ship of a camera is enough. Two bodies, a few lenses, and a business card to the trick.

Indeed, anyone can claim to be a professional photographer.

In reality, there is a great difference between the hobbyist and the established, full-time freelancer.

Do the pros have certain things in common? I interviewed about a hundred successful ones for this book. They did indeed share certain character traits, attitudes, natural or acquired talents. The common ground seemed all the more remarkable because of the differing specialties, ages, nationalities, and ethnic backgrounds.

You might measure yourself against some of the descriptions that follow.

Let's begin with "the eye." "You either see or you don't see," says De Sciose. And Lou Jacobs, Jr., the respected photo teacher, explains: "You can only become a pro if you have a strong visual orientation. Perhaps that's why so many well-known names in the field began as painters, studied art, or worked as art directors."

An unseeing amateur may walk one hundred times through Red-woods National Park and come up with only snapshots, or un-interesting postcard-type pictures. The superbly creative and per-fectionist David Muench sees the same scene and shoots paintings. He walks in Yosemite and immediately notices the best angle from which to photograph a trio of trees; he focuses upward from their roots, so the trunks slant dramatically into the sky. Muench views the all-too-common quaking aspens in the fall; they're brilliant as they glow in the water.

For some people, "the eye" is instinctive. It will be built in like the light meter in the modern camera. Grant Heilman says that seeing can be "an intangible, natural ability." Some people acquire it by observing, looking, studying, or learning from the Muenches. Others are not observant enough to detect a good picture. Grant Heilman says: "I once hired a botanist, to become a botanical

photographer. He was everything good: hardworking, bright, interested. But after about a year, it was obvious he was never going to be a photographer. His pictures were just awful. He didn't see."

This situation can apply to many writers who attempt to be photographers as well. Editors often say, correctly, that "photographers should photograph and writers should write." Lou Jacobs, Jr., a longtime photojournalist and teacher, takes a stab at "nonseeing" authors such as Susan Sontag who wrote a book about Jacobs's métier: "Sontag is an intellectual whose writing style serves to obscure her subject when it comes to photography," says Jacobs. "She is verbally oriented, not visually oriented."

Actually, the true photographer not only sees well. There is also a magnetism between an object and the photographer's eye. Sometimes, you do not take pictures. The pictures take you instead. You are magnetically attracted. You are entranced. I first noticed this when I accompanied the late Evelyn McElheny, who did some of the photographs for my book about mountains. Our first trip was to Colorado Springs, where she stood transfixed in the Garden of the Gods. Ah, that early light on those red spires and towers! She was almost hypnotized by the ancient group of rocks assembled like deities. Although a nonclimber, she decided that she had to reach the five-meter level of the stone to be among the rocks. And she painstakingly made her way up to that perch. Here, her eyes told her, was the most unique angle.

Like every gifted photographer, Evelyn McElheny saw in images: golden aspen leaves floating on a pond near Georgetown, Colorado; the dignity of a storm-bent bristle cone pine on a fourteen-thousand-foot summit; or the smoothness of driftwood. Her attention could be riveted by multihued lichen growing on granite, the product of many seasons. Color! She once spent half a morning on her knees to concentrate on red-berried kinnikinnick.

Each of our hikes brought new revelations. A few drops of dew on a pine branch could stop this nature-immersed always-seeing woman in her tracks. She'd spend an hour and use up five color films to do justice to a few tundra sedges.

She certainly had the eye. And each new scene captured her. "If

you can't say 'gee whiz,' you're on the wrong track," Tom Holly-
man comments.

The best professionals master composition, of course. What is
more, they know the visual impact of a picture in advance. They
can visualize how the lighting and the tints affect the final product.
In a now classic end-of-World War II story, Alfred Eisenstaedt
witnessed how the returning soldiers hugged girls in the Manhattan
streets. Eisenstaedt bid his time until he finally saw a nurse in a
white uniform being kissed by a swarthy G.I. The white made
the difference. (In the same sense, it seemed logical to shoot a
ballet dancer wearing black leotards in black and white, not in
color.)

Carl Iwasaki, the *Sports Illustrated* and *People* photojournalist,
thinks that many amateurs still don't have it together. "Newcomers
show me a lot of portfolios," Iwasaki says, "and I can tell at once
that they don't *see*. For instance: They totally disregard back-
ground. A telegraph pole may stick out from behind a person's
head, for instance." Indeed, most pros claim that the hobbyist may
spot one thing while the camera records another. And Lisl Dennis
points out that professsionals "challenge the so-called reality of
what they see."

Creativity

The part-time amateur may often shoot adequate and even sal-
able pictures by accident. On the other hand the pro will plan,
think, and select. Fashion photographer Robert Farber (who came
to his current career by way of gallery work) puts it this way: "I
feel that the pro's most important trait is a desire not just to
record *but to create*." This distinguishes the dull from the imag-
inative freelancer. Consider the pyramids of Egypt, for instance.
Hundreds of amateurs or semipros photograph them every week,
mostly in the same manner. But when a French book publisher
sent Duane Michals to the familiar scene, this artist soon saw some
creative possibilities. He set up his tripod in the moonlight. He

thus evoked all the mysteries of the pyramids. And not a tourist in sight.

More examples? James Milmoe, a university photo instructor, was once asked to test a new Kodak color film to determine its sensitivity to subtle color distinctions. He was to capture the broad range of whiteness. Milmoe flew to the ski slopes above Aspen, Colorado. Here he set up a unique, almost surrealistic scene: a bride and groom completely dressed in white (including white top hat for the groom, white flowers for the bride, white gloves for both) in a white sleigh with a white fur on the back, drawn by a white horse (with white reins) attended by a white-attired footman (with white hat, tie, gloves, shoes, and beard) in a snowy winter setting. Every line and gradation of whiteness became visible in his final photograph. It appeared on the back cover of eight national magazines and Kodak's catalogue.

Another excellent illustration is furnished by Pete Czura, the imaginative outdoor photographer. Writes Czura:

The editor of *Sports Afield,* once telephoned to ask if I had some color shots illustrating an archer aiming his arrow—with bow at full draw—at a deer. He wanted it for a cover.

Just about that time I recalled a herd of deer being kept at one of the state recreation areas. A day after Christmas—after I had called several store owners and obtained promises of help—I hauled nearly three hundred Christmas trees from these stores to the recreation area. Here with the assistance of some men we built a forest. We created a small path and at the end of it, we set up a couple of logs which would force a running deer to jump over these hurdles.

I positioned the archer so I'd have some blue sky at the top for the magazine logo. I had him pull back on his bow to full draw—incidentally, the bow had a five-pound pull. Eventually a big buck deer raced through the forest and down the path. When the buck was in full leap over the logs, I tripped the shutter of my camera. Needless to say, I did this a number of times to make certain that I had the one which would please my editor. Well, one of my photos was ultimately used for a cover, and I learned later that this particular issue set a sales record on the newsstands.

This story simply illustrates that if a pro uses some imagination, he can make money with his camera.

Savvy

Naturally, such creative feats also point to the full-time freelancer's savvy. Editors and clients expect it; that's why big magazines or influential art directors do not want to hire dilettantes. In the newspaper field, know-how can be critical, too. You can't always reshoot.

It was always elemental among full-timers to understand equipment, to know precisely what their cameras could do, to use the proper lenses. Things have become easier with the automatic (and even motor-driven) cameras. Shutter speed and exposure have been automated. Instructors insist that professionalism must include knowledge of light meters, filters, the ideal hour to shoot an outdoor scene, studio lighting, and darkroom procedures. "The difference between the pro and the amateur is a sense of control," says Duane Michals, who became famous for his double-exposures and sequence shots. And every interviewee agreed that perfect mastery of techniques is essential for a livelihood.

How do you acquire such mastery? One of my contacts likes to tell the story of a young violinist who walked with his violin case on New York's Fifth Avenue. The young artist stopped a white-haired gentleman and asked: "How do I get to Lincoln Center?"

The man stared at the youth. "Practice, my boy, practice."

Photographers will also add "experience, experience, trial and error, commitment, dedication."

Beginners sometimes give up when the going gets rough. They realize that they do not have the right equipment and need to rent some. They do not bother and so are never heard from again. Or they notice that instead of five hours, they will have to put in fifteen hours on a certain assignment. So they never finish it. Whatever happens, the professional has enough savvy to anticipate problems and still see a project through to the end.

Enthusiasm, Determination, Persistence, and Other Traits

Call it what you will: an inner calling, or enthusiasm, a deep involvement, commitment, a passion. All of the leading photo artists in every field seem to share this trait. "I was obsessed. It was like falling in love," says Patricia Caulfield, who made it as a full-time professional. "You must be compelled. It must be necessary to be a photographer," Francesco Scavullo, the portraitist of celebrities told me. James Alinder, director of a California photo school, speaks of "an addictive quality. They feel naked without their cameras." And a respected photo editor warns beginners: "Anyone who is ambivalent about becoming a photographer shouldn't try to be one."

All the superlancers I spoke to were steeped in their work, endlessly fascinated by what they were doing, unable and unwilling to do anything else. "I think only about photography," says Suzanne Szasz. "Photography is my life!" Just like writers, photographers feel the inner prods and urges to proceed again after a few days of rest. It becomes a need; they can seldom go for long periods without taking pictures. Dorothea Lange, a pioneer, once explained, "It is no accident that the photographer becomes a photographer any more than the lion tamer becomes a lion tamer."

I personally witnessed this enthusiasm, this great urge, when I worked with the late Evelyn McElheny. She was a visual glutton. She couldn't stop herself. One evening, for instance, we arrived in Santa Fe, New Mexico, for the opera. As always, she carried her heavy camera bag. She was told by the PR woman that no one could enter the outdoor theater with a camera. No pictures were to be taken. But she had to do it, anyway. Because patrons were checked at the gate, Evelyn McElheny hoped to reach the inner sanctum by scaling a three-meter fence. The fifty-year-old photographer was promptly caught on the other side.

Another time she was so obsessed with the visual power of a mountain scene that she forgot certain dangers. When Colorado's

Big Thompson River rose to flood stage, we were atop Niwot Ridge, not far from the disaster that cost many human lives. The clouds came down on us, then the first fat raindrops, then torrents. Evelyn McElheny wanted to shoot the zigzag flash of lightning at timberline. And she did. I finally rushed her down the mountain along a trail transformed into a shin-deep waterfall.

She was more involved in photography than anyone I ever met, missing airplanes and getting stranded to shoot two more pictures, breaking her leg in a skiing accident because of the superheavy equipment. It all foreshadowed a lyrical end: Evelyn McElheny died on an assignment in Greece. She fell off a four-hundred-meter cliff while aiming her camera at the ocean below. She died because photography was her be-all and end-all.

Evelyn McElheny is no exception. The editor of a photo magazine told me that he learns about the deaths of dedicated pros year after year. This is sad indeed.

The taking of chances is common, especially among photojournalists covering wars or revolutions. A young Aspen, Colorado, pro once remarked that if you have an assignment that calls for "flying an untrustworthy plane with a sixteen-year-old pilot in a thunderstorm," you still fly. "You've got to get the picture."

Prudence is always to be advised, of course.

In my own travels, I always noticed that all great photographers have a special sort of determination, plus the stamina to pull it off. They can't be dismayed or derailed. It is routine for advertising specialists to jet long distances to a location for a certain shot. When the pro finally gets there it rains. It may rain for ten days. Only then, after great financial losses, can the pro get his shot. In the same vein, a well-known advertising photographer was once faced with sudden failure of equipment. One day, an essential eight-hundred-dollar gadget conked out on a remote island. A deadline loomed. The man flew back to the States to pick up a new one, going without sleep for almost thirty-six hours. His colleague, Dean Conger, reports crossing "seventeen time zones in seventeen days" and then "hitting forty-five cities in forty-five days." The

flights often left at weird hours. Such a schedule can reduce a photographer to a walking zombie. "You really need stamina in this business," warns Hollyman. "Unless you have it, plus good health, there's little chance to make your living this way."

The livelihood also demands some *inner* stamina that makes you stick to photography, despite the reverses. You cannot bail out. You cannot run back to the old office job.

In most cases, the big questions loom: Can the photographer accept the inevitable rejections? Do photographers have enough resilience to bounce back? Can they cope with sudden financial problems? And what if all their major markets collapse?

One of the best examples is that of the late W. Eugene Smith. Smith stuck to his calling despite tremendous reverses. It began with an industry blackballing. Smith stuck it out. He used up his savings, got and spent loans. To survive, he accepted the smallest advances from publishers. The moneys were spent at once. Later, he not only had to deal with lack of funds, he also suffered a physical beating in the line of duty, and then ill health. Yet Smith kept photographing to the end.

Most freelancers must expect long hours, much fatigue, and physically difficult assignments. You certainly need the willpower to get up at impossible hours. "Photojournalism is most inconvenient in that respect," says Carl Iwasaki, who sometimes has to be alert at 4:00 A.M. to cover some news event.

The inconveniences are there more often than not. This goes particularly for wilderness and wildlife work. Dean Conger, of *National Geographic,* explains some of the reasons: "Light is a photographer's palette and waiting for the 'decisive moment' in light is almost as important as waiting for that moment in people's expressions, position, and so on."

The early light may force you out of bed when it is still dark. Lou Jacobs, Jr., headquartered on the West Coast, says he has gone to "inconvenient lengths" to be places when the light or the atmosphere were right. He made half a dozen sailings at dawn on a

Marineland boat to shoot the capture of a dolphin species, for instance. "Getting up at 5:00 A.M. was a pain," Jacobs admits.

Wilderness specialist Boyd Norton still remembers one harrowing episode:

I needed to shoot one of those crisp, colorful winter sunrises in the Teton Range for a book. That hour before dawn, the temperature was well below zero. As I waited, a chorus of coyotes were howling in complaint of the frigid weather. Finally, the rising sun began to paint the mountains a brilliant red. I made my last-minute adjustment of the lens focus.

It was so cold that my fingers actually froze to the metal lens barrel! Prying them loose was a painful experience. But I got the picture I wanted, despite the loss of some skin.

Few assignments result in such mishaps. But all outdoor specialists know that they need tenacity. They must return often to the same scene to obtain a certain picture.

A typical comment comes from Ray Atkeson, a long-time photographer in the Pacific Northwest. He says: "I have often waited for hours, days, weeks, frequently returning to the same scene to record it under the most favorable and exciting conditions. I traveled nearly two thousand miles round trip, three different years, to record an outstanding scene in southern Montana."

Jack Fields writes of "journeying up a peak on horseback at night, stumbling in the dark." Galen Rowell tells of "twelve trips to a canyon in winter to find the (endangered) Sierra Bighorn sheep before I finally saw one." And Robert Wenkam, author-photographer of several "coffee-table" books on Hawaii says: "The Halekalala photos in my Maui book made it necessary to return every day for a week, driving to the summit each day until I finally found the favorable weather conditions I needed."

The final word belongs to David Muench. "Ah, to wait, to return for the most exciting or most salient moment! Nature has a many-faceted and complex face! The professional doesn't just 'happen by.'"

A *Tall Order: and Humanity, Too*

Determination, tenacity, industry, energy, vitality—anything else? Patricia Caulfield writes: "Any aspect of professional photography is very hard work, so the ability to work hard is important." This could entail ninety hours a week, including Sundays and often holidays. J. Wesley Jones, leading liquor advertising specialist in New York confesses that he generally begins shooting at 8:00 A.M. and often labors until 11:00 P.M., seven days a week.

There are human qualities that are important, too:

The wilderness specialist who trains his or her lenses at nature subjects can be a different person from a colleague who deals with people. The former may be an introvert, but the latter must be outgoing. "You must have to get along with others," says Ursula Kreis, a personal rep. (Ms. Kreis has only two clients, both of whom make a great deal of money.)

Success comes easier to those with a knack for psychology, the skill to discern relationships.

In some cases, a photographer's humanity radiates from every pore. Suzanne Szasz is such a person; this is perhaps why she was asked to photograph the Kennedys in their Cape Cod retreat, or why she does so well with children. Youngsters at once sense her warmth.

The best generalists are not only human; they are personally simpatico as people. They fit in everywhere. During the last year of her life, Evelyn McElheny and I mingled with Basque sheepherders near Sun Valley, Idaho; we spent time with meteorologists and foresters in the Colorado Rockies; she became fascinated by the New Mexico Indians, and she rode the busses of Mexico and Guatemala, affectionately photographing the *campesinos*. She always blended in. She was interested in others, yet considerate enough to ask if she could take their picture. An old man on a Denver park bench, a woman cooking at an ancient wood stove, a couple exploring an autumnal hillside all interested her. This pho-

tographer was intensely human, a *mensch* who cared equally about human beings and about the beauty of nature. This brought her success as a freelancer.

Business Sense Plus Sales Ability

The neophyte may give away pictures; the part-time freelancer knows that one must shoot for money. And the superlancer considers photography a *business*. The above distinctions are important.

You can still moonlight and make a few dollars. But getting into fulltime freelancing requires a different attitude. Much of it has to do with the business side of photography. For instance: Do you spend too much on office/studio rent when you could be working out of your home? Or could you possibly share space and darkroom with some others? Your overhead has to be kept in line with your income. The latter must be kept up or increased by making new contacts, finding new clients, branching out, and at the same time improving your own performance. After all, you're now self-employed and your own boss, and it's up to *you* to organize a better picture filing system, to stay in touch with old clients ("Send them some promotion stuff that tells them you're alive and well," suggests Nicholas De Sciose), and to keep developing new sales possibilities.

This takes aggressiveness, of course. An articulate person naturally has the advantage. Ron Adams, a commercial photographer who shoots catalogues for the largest San Francisco department stores, reminds us that the sales personality is crucial. "You must keep selling your style," Adams says. "You're selling your background and your ability—you must be selling every second."

Naturally, there are a few exceptions. Anthony Armstrong Jones became a top photographer after he married a princess. Susan Ford got a good start because she's the daughter of a former president. And Candice Bergen, though competent, doesn't need much for *her* photo business, thanks to a ventriloquist father and her work as an actress.

Independent wealth helps, of course.

The average freelancer must expect to live with insecurity. Competition is keen. Bills are due. Film has to be bought. Assignments may suddenly plummet.

"It takes guts to survive," says Ron Adams. "You need nerve and a strong ego. You need self-confidence, perhaps even a supreme arrogance. And before all, a sales personality."

Dick Durrance II now freelances for advertising and corporate clients from his headquarters in New England. He sums it all up:

A professional freelancer must be one-third photographer, one-third marketing manager, and one-third administrator/accountant. A person who does not enjoy all three phases of the work should consider a position with a publication or corporation.

All about Equipment

Photographers love to discuss their clients, their reps, and their stock agents.

And equipment. To make things more interesting, pros totally disagree on the topic. There appear to be two camps. One favors a lot of hardware for everyone. The other camp stresses simplicity. In counting the interviewed heads, there are more "simplify-simplify" photographers than gadgeteers.

Photo editors and longtime pros all suggest that you first define your own freelancing bailiwick. You will need more cameras, lenses, and other items for specialties like studio portraiture or fashion, which is discussed in the next chapter. The corporate or big-time ad person needs fancier and costlier cameras. Likewise, a major New York or San Francisco commercial photographer—one with a studio—requires a much heavier dollar investment than a photojournalist or outdoor photographer. "The so-called street photographer needs relatively little," says one photo editor. What is a little? H. T. Kellner says: "A freelancer starting out in 'people photography' (for which there is an excellent market) could easily succeed with any reasonably priced 35mm SLR, a 50mm lens, and

perhaps a 35mm lens for an investment of under five hundred dollars. Later he could add a zoom or perhaps a 90 or 135. That's really all he would need for people pictures."

Most professionals suggest that you own two 35mm single reflex cameras and two or three extra lenses; the duplicate bodies can be used alternately for color and black and white. For certain specialties—calendars or architecture, to name just two—a large format camera which yields 4 × 5 transparencies is essential.

Knowledgeable photo instructors advise that you invest in the proven, rugged professional camera makes—the recognizable ones like Canon, Minolta, Olympus, Pentax, Konica, or the more expensive Nikon, Leica, or Hasselblad. Some pros will endlessly discuss the merits of the various brands. In the end, the selection depends on what you can afford; indeed, the camera brand matters less than your knowledge of what it can do, and the pictures you make with it. A witty insider likes to illustrate this with a few lines of dialogue:

Writer to photographer:
"What kind of camera do you use?"

Photographer to writer:
"And what kind of typewriter do *you* use?"

Lisl Dennis, the travel specialist, says simply, "You need the tools for the job, just as a painter must have a variety of good brushes, or the sculptor a range of chisels."

Some pros point out that they are competing against other pros. To survive in the marketplace, they must equip themselves adequately. Others spend big sums on gear for the sake of clients. Phoebe Dunn, well-known for her advertising photography, puts it this way: "My clients demand top technical quality. That's why I own so many Hasselblads and many lenses, portable lighting units, and studio lights."

One advertising superlancer enlightened an audience of art directors on his reasons for a lot of photo gear. Here's how he saw his own situation: "When I knew only a little about photography,

I thought I knew a lot. I used to say: Who needs all these lenses? Who needs the zoom? Who needs strobes? Window light, a white background, and a couple of lenses were all I needed. Now I find that approach is not enough. Some pictures require a much more involved technical solution."

One of his colleagues is known for actually carrying eleven cases of equipment in his microbus. He explains: "I want to have whatever I need to create the picture. I don't mind traveling heavy. I don't want to have to tell anyone that I didn't go into that restaurant and get a picture of the chef because I didn't have the proper lights with me. I see no virtue in going on location light unless you're planning to climb Mount Everest."

Boyd Norton, the wilderness photographer did indeed take some ninety pounds of photographic duffle to the Alaskan peaks where he had to work on a book. It involved a thirteen-day back-packing trip into the Brooks range, one of the wildest regions left on the continent. Norton took three camera bodies, including one with motor drive.

Norton argues, no doubt correctly, that "When you're that far from the nearest camera repair shop, you need extra insurance against a malfunctioning camera." As for lenses, Norton lugged a 15mm and a 20mm ultrawide angle, a 35mm, a 55mm macro, a 105mm, 200mm, and 400mm telephoto. He also had with him two tripods (one a miniature for close-ups), about ninety rolls of film, and an assortment of filters.

"People thought I was crazy," he recalls. "Did I use all that gear? You're damn right I did. Everything I brought proved valuable to me. The front jacket of my book was shot with that big 15mm ultrawide and the back jacket photo was made with the 400mm telephoto."

Robert Wenkam, a landscape photographer, agrees with Norton. "No sense in restricting yourself with limited equipment," says Wenkam, who specializes in books, also. "You should be able to shoot under any condition." On the other hand, Wenkam warns against carrying things which you seldom use. For example, Wen-

kam never takes along sky filters or a Polaroid screen. Like many pros, he does not like to be loaded down. He says: "A multiplicity of lenses and filters doesn't make that much difference in the end if it interferes with photography itself. It's difficult to be creative when all the junk gets in the way of simply raising the camera and shooting." (In the same vein, a well-known photo pioneer used to say, "I don't carry a light meter. A meter gets in the way of creativity.")

Stories abound about the famous photographers who manage with little gear. According to one classic account, for instance, a New York portraitist and his two assistants arrived in the south of France to photograph author Lawrence Durrell. The trio unfurled their bags full of fine cameras and other hardware. They made Durrell pose this way and that way. They shot one hundred and fifty pictures. The assignment took up a whole afternoon. When they were at last ready to leave, a short, elderly Frenchman showed up with a battered Leica. Ignoring his American peers, the Frenchman studied Durrell for a moment. Then he set the exposure on his camera. He aimed and quickly shot three pictures. It was Brassai.

A 1954 Pulitzer Prize in photography was garnered, it seems, by a man with a Kodak box camera. And Karsh once stated that "memorable photos have been made with the simplest of cameras, and without artificial light." (Duane Michals owns no strobes and shoots mostly with Tri-X film, which requires no flash, of course.)

It's actually a standing joke in the business that the working pro cannot afford all the fancy hardware which many a well-heeled amateur insists on buying. Charles Whitin, a former editor of *The American Photographer*, agrees. "More photography people are overpowered hopelessly with gear beyond their photographic if not pecuniary means," says Whitin. New York advertising photographer Bruce Pendleton tells beginners to limit their initial spending. A mother of a talented nineteen-year-old asked Pendleton if ten thousand dollars would get the young man started? Pendleton suggested two to five thousand dollars. "It's like buying a Steinway for a beginning pianist," he told the woman. She did not take his

advice and blew the ten thousand instead. Her son happened to be in love with gadgets.

One cannot blame newcomers for such unnecessary extravagance. The photo equipment of the '80s is alluring. It glitters. Shutters click musically. Lenses do wondrous things. Certain cameras can be status symbols that nourish the ego. The automatic this-and-that appeals to many Americans. Equipment can make a good conversation piece and may arouse the jealousy of the person who doesn't have it.

Unfortunately, even the most advanced cameras will not propel the fledgling freelancer into the ranks of the superlancers.

In one typical case, a Big Name photographer was approached by a fellow American on the Piazza San Marco in Venice, Italy. The amateur was heavily loaded down with expensive cameras. He looked helpless. "May I ask you a couple of questions? Before the neckstraps strangle me, how do you *use* these cameras?" As they sat down in one of the outdoor cafes, it turned out that the newly minted photographer had never heard about various film properties, ASA speeds, depths of field, or lens distortions. Yet he wanted to freelance. Recommendation: Obtain some basic knowledge and begin with some simpler equipment.

In short, some cameras may be far too complex and advanced for a novice, especially for a person without a mechanical bent. Moreover, some of the most sophisticated and automated cameras, like the newest instruments in a jet cockpit, can let you down. Sticking to simpler makes can prove beneficial. Dan Guravich has some excellent comments about the situation:

> Equipment gets easier and easier to use and at the same time it gets more and more temperamental. I went twenty-five years without mechanical failure. Now it is unusual to complete a major assignment without something going wrong.

Boyd Norton sees another problem for the up-and-coming photographer. "Modern 35mm equipment is so light and easy to use—and motor drives make it all so quick and fluent—that many peo-

ple are substituting quantity for quality," he says. "Instead of taking the time to create one great picture, many photographers are producing an enormous quantity of mediocre pictures."

Most experts are in agreement that the photographer is more important than cameras. The top freelancers seem emphatic about this. Myron Sutton, who not only shoots for books but also teaches photography expresses his viewpoint: "Photographs are made by brains, not cameras. The best and simplest equipment means everything. The fanciest means nothing. After the photographer, through talent and experience, finds and arranges a picture, the lens had better record it faithfully, or as ordered."

And Sutton's fellow teacher Lou Jacobs, Jr. says: "Obviously, talent, vision, and familiarity with tools are more important than brand names, motor drives, 250 OWS strobes, or whatever. I have always downplayed the machinery in favor of using it wisely and resourcefully."

Duane Michals, one photo artist who should know, adds this thought: "The best equipment is imagination."

Lastly, how and where should you buy? All the superpros agree that it is advisable to *shop* for your needs. Study the ads for new equipment in photo magazines and newspapers. *Used* cameras are not for beginners. If you live in a large city, visit discount stores and chains to compare prices. Discuss your needs with other pros. Where do *they* shop? Ask questions. Seek some business advice. Consider renting any specialized gear. Acquire only what you need. And do not buy everything at once, but pick up items gradually as you earn money from freelancing. In this respect, Los Angeles photographer Lou Jacobs, Jr., deserves the last word. "Never be seduced by optics," he says. "Every item has to pay its own way!"

The Darkroom: Pros and Cons

Should you have your own darkroom? That depends. If you shoot a great deal of black and white, you may want to do your own developing. You can achieve better quality that way. It is *you*,

not the lab, who has control. You can crop at will. You can experiment with various types of paper. Most of all, you can use it to get some special effects. To do your own printing is important for exhibitions.

Some photographers get great satisfaction from their darkrooms. Others find it convenient and practical; they don't have to drive to the nearest lab. They are more self-reliant that way. This applies especially to pros in smaller towns. Grant Heilman, who operates a sizeable black and white business—he specializes in agriculture and science—explains his own reasons for a darkroom:

> I like to be able to have everything, or almost everything, done "in house." I don't figure this makes me money, but it does increase quality and, immensely, flexibility. I have two darkroom technicians. They are both superb, and I rely heavily on them—I don't do the work myself, but we keep a very close liaison.

The situation is different for photographers who only shoot color. They generally send their film to a custom lab or to Kodak. The pros consider it a waste of time to process Ektachrome slides themselves. "There's no creative control exercised in such processing—it's just sloshing a bunch of chemicals around in a tank at the right temperature and time," explains one freelancer. Nor will you need to make color prints because 99 percent of the buyers work from your transparencies.

There are good custom labs in almost every state. Many pros even send their black-and-white film for processing. They want to make money with their cameras. David Muench, whose photography is sometimes compared with that of Ansel Adams, says candidly that he prefers "to be out photographing to being shut up in a darkroom."

What does it take to install a darkroom in your office or home? Not much. According to Ken Poli, editor of *Popular Photography*, you can start with some processing tanks, an enlarger with a good lens, sink, timer, safelights, dryer, and washer. Add a few trays, tongs, and thermometers.

Lastly, H. T. Kellner suggests getting "a stabilization printer, too. Photographers can make contacts speedily, send the negs off to the lab, and get back to shooting. The stabilization printer is also helpful for turning out those rush prints in black and white." You do not need much space for all this. And you get a nice darkroom for about three to six hundred dollars.

Cameras, lenses, labs, a darkroom. Important technicalities all. In addition, it helps if the photographer can also *write*.

The Photographer as Writer

Captions for Black-and-White Pictures

SOME PHOTOJOURNALISTS—Carl Iwasaki, for example—are lucky enough to work with writers who do most of the research and supply the text for a story. Iwasaki still has to write his own photo captions, though. So must the beginner or semipro, of course. Magazines and newspapers demand this. After all, your editor was not there. *You* were.

Professionally written and presented photo captions impress editors. Your style can be simple, and the information need not exceed two lines.

But it should be to the point. One stock photo agent explains: "The purpose of captions is to identify people, objects, and events relating to specific pictures but not to repeat information already given in the text or obvious from the pictures themselves.

"Captions ought to provide exact data. Let's say you photographed dead trout on the banks of River X. An incomplete cap-

tion would read: 'Dead Fish.' Correct version: 'Dead trout 700 yards downstream from factory Y.' Note that there is no reason to repeat River X, as the entire story is about a specific river X. But by pinpointing the distance from the factory, the caption complements this particular picture (or variations of it) shot at this particular spot.

"Maybe you don't cover pollution stories. So here's another illustration: You've done a photo feature about children and their pets. One shot shows a boy with his dog. It is insufficient and redundant to say 'Boy and Dog.' Instead write 'Seven-year-old Tom Jones and his six-month-old Airedale named Rover.'"

You can type captions on strips of paper which you paste on the backs of your 8 × 10 glossies. (Typing directly on a photo may ruin it.)

Many freelancers prefer to use a separate letter-sized sheet to explain the subject of a dozen or more shots. It is easier to make a carbon this way. Example? When *Grit*, a newspaper for small-town readers, requested some Christmas pictures, the caption sheet read:

1. A few more days of school, but soon it's Christmas!
2. The snow-covered logs are piled high to last through another family gathering around the fireplace to celebrate the Christmas season.
3. A glistening and shimmering small-town Christmas Day.

The pros will "key" pictures all the way through, ending (in this case) with photo number 12 and caption number 12.

One note of caution: Never write in ink on the back of a black-and-white photograph; a pen can damage the paper. A grease pencil may be used to indicate #1, #2, etc.

Captions may be flippant, humorous, sentimental (if necessary), serious, or irreverent. It all depends on the medium, the subject, and the photographer's writing ability (backed by the editor's). Two examples from W, the glossy fashion and people newspaper, are:

Two heavyweight headline-grabbers waited until the fall before making their moves. Jackie O. showed up at a party for a literary magazine and chatted amiably with an old critic, Norman Mailer. That's Norman, on the right.

Jackie O. gave a birthday party for her children, John and Caroline (above). It was at New York's Le Club. A small number of preppies and a large number of photographers showed up.

The above descriptions for the black-and-white pix may be a bit long. But they are witty and sophisticated, even poking a little fun at the paparazzi. A publisher of photo books considers most captions too short. He says: "The photographers throw them away. Captions should entice the reader. They should contain an element of surprise. After all, most people just look at pictures. This way you get them to read, too."

What happens when you supply a great number of black-and-whites on contact sheets? Number your sheets chronologically, starting with 1. Next identify the captions as follows:

> Roll 1—Frame 1: "........"
> Roll 2—Frame 2: "........"
> Roll 3—Frame 4: "........"

You don't need to describe every frame on each roll. Sometimes you can group entire sequences of frames as:

> Roll 1—Frames 1 through 19: "....."

If you shoot with 120 film, get the professional type that is numbered. The next best thing is to number your frames by hand, before you print contacts. Never caption frames by saying: "left row, top frame . . ."

People must often be identified. In this case make a short description: "Frames 28–35, Johnny Smith (with plaid shirt and handlebar moustache) with Mayor Tom Jones (dark suit, bald, wire-framed glasses)."

Guy Cooper, agent and photo editor, suggests that you always start your caption research while you're on location. He says:

"While shooting, take down the relevant information (miniature tape machines have revolutionized this process) in such a way that you can retrieve it rapidly if needed. You will be able to decipher the details without spending hours at a typewriter. One of the best ways of checking out your caption technique is to go through a friend's portfolio and ask questions about each picture. Reverse the process and become the interviewee and you will soon find gaps in your knowledge."

"Be quick," Cooper adds. "And forget about data like 'this was shot at f16 with a purple filter on my new Nikon system on Fuji-color 36.'"

Captions for Color Slides

Captions for transparencies? Two possibilities. Use separate sheets for material that is especially complicated. Key each picture to the typewritten sheet. When a folksy newspaper asked for some transparencies to illustrate upcoming holidays, an agent submitted color with these appropriately solemn captions:

1. Church tolling for early morning *Easter* Sunday services.
2. An *Easter* Sunday inspired by grace and serenity.
3. A time to reflect on the true meaning of *Easter* surrounded by quietness and peacefulness of a small New Mexico town.
4. Even on *Father's Day* the meteorologist will have to be high in the sky to survey the weather.
5. Remembering the unsung heroes of our country on *Veteran's Day*.
6. Snowed in on a *New Year's Day* in the country.
7. Mommy, I love you, *Happy Valentine's Day*.
8. Enjoying the quieter side of the *Fourth of July*.

Stock agencies which service many papers and magazines sometimes prefer the second choice. They prefer that you write directly on the 35mm slide mount or on a narrow slip of paper that can be affixed to the mount. More guidelines? Put your information on one edge of the slide frame. Use another edge for your name and

address. (Unless you do this, valuable pictures can get lost at an office.) Always print neatly, of course. Some photographers use tiny rubber stamps or small address labels to identify their work. Your name is an important part of the *credit line*.

Captions should appear on the front of the mount. This is the side that does *not* carry the brand name of the film. It corresponds to the shiny, acetate side of the film as opposed to the duller emulsion side. If, however, your picture requires more extensive captioning, use the back of the mount. In this case, write the most important facts on the front and the more specific information on the back.

The captions for color should also be brief, but informative. They should tell something that is not obvious from the photo, such as specific locale (if relevant), species of animal, or plant names, as: "Morels, edible type of fungus." "Mount Kilimanjaro, Tanzania, the highest point in Africa." "Johnny Jones, five, and fox terrier." "Holstein cattle and calves in Iowa." If the photo depicts a butte in the Grand Canyon, give the name and other pertinent information (Dana Butte, Grand Canyon, Arizona). It is often advantageous to mention *where* the picture was taken. For example, "Yosemite, California, Yosemite Valley with Half Dome seen from Glacier Point."

The Package: Photos, Captions, and Text

The editorial photographer can sell an unrelated picture, of course. But your black-and-whites or transparencies stand a much better sales chance if you can supply some factual matter as well.

Do enough research for a few paragraphs of text. If one of your pictures is "worth a thousand words," as the philosopher wrote, then ten pictures plus one hundred or two hundred explanatory words add extra value. And they get you a bigger check.

A stock agency or an editor cannot do much with the photos by themselves. A case in point: A photographer once sent Guy Cooper some good slides with an acceptable caption sheet. The

material was held together by the theme, "A Rodeo in America."

Cooper recalls phoning the part-time freelancer. "We need more input," Cooper told him. "Write a few paragraphs of text, too." The freelancer was stumped, so Cooper suggested he simply supply answers to a few questions: Where did the rodeo take place? When? Why was the event interesting or exceptional? How many people attended? Who were the riders you show in action?

The freelancer complied. Result: Cooper could now sell a "package."

H. T. Kellner agrees that the demand for packages keeps increasing. "Probably the best field in the future will be photography-writing, that is the photographer (a master) who can write clearly and coherently. This person will be able to sell many packages of photo essays accompanied by text to unlimited markets."

Many photographers are afraid of the typewriter. You can't blame them: They are visual people, not verbal people. Others are reminded of the newspaperman who said, "Writing is very easy. All you do is sit in front of a typewriter keyboard until little drops of blood appear on your forehead. Or they hear an imaginary conversation among scribes: "Do *you* like writing?" "No, I like having written!" Yet a short text shouldn't present great difficulties. You merely gather the pertinent information, jot it down, and then put it together.

It helps to think like a journalist, of course.

Include the five basic Ws—who, what, where, when, and why—in your opening paragraph. Plunge into it fast. Your lead fulfills an important function: It tells your would-be buyer at a glance what the story is about. No editor has the time or inclination to read a lengthy piece of writing to decide whether he or she is interested in the material. Naturally, the idea has to be good in the first place. One journalism professor puts it this way: "Writing is like pulling the trigger of a gun. If it's not loaded, nothing happens."

A few paragraphs of text won't give a photographer the license to philosophize or to meander, wasting the reader's time. Get

straight to the point. And tie it in with your pictures. Don't digress or lead the viewer/reader astray.

An executive of the Globe Photo Agency gives you an excellent example:

> You photographed a river being polluted by the dumping of waste material from an industrial plant. It is wrong to start off your text by saying, "Americans are becoming very concerned with the pollution of the environment." First, you have not photographed American showing concern; second, you have not photographed all the pollution of the environment but merely a segment of it; third, it can be assumed that everyone is now aware of that concern and it is, therefore, redundant; and fourth and most importantly, your statement tells the client nothing about what you have shot. The correct way would probably be something like: "River X, once a fisherman's paradise, is today a foul-smelling body of water, its banks littered with dead trout, as factory Y dumps Z gallons of chemicals into its stream each day."

Professional photographers are not expected to be equally skilled with words. Editors often forgive the great names if their manuscripts lack style. So be it; they show style in their images. An editor will ride to the rescue of an Avedon or a Penn. Even the commercially successful superlancer's text need not shine. It suffices that he or she can say what needs to be said.

Nor will an inept text piece kill truly superb photos. It makes the particular package less acceptable though. In fact, what if a competing photo illustrator had the same idea and supplied not only excellent pictures but a well-written text, too? Logically, the editor would probably buy the other person's package. Publishers are realistic when it comes to photographers who do books. A dual talent is rare. When an editor finds it, as in the case of mountain-climbing photographer Galen Rowell, the response is immediate attention and respect.

Polished writing takes years of practice, of course; that's why the *top* markets hire the word-workers and image-makers separately. "Let the writers write and the photographers photograph!" says one book editor. Most small and run-of-the-mill publications ex-

pect you to furnish pictures and text. That is why articulate photographers have the advantage over those who can't express themselves. The smoother the copy you turn in, the more an editor will appreciate you. You will have saved the editor's own valuable time, especially when you submit pictures with a complete two-to-three-thousand-word article.

What Is Good Writing?

This is a book about marketing your photography and not a writer's style book. Nevertheless, a few words are in order.

1. *Keep it brief.* Luther said it best: "The fewer words, the better prayer." Instead of saying "each and every one of us," write "all of us." Likewise, the brief word "now" is better than "at the present time."

You need only recall the architects' dictum "less is more." Prune the adjectives. Go easy on adverbs. Don't ramble; your words compete for the reader's time, along with television and books.

2. *Choose common words.* Fancy, unknown, or long words only confuse your reader. Good writing takes a certain modesty. Some people want to show off. I know a competent photographer who always turns into a pompous ass as a writer. How? He chooses complicated expressions. He lengthens his sentences so much that you can't follow him any longer. He picks long words when short ones would do. All of which makes him appear stuck up. A simpler language—and a little naturalness—would help the fellow.

3. *Avoid monotony.* Never repeat yourself on the page except for a few "ands" and "buts." Buy a paperback thesaurus and work with it. One editor who deals with many photographers also advises that you vary your sentence structure, your meter, and the length of your paragraphs. Sentences, he says, should also surprise and delight the reader. "Mix 'em up. Shrink 'em down. Stretch 'em out. Make 'em gallop. Make 'em funny. Make 'em sad. Make 'em abrupt. Make 'em languid!"

4. *Write in plain English.* A seventy-year-old photographer I know insists on a hopelessly old-fashioned language. He uses expressions that have long bitten the linguistic dust. You cannot get away with phrases like "inasmuch as," "attached hereto," or "notwithstanding the fact that." The opposite—a hip language—has its own perils; some youth slang may be passé next week. Rohn Engh, newsletter publisher for photographers, explains it well. Says Engh:

Instead of attacking that blank sheet of paper in your typewriter as a technically perfect erudite report, consider it as a letter to a friend. Keep the tone and mood friendly. You can even go so far as to type in a fictitious 'Dear Bill' at the top of your "letter." (Cross it out when your first draft is complete.) Never attempt to be "cute" in your writing. If something strikes you as extremely cute, nifty, or clever, then strike it out!

5. *Avoid clichés.* A first-class editor considers them fourth-class. One example might be to overuse the word "fun." It is a cliché in the eyes of sophisticated writers. You can do better. A travel editor told a group of photographer-writers in Utah:

If a friend informs you about witnessing a "purple sunset" over "breathtaking majestic" mountains with "quaint, picturesque" villages, then you'd better find another friend.

One good rule? If you think that you're facing a cliché, you probably are. Say it differently. Close your eyes before you commit a sentence to paper. Language can be as fresh as crocuses sprouting in your garden. Be creative; otherwise, you are like a photographer who takes snapshots in lieu of pictures.

After listening to a student's read-aloud prose, a famous author said darkly, "My friend, this time you were not writing—you were typing!"

6. *Get your grammar and punctuation right.* A Denver, Colorado, photographer told me that he met with great resistance in trying to sell his packages. It turned out that he used exclamation points instead of question marks. And all his commas were in the

wrong places. Editors are as finicky about such things as top photographers are about lighting.

Bad grammar can kill the clarity of your text. The editor tolerates an occasional misspelled word. After that, the entire manuscript—facts and all—can become suspect.

Also get hold of some paperbacks on the subject of good English. Read *The Elements of Style,* by Strunk & White (Macmillan), or *Writing with Style: Conversations on the Art of Writing,* by J. R. Trimble (Prentice-Hall), and *Freelance Writing: Advice from the Pros* (Macmillan). You will find detailed listings for these books in the bibliography.

The Writer as Photographer

Not all professional authors are equally handy with the tools of their trade. But even mediocre scribes can make more money if they also know how to use their cameras. One travel writer explains:

Years ago I decided if nonfiction freelancing was to be my life's thing, I had to become a first-rate photographer. Today, my photo files contain more than 25,000 negatives. I use them *every* day. For the multimarketed nonfiction writer (magazines) and author (books), a camera is a positive essential. You interview a source for a third-person piece and stay awhile to do a question/answer first-person interview, with multipix of your subject and you've got a second story that's excellent (*not* just 'good'). You do a routine text-photo piece and an ad agency calls to buy onetime rights to one of the transparencies. The original piece, with photos, brought $500 . . . the single agency-purchased photo, $1,500."

Paul Brock, one of Canada's most prolific writers, says that he owns three cameras: "All are simple automatics. And each has paid for its cost dozens of times over."

Apart from yielding extra income, some wordsmiths also consider picture taking "a diversion." Others say that cameras make a "good tax writeoff." For certain specialties—trade magazines, for

instance—it becomes crucial to take pictures because editors expect them and pay extra for them. Small trade publications can't afford to hire their own photographer, so the writer must do double duty.

Some writers eventually fall in love with the visual medium. They become full-time photographers.

For both métiers, you need to observe the proper manuscript format. One magazine editor shows you just how a manuscript should look. He shows where to list your name and address, the approximate number of words in your text (expressed in hundreds), and the title of your photo package. As you have already seen, captions go on a separate sheet. The format follows:

Your Legal Name About 0,000 Words
(Your Pen Name)
Street Address
City, State, Zip Code

CENTER YOUR TITLE IN CAPS
by

Your Name (or Pen Name)

Begin your text about halfway down the first page, three or four spaces below the name you wish to appear on it when published. Indent paragraphs five spaces, always double-space your copy, and type only on one side of the paper. Double-space between paragraphs, do not triple-space.

Letters, telegrams, newspaper clippings, etc., when used within the body of the text, should also be double-spaced; they must be given indentation of five or more spaces to make them stand out.

For pica type, your margins should be $1\frac{1}{4}''$ at the top and on the left; about $1''$ on the right; and $1''$ on the bottom. For elite type, use a uniform margin of $1\frac{1}{2}''$ on all four sides. Avoid faded or worn ribbons or paper that is colored.

These manuscript instructions were furnished by the Editorial Board of *US Veteran Magazine* in hopes that the information will help you with future sales. The instructions are standard with other publications, too.

The Photographer as Book Author

There are some photographers who have a passion about books
—touching them, reading them, collecting them. Eventually, they
want to be part of a book, too. One route toward this goal is to get
acquainted with a professional writer who specializes in books.
Does he or she have a project in need of a photographer? Unfor-
tunately, all too few camera people bother with writers. Instead of
approaching them—and staying in touch with them—some pho-
tographers shun authors.

Another possibility is to take the pictures for a book *and* write
it. Why not? You merely need a strong central idea, one that really
fires you. The contents of the chapters emerge as you gather the
material. Facts present themselves while you shoot the pictures.
After you wind up with a pile of notes, you lay out this informa-
tion for various chapters and start writing. Write naturally as if
talking to a friend.

A book can be enormously rewarding on several levels. It can
be a challenge to someone who usually takes only pictures.

It can be an ego trip. I once did a picture-filled book on ski
racing and ski racers. A lot of people in Aspen, Stowe, and St.
Moritz suddenly knew my name. Even now, fifteen years later, the
seat companion on a chairlift may look at the identification on my
skis. As we ride up, the other person may suddenly say, "I know
who you are. I saw your racing cover in the library."

Besides, a book project can stir a photographer's creative juices.

Boyd Norton, who photographs and writes about wilderness
travel, derives great pleasure from the creative dual job of the
medium. Norton explains: "When I'm conceiving a project, I craft
a theme drawing from both the visual impact of the landscape I
plan to photograph, and the prose I plan to write," he says. "Then
I immerse myself in the setting. I capture images in words and in
pictures."

Back home in Evergreen, Norton later locks himself into his
room and hammers out the details. His nonfiction has focused on

Colorado and Alaska; on Wyoming's Grand Tetons, on western rivers (see bibliography). The blending of pictures and text is especially common among outdoor specialists. Sample: Myron and Ann Sutton's *Wild Shores of North America* received accolades. "Photos and text are so well integrated that the book becomes a remarkable personal journey," wrote one critic.

A book project can be an exciting assignment. Dan Guravich, for instance, spent eighty-three days in the Arctic on a ship while working on *Northwest Passage,* a hardback. *The Throne Room of the Gods* meanwhile took Galen Rowell to K2 in the farthest reaches of the Himalayas. Here, as part of an expedition, Rowell not only took memorable pictures, he also kept a diary which became a book manuscript. Rowell dug under the surface. As one reviewer observed: "Here is the story of human strength and weakness, selfishness and selflessness, pettiness and generosity. The participants do not come through as 'storybook heroes' by any stretch of the imagination. They are real people, their flaws clearly exposed." This is rare in the annals of mountaineering literature and must have given the photographer-author deep satisfaction. A book such as this one lives on. It also serves as a terrific portfolio and even helps make stock sales.

You may also achieve a "first." Lisl Dennis says that her *Catch the Wind: A History of Windmills and Windpower* was the first photo-illustrated book on this alternate energy source, for instance.

Naturally, the ratio of pictures to text can vary from 80 percent or more visual material and 20 percent text to the reverse—80 percent writing and 20 percent photo illustrations.

Many photographers think that it would be easy to slap together a picture collection with a few captions. People who have done it warn that you should not underestimate the task. Nicholas Ducrot, a "packager" who specializes in visual books (which are then distributed by a regular publisher) voices this caveat: "Remember that each photo in such a book must stand on its own feet. Each photo must be different from the others, yet express and complement the overall theme. This isn't easy. It requires an eye for

quality." Durcot's opinion deserves respect because he has published the works of photo pioneers like Kertesz, for instance. Such photo books—as well as those by Haas, Skrebneski, or Avedon—show great editorial balance.

Certainly, travel books with photo illustrations stand a good chance. And while the genre seldom becomes a bestseller, the titles generally allow a publisher to recoup the investment for paper, printing, binding, editorial work, and the advance against royalties paid to the photographer. (Such advances against future book income range from five hundred to twenty thousand dollars, with an average of five thousand dollars).

Regional travel books are considered a good way to break into the field. So are practical how-to volumes; some of the latter may deal with some photographic specialty. Boyd Norton's *Wilderness Photography*, for example, is used by photo instructors. Specific nature books—one on identifying mushrooms, for example—that combine sharp photos with practical information, is another salable idea. Birds, mountains. and new sports all make acceptable themes. A photo book on ballet for children has done well and will do so again. Suzanne Szasz's cat books—all with loads of pictures —have sold nicely, among many other types.

Publishers have become extremely profit-conscious. The impact of your pictures is not enough by itself; you also need an idea that makes money for all. The wider the readership the better. And while some oldtimers and Big Names occasionally get away with inferior or narrow ideas, publishers expect originality from the first-book author-photographer. He or she will not be able to sell a title that simply duplicates another. It is true you see a lot of repetition in the forty-thousand-titles-a-year marketplace. But novices rarely succeed with rehashes.

Obtaining a Book Contract

Just how do you sell a book idea to a publisher? Step by step, how do you go about it? Whom do you approach? How much material will you need, and in what format?

Your route into print begins with selecting the right publisher. Not all publishers are alike, and it is up to the photographer-author to study the output of the various firms. How can you tell? Diane Cary, who runs a large university bookstore on the West Coast, suggests that you start with your bookseller. Ask for recent catalogues of various publishers. Study the list of titles. If a house does mostly novels, it isn't right for your photo book idea. If they do only textbooks with drawings, you may have to turn elsewhere.

The large "trade houses," meaning publishers that deal mostly with bookstores, often feature titles that express special editorial interests or idiosyncracies. One house, for instance, publishes reams of photo-illustrated hardcovers on sailing; another firm goes in mostly for large-size original paperbacks with a lot of outdoor photography. "Look on store shelves for the kind of photo book you want to do," advises Diane Cary. "Make a note of the publishers' imprints. Then look up some of the editors' names and the addresses." The data can be found in *Literary Market Place*. Also check the listings in *The Writer's Market* (see bibliography). Some photographers choose their publishers as carefully as their spouses or friends. They want a warm relationship, one that makes them feel important, one that lasts.

Apart from offering your proposal to a specific editor, you can also approach one of the publisher's sales people in your region. Sales persons often double as talent scouts. (Finding a profitable book venture is a feather in their cap.) On the other hand, the editors themselves always hope to discover a successful title.

To get signed up for your project, you will need to learn the art of querying. You can start the process with a half-page letter describing your idea and your personal background. Explain briefly what you have to offer. Don't exaggerate. Editors become skeptical if you announce "a surefire bestseller." Ideally, the publisher will now ask for more information about your book. If so, you are expected to supply:

- An outline, consisting of tentative chapter titles plus brief, but specific, descriptions of what will be covered.

- A brief biography that can mention any other books you have sold (or contributed to), awards received as a photographer, articles you have placed. Describe your specialties, too.
- A page about the audience for your proposed venture, a brief market study on why it would sell, some data that tells what makes your work different from or more desirable than existing titles.
- Figures that tell your editor the estimated word length of your manuscript, plus the type and approximate number of photos. (Give some details. Dean Conger, for instance, shot an impressive thousand rolls of film for a book on Russia.) Editors also want to know whether you have completed all or part of the book, or when you can deliver the finished product.

For newcomers, one or more sample chapters are required. Do them before you approach anyone with your idea. This way, you will be ready when an editor wants to take a look. In addition to a typical chapter, you should also be able to furnish a coherent contents page. That should be easy to do with nonfiction, especially if you are familiar with your subject. If you offered a photo book on Colorado, for instance, your contents page would list the individual chapters, and then the so-called subheads.

CHAPTER ONE COLORADO: THE QUALITY OF LIFE

Colorado in brief. Space: Scenery. Moods of weather and climate. Colorado mountain air and Coloradans' passion for *their* mountains. Hiking land. The backpacker's state. The climbers. The superclimbers. Golfing, tennis, fishing. Camper's delights. The good life: When Coloradans dine out.

You do this for the balance of the book, of course.

How long should your proposal be? That depends on the house, your particular subject, the number of other people pitching *their* submissions, the time pressures on the editors, and your own track record.

Aim for brevity and conciseness, yet give enough details so that

the editor can visualize your photo book. Some actual photographic samples may be better than Xeroxes.

Bear in mind that few editors have the power to give you a contract on their own. Most buying is done on a committee basis, which means that you must supply sufficient ammunition to an editor.

During a long workshop for the members of the (highly professional) American Society of Journalists and Authors, the assembled editors made these additional points:

• Always mention competing titles. Do not be afraid there might already be too many. Often the opposite is true. It proves to the editor that there is an audience for your kind of book. If that house does not have a book in that field, they may want one to penetrate the market. By all means, show the competing books' weaknesses. Give your reasons why your product will be better. Praise other titles if they are to be praised. Do not say all are rotten. It turns an editor off. Try to find legitimate differences. Are the current titles priced in the Rolls-Royce range? Maybe you're planning a Ford. Are the other books out of date or three times longer or three times shorter than what you are planning? Then say so.

• Don't expect to hear a publisher's cry of joy when you propose a nonfiction title that requires a lot of color printing. Elaborate books with a lot of color make for prohibitive manufacturing costs. Unless you offer a very broad (or a unique) idea, you are not likely to get an acceptance.

• Your proposal *must* answer questions like: Why is the subject worth doing? Why are you a logical or possibly *the* logical person to write it? Why are you enthusiastic about the topic? What is your point of view? (and editors expect that you have a viewpoint.) Why did you choose the particular house?

The speakers also stressed that the presentation counts. "Many proposals tell a long rejection story," said one editor. "The pages are all dog-eared. And I always wonder when I get a prospectus

where the photographer-author writes 'Forward' instead of 'Fore-word.' "

Selling a book—and later working with one or more editors—is not always a primrose path. Be prepared for some thorny moments. You may receive printed (or mimeographed) rejection slips from editors who invited you to submit the very proposal. You may have to wait for four months until you get the contract for an accepted book, plus another eight weeks until you receive your first check. (On the other hand, not all photographers are angels, either. After cashing his check, one man took off for Mexico. He never supplied a single photo or more than one sample chapter. In fact, he was never heard from again.) Manuscripts may be held for long periods. They can even get lost. One first-book author learned this the hard way. He did a photo book without making a carbon. The original manuscript was never found. It took him six months to write the book a second time.

Should you attempt to sell through a literary agent? You are better off handling your own sale. Agents are seldom interested in newcomers. They want only big moneymakers. "You can get a contract on your own for a good idea," says one pro. "You are better off that way. And at least you know what is going on with your idea. If you let an agent have it, the proposal may just sit on his shelf."

Your battle is not necessarily won after you make it into print. You do not always get advertising support, especially if the book is new and has not proven itself as yet. Doors of TV studios seldom swing open to interview you. No one can guarantee reviews in newspapers or magazines, and after just one year, or longer, your cherished title may suddenly go out of print. The reasons can be obscure. Or they can be clear enough. Old titles must often make room for new ones. A bleak picture? No, a realistic one. Dr. Sidney Werkman, a psychiatrist (and author) once told me that to succeed, a writing photographer requires before all "the ability to accept obstacles, to deal well with frustration."

It simply means holding out, hanging on. When many New

York publishers refused to accept a perfectly valid travel guide on a much-visited state, a certain photographer took his idea to Tokyo, Japan. Here, one of the major houses was willing to make the investment. The book now does well in the United States.

Self-publishing

There are a number of other alternatives as well.

Some photographers publish their own books. A number of superlancers who assisted with *Freelance Photography* belong to the self-publish group. Robert Wenkam, an excellent photographer (and able writer), has published several books on Hawaii himself. (He later goes to a large house for distribution). Ron Adams, the San Francisco commercial photographer, has created his own sleek titles on drinks (and one on desserts). He aimed these big "coffee-table" volumes at women, and estimates that he sold eight thousand copies in a two-and-a-half-month period.

The advantage of self-publication is that it is you—and not the publisher or art director—who decides the jacket design, layout, choice of photos, quality of paper, reproduction, and print type. It is you who will be responsible for the writing, too. You can self-publish the most sublime or the most absurd books. It is up to you. One nameless author gives an example:

"I published a book that had a million dots in it. It didn't have any pictures, and only a little introduction—then it had a million dots to show people what a million looked like. It was called *One Million.* Surprisingly enough, the Japanese are still selling it. It was a disaster in France."

The same author has also self-published valuable, quality-conscious art books, including one on China. "I went into this because I wanted to have total control over my work," he says. He admits getting so involved with each project that he works seven days a week.

Self-publication can be especially advantageous if you have a ready market for your output.

• One photographer did a Mississippi River guide for house-boats. It contained sixty-five pictures plus valuable information on ports, rental and supply firms, and so on. He sold it to every marina along the Mississippi, plus stores in the major cities. He even sold advertising to the very firms whom he mentioned in his guide. (In fact, I know an author who actually sells his acknowledgments, too.)

• A graphologist with a large following of students in private classes and at various colleges published his own paperback on handwriting analysis. He has a ready market because he uses the material in his classes.

• A big-name TV preacher has published his own Christian book. He sells it to his audience via television and through his church. He also hired commission sales people to call on Christian bookstores. His pocketbook added considerably to his (tax-free) income.

There are many such examples.

There are, however, disadvantages of self-publication. First of all, it requires money. Not everyone can dredge up six to ten thousand dollars for a guide book, or twenty-five thousand dollars for a photo-illustrated art or nature volume. Remember that you always lay your own money on the line, along with the expenses to shoot and process pictures, and the time for photography and writing. Sure, it is you who has editorial control. On the other hand, *you* are saddled with the chore of copy-editing and the responsibility of final proofreading. Will you be as skillful as a professional editor? (If not, can you afford outside help?)

You are also at the mercy of your printer. What if he happens to be sloppy? What if the illustrations are printed upside down? What if the printer is late for a seasonal book? What if you have paid a chunk of money and the cover does not live up to your expectations, or the pages are badly glued together?

Self-publication can be risky.

Its greatest weakness shows up in sales, however. Robert Wenkam is well-known to the publisher who ultimately buys the

copies (hopefully at a higher rate than Wenkam paid to produce them). It may take a new photographer-author a year or longer until a distributor can be found. And alas, some fine self-produced books are never taken on by trade houses who may have competing titles, or who prefer to originate every project in the house.

So you may invest twenty-five thousand dollars—all your savings!—and then be forced to call on wholesalers, booksellers, department stores, banks (books can make give-away "premiums"), major drugstores, art galleries (for art books), and airport shops. In short, you are no longer just a photographer who also writes. You are also a sales person. Some artistic people dislike these roles. Nor do they have the additional funds to spend on advertising. Even classified ads now cost big money. The returns can be modest. Once your self-published book is in print—and you have found outlets for it—you must arrange for packing and shipping the books, and do the billing or collecting.

All of which is a tall order. It makes many a photographer scurry to the nearest publisher willing to pay an advance and royalties for their brainchild.

One final item is "vanity" publishing (it is also known as "subsidy" publishing). Fortunately, most photographers ignore the deceptive "manuscripts wanted!" ads placed by the exploitative vanity sharks. No trade publisher needs to solicit manuscripts; the editors already receive too many offers. And a regular house pays you. With vanity houses, it is the other way around. Your investment may range from six to fifteen thousand without a guarantee that you will ever receive the bound copies of all the books you paid for. In fact, it is nearly impossible to recoup your investment.

Don Bower, a former trade-book editor who is now the director of The National Writers Club, investigated the major vanity firms on behalf of his seven thousand NWC members. Bower's files are now full of horror stories involving Vantage Press (which gets the lion's share of the business), Pageant-Poseidon Press (which disappeared mysteriously without refunding authors' moneys), and Exposition Press (which advertises heavily in consumer media),

and many others. Bower tells about his findings. "The vanity house has no incentive for ensuring that book sells; the house makes its money directly from the author, and if delays or other problems arise, more charges will often result. After having paid thousands, you may discover that only a few copies were ever sold."

Claims or promises in the vanity publicity that the book will be promoted stretch the truth to the breaking point. Reviewers, as a rule, will not look at a vanity title. Libraries refuse to take them seriously. And bookstores, upon seeing vanity imprints, will tell you they want nothing to do with them. Vanity books are treated the same way vanity press editors treat their manuscripts—with indifference. These publishers do not employ salesmen to call on stores. TV, "autograph parties," and other interviews which the ads promise should be seen as pure hype. Over the years the National Writers Club (NWC) has accumulated a complaint file as thick as a metropolitan phone book. There are no happy experiences recounted in this file. Says Don Bower. "The majority of the people—including our member photographers—were fleeced and are now outraged. The photographer-author in search of book publication had better go to a regular trade house."

So much for the photographer as writer. We can now concentrate on your freelance career. It can take a number of directions.

The next chapter examines your opportunities as a generalist, plus some specialties.

The Specialists

Taking Stock: Where Do You Fit in?

THE FIELD OF FREELANCE PHOTOGRAPHY IS VAST. You could compare it to medicine. There are many specialties, and some physicians start out as specialists. But others begin as general practitioners. Likewise, most established pros advise you to start as a generalist. "Do a variety of things at the beginning," advises Lisl Dennis, who broke into the business as a press photographer in Boston and now freelances in the travel field. (Her husband Landt Dennis is a travel writer.)

Some people manage to plunge at once into a specialty on the basis of their particular background. One example might be Myron Sutton, author of many picture books, who was trained as a naturalist and a park ranger. A degree in astronomy may lead to specialized photography of stars and planets; a student of architecture and design may moonlight as an architectural photographer

and later decide to go at it full-time instead of becoming an architect.

Actually, even your general area of photography will be dictated by your likes and dislikes, personal interests, emotional needs, and talents. Suzanne Szasz often counters the what-field-to-choose question of young photographers by asking, "How did you spend your day? What are your hobbies?" She feels that the best direction—be it photojournalism, wedding photography, industrial or medical specialization—always grows out of a person's interests. "Capitalize on your assets!" she says. Like a writer, you must choose the subject area that fascinates you the most.

Suzanne Szasz herself, while a generalist who has photographed portraits, pharmaceutical ads, parks, and especially cats, was always drawn most strongly to photographing children; this fulfills a deep need in her. A freelancer who can not swim had better stay away from underwater photography. And an individual who does not like to dress up or is not an extrovert would not make an ideal wedding photographer.

So where do you fit in? Tom Hollyman suggests that you define your motivations. Do you seek personal fulfillment? Money? Fame? The answer will help you to gravitate toward your ideal livelihood. A specialty will emerge in time. In a large city, the specialty can lead to money and success.

Being a generalist is at first a necessity, all the more so for those who live in a small or medium-sized town. "The ultraspecialist—say someone who only does liquor or only fashion—would starve to death in Denver," says one of the city's commercial photographers. The same holds true for other communities like Kansas City, Dallas, or Omaha. Most pros have no choice but to be generalists if they want to make their living there. Doing several kinds of photography—a combination of PR, advertising, industrial, perhaps some portraiture—can thus become essential for survival. The variety provides more chances to earn a living. (As a result, there are more generalists than specialists in North America.) And it makes life more interesting. If you begin as a versatile photogra-

pher in a large metropolis like New York, you reap some other advantages. For one thing, you won't be immediately "typecast" and refused assignments you would otherwise get. You are more likely to succeed because you *do not* have all your eggs in one basket. And lastly you learn more and therefore become a more well-rounded photographer when you finally specialize.

Dan Guravich, who has made a good living as a generalist for several decades, adds this personal note: "I turn down very few assignments. During one typical month, I was asked to cover the following subjects:

polar bears	a pecan harvest
antique airplanes	the Mormon Trail
Padre Island, Texas	

The high point of my career was undoubtedly being chosen to photograph the voyage of the S.S. *Manhattan* into the far north."

Even Dean Conger, who shoots mostly for the *National Geographic*, considers himself a generalist.

It can be a mistake to specialize too soon. In some cases, not getting into a rut and photographing different things might be a greater challenge and more satisfying. (On the other hand, a beginning generalist makes less money because problems must be solved in so many diverse areas.) In time, you will "back" into the kind of photography that suits your temperament. Naturally, opportunities in each field vary from one coast to another. Competition is especially fierce in advertising, glamour and fashion, and in freelancing for magazines.

Some of the interviewed photographers say that eventual specialization can lead to success and money. "Yes, yes, yes!" writes Grant Heilman, who is considered a leader in agricultural photography. This includes zoology, botany, horticulture, and other living things. "What sets my photography (and that of my associates) apart from generalists is that we have a knowledge of a subject in addition to being photographers. That knowledge is increased and improved upon just as our photographic skills are increased and

improved upon. I'm a believer in specialization, but it requires additional curiosity, and not everyone can *want* to learn about some important field in addition to photography. I find it exhilarating, and to a large extent it is responsible for what success I've had."

"I specialize in the recording and preservation of the natural scene," says Ray Atkeson. "I would advise specialization after a foundation of varied photographic experience."

Two photographers voice viewpoints that are both pro and con. Dick Durrance states: "Magazine work can produce generalists. The advantage is I can compete for a wide range of assignments. The disadvantage is that I compete against specialists. The choice to specialize must depend on one's opportunities and inclinations."

And Galen Rowell writes from California:

Yes, I'm a specialist in mountain photography, best known for mountain climbing photos, but also for wildlife, quiet scenics. Having a specialty is a two-edged sword. It has gotten me assignments I'd never have had as a generalist, but it has also pigeon-holed me in editors' minds so that they think I can't do general stuff. Now I try to do things outside my specialties as much as possible so as to avoid the compartments.

It's true that specialization can go too far. One New York pro whimsically recalls the instance of a well-known photojournalist who was so typecast for war coverage that his editor refused to let him do a story on inner-city children.

Agent Ursula Kreis admits that art directors can be equally difficult. "They somehow put a photographer into a very tight niche. I show his portfolio. It contains magnificent color stuff on apples. And the art director asks, 'But can he do *pears?*' " One of her agency clients, Bruce Pendleton, meanwhile says that too tight a niche can harm the photographer as well. "I know one colleague in advertising. He now only shoots inside. Studio work. When a client wanted him to photograph *outside*, the fellow got completely freaked out."

The Advertising Photographer

Of all the specialties, ad agency work is the most lucrative, but also the most competitive. Tom Hollyman estimates that there are perhaps five thousand advertising photographers in New York, with two thousand more elsewhere in the United States. "You should really live in or near a large city," Hollyman warns. "You can't expect a Manhattan advertising giant to work with an individual in a small Nebraska town. I *know* because I'm from the Midwest originally myself!"

As every ad person knows, there are huge sums spent for advertising in America. The United States cigarette industry, to name one example, shells out about $400 million a year for magazine ads (the Marlboro cowboy is typical), posters, billboards, and trade ads. In a twelve-month period, a perfume company paid $200,000 to one photographer (Avedon) and his model.

A visit to freelance photographer J. Wesley Jones's studio in New York City was a revelation to me: Jones said he grosses about $250,000 a year. The majority of good advertising photographers shoot for all kinds of clients. J. Wesley Jones, however, specializes in liquor, cosmetics and food (for the latter he hires a home economist at $250 a day). He employs two assistants who load cameras and handle the strobe lights; Jones sometimes gets hold of a part-time set designer and deals with models and with ad account executives (who are in the studio on behalf of their clients). Jones is a connoisseur of the good life, and he needs to have a finger on the pulse of current fashions.

Jones can pause for minutes to study a martini olive in a glass. The studio is hot; he wipes his forehead, strokes his blonde beard, and painstakingly changes the position of the olive by one millimeter. The shot may consume a few hours or a whole morning; it can take Jones and his assistants three working days to do photographic justice to a Heublein bottled–martini still life. And one morning can pay $20,000.

How do you get into this kind of work? J. Wesley Jones's story may be characteristic and give a beginner some clues. Schooling at the Massachusetts Institute of Technology. Four years of apprenticeship (always a good route) with another ad photographer. One and a half years of helping with setups, reflectors, lights, then camera work. An in-house job with a cosmetics firm as staff photographer. After three years, many outside offers. But J. Wesley Jones decides to freelance. Rents tiniest Manhattan studio. Cannot afford to hire assistant or even secretary. Initially does it all alone. ("Be prepared," he says. "At first no one wants you. But make your calls. Persist! Show your portfolio.") Jones enters the big time when he lands the National Distillers account. During the past ten years, he has also freelanced for Seagram's and Schaefer beer. None of this would have been possible if he had not set up shop in Manhattan.

Jones and some of his colleagues deserve to stand at the top of the pyramid. They are perfectionists who know about the products they shoot. They also understand design, graphics, layout, printing, and of course, they possess an in-depth knowledge of photography. They often rent large studios; Pendleton has one with a complete kitchen, for instance, which is also his favorite place for staff lunches. Other superlancers use the client's own backdrops, or do a lot of shooting outdoors. (Hollyman manages to work out of his apartment in Manhattan).

Advertising photographers seldom get bylines, so they are unsung heroes and heroines. (Phoebe Dunn, for instance, is one of the women who made it in ad photography. She specializes in children.)

In most American cities the ad specialist will have to be a Jack or Jane of many trades. "We must do it all," says Dick Burnell, a Denver, Colorado, photographer. "Not just liquor or food or children. Last week, I shot sterling silver bowls as premiums for a bank. Tomorrow, it's a ski area, or ad photos for a steel mill. Next month it's a building for a corporate ad."

What do the typical ad photographers get out of it? To one individual it is mostly the money. To another, it is an ego trip to

"create" a new travel destination; a series of his or her color ads may bring a stampede of tourists.

Ron Adams, the articulate superpro in San Francisco, can explain the power: "Imagine! A quarter of a million people go out and buy a product because of the way *you* have shot it! A photographer can sell millions of dollars worth of lipstick! Think of it! A lot of people will look at one of your pictures and say, 'Isn't that beautiful? Wow! I want to buy that!' What an ego trip!"

The Commercial Photographer

Ron Adams not only takes pictures for magazine ads, poster ads, and fashion ads, but he also illustrates catalogues. He has several major California department stores among his clients. "I find it a great challenge to shoot kitchenware," he says. His versatility is enormous: Adams can shoot blankets, pillow cases, towels, china, and glassware with equal expertise for a Bullocks catalogue. He can make wine glasses brim with romance or bring curtains to life. "You've done a good sales job," he says, "when you bring out the textures. When you make the merchandise into something the public wants to touch. Thanks to you, a pillow becomes desirable. Something they want to possess. If you're unable to deal with these items on a sensual level, you won't motivate people to buy."

Ron Adams has photographed gourmet dishes and cocktails for a book publisher; done glamour for women's magazines; set up his equipment in a funeral parlor; covered an automobile race "complete with flaming wrecks"; and even done ("I recommend this to newcomers") baby pictures.

All the above (which includes a lot of nonadvertising work) puts Ron Adams into the class of the so-called commercial photographer. How does he see his mission? "To make as much money as possible!"

He has a point. Most experts consider photography a good vehicle for solid profits; you do everything on assignment and get

paid by either the job itself or by the day. Guravich points out that such photography might include working for smaller companies who need occasional photos but who do not have an agency. The firm may not be willing to pay for a top name. That is where *you*—as a new freelancer—come in. Once you *have* the account, you might get some repeat business. You may get to do brochures and posters. And word-of-mouth recommendation could get you other clients. Many young commercial photographers work strictly from their homes. They don't bother with studios.

Commercial photography is taught at major photo schools and, at less cost, in vocational schools. The courses include photographing the exteriors or interiors of homes, buildings, shopping centers, and so on. And you may have to learn the skills of shooting cars, appliances, furniture, jewelry, store windows, and even portraits. A public relations firm may commission you to do typical PR shots of a hospital or a college, or the agency may need a freelancer to photograph a building, real-estate development, or a resort. The aggressive freelancer reads business sections of local papers, or finds leads in local trade magazines and through personal contacts. The more varied your interests—in music, medicine, politics—the greater your chances to get some business. Ron Adams says: "There're only so many accounts to go around. Do your homework, and you better be there first and learn to sell, sell, sell."

Architectural/Industrial/Technical Photography

Has design always fascinated you? Did you want to become an architect but never got around to it? If you now live in a large city, you might indeed cash in on your special interest and approach a group of architects. Some pros take the risk of making up a special portfolio for this purpose, so that they can show off their special skills to prospective clients. Some architects are so enamored of a building that they may hire *several* photographers over a six-month period to do justice to the design. (Architects later use the pictures in architectual magazines, for exhibits, or to attract new

business.) From the beginner's viewpoint, such work is easier to get than other kinds: after all, builders, contractors, construction material companies, realtors, and even home owners may need your services. It's just a matter of making calls.

Architectural photography can become such a specialty that you wind up doing it exclusively. To achieve this, you'll have to get deeply into design, to sharpen your understanding of structures and styles, so that you can document both for the client. In general, architectural photography requires 4 × 5 instead of 35mm pictures.

In Connecticut, one well-paid architectural photographer specializes in modern suburban townhouses and office buildings plus Colonial farm houses and Victorian mansions. He has a feeling for detail; he utilizes sunlight across the facade of a building to the fullest. His fees are high. And he earns some extra money from teaching and has written two books. Other people—including many women photographers—do mostly interior shots of apartments, offices, and so on. A few people get rich on aerial photography.

A representative of the Hasselblad Camera Company stresses that you need flawless technique; you must be better than the architect or contractor, or there'd be no point in hiring you. Some of your output will be printed in architectural and technical magazines and exhibitions. This kind of photograph usually stresses the character and features of the building itself. Shots are often taken from dramatic angles and with as much contrast as possible. They usually look striking, perhaps even elegantly exaggerated. All this can be learned, of course.

Architectural photography is closely related to its somewhat less regal aristocratic cousin, industrial photography.

Many large factories and plants have an in-house (staff) photographer who gets a salary. But on occasion, there is an overflow of work and photographers must be hired. Too, smaller plants rely on freelancers. Your assignments run the gamut from plant operations, equipment, and products to plant personnel, stockholders,

and publicity shots. House organ publications consume mountains of pictures. Technical applications of photographic skills in industry are booming.

As an extension of our vision, the camera instantly records information to aid the engineer, the scientist, and the surveyor. The industrial photographer is involved in almost every type of photographic activity, from helping the research department, making visual aids, shooting commercial and advertising illustrations, to the taking of portraits of executives. You need to be truly versatile. And you must have a feel for industrial subjects.

Your pay will be far less than for regular ad photography, but you will probably get your checks more quickly. (Ad agencies sometimes wait until they are paid by the client.) Certain commercial photographers, especially in small communities, are also drafted to shoot factories and other facilities. Dick Burnell, one such generalist, explains what is expected of you. "You must glamorize an industrial situation. This isn't always easy. It takes curiosity and imagination," says Burnell.

All the experts recommend that your technical knowledge should be enhanced by such refinements as micro- and macrophotography, audiovisual, and so on. Such knowledge can then get you into even more specialized areas like X-ray, spectography, and photos for medicine. Some stunning color pictures are being made of cholesterol deposits in an artery; a sperm en route to fertilization duties; or tumor cells. Doctors seldom handle photographic tasks these days; these have become far too complex. The electron microscope has opened new frontiers to you, the photographer who charts the new discoveries. The eight thousand or so hospitals in the United States offer an area for the trained photographer and technician.

Some of the hospitals have their own photographic department or employ a staff person. Other hospitals, however, use outside help. It would pay to call them in your community. In addition, clinics or groups of doctors often ask a freelancer to take a shot of a medical case, record the before-and-after situation, and pre-

pare a slide show which the physician gives to peers or students. Photo schools include the medical field in specialized industrial photography.

Photo schools excel in courses for self-employed medical photographers. One typical 150-hour curriculum might include courses on photographing subjects associated with such medical specialties as obstetrics, pediatrics, plastic surgery, orthopedics, oral and dental hygiene, dermatology, burns, and ophthalmology. Other medical subjects might include operating-room photography, in-patient photography, and the photographing of compound microscopes, cultures, electrophoresis slide plates, specimens, radiographs, and many other items. Such work must be backed by solid studies in biology, anatomy, and other similar disciplines.

Some freelancers pursue other routes altogether. They choose to enter the missile field, for instance. You may be present during missile preparations, the actual launching, and the final tracking. In both the civilian and the military capacity, and in astronomy, photographers and the missle age have become inseparable.

All kinds of other scientific areas—above or below ground and underwater!—gobble up full-time freelancers. They are expected not only to wield special cameras and understand all kinds of films and paraphernalia, but these specialists must also know their *subject*, along with broad scientific knowledge in the particular field. You get all this via university studies culminating in a degree.

Commercial Photography Schools

North America's major photo schools can also play a major part in getting you ready for a specialty. You won't need them for studio photography or portraiture, and many people even go the apprentice route in the commercial or advertising field. But some specialized courses in photography with the scanning electron microscope, or advanced lab techniques, or undersea photographic technology at a photo school should pay off with earnings later on.

The leading photo schools have definite entrance requirements and are generally expensive. But they also invest in expensive equipment and pay high staff salaries. Such schools become invaluable for the rapport between the teacher and yourself; this is an impossibility with correspondence courses. Most freelancers consider the learn-by-mail method useless, and the home-study courses a rip-off. By contrast, some photo schools later assist you with employment searches.

Some schools which may be of interest to you:

Artography
Academy of Photographic Arts
5352 Laurel Canyon Boulevard
North Hollywood, California 91607

Brooks Institute
School of Photographic Art & Science
2190 Alston Road
Santa Barbara, California 93108

Center for Photographic Studies
722 West Main Street
Louisville, Kentucky 40202

Germain School of Photography
225 Broadway
New York, New York 10007

New York Institute of Photography
263 Ninth Avenue
New York, New York 10001

New York Institute of Technology
Old Westbury, New York 11568

Ohio Institute of Photography
2029 Edgefield Road
Dayton, Ohio 45439

Rochester Institute of Technology
School of Photographic Arts & Sciences
Rochester, New York 14623

School of Modern Photography
1500 Cardinal Drive
Little Falls, New Jersey 07424

Winona School of Professional Photography
Winona Lake, Indiana 46590

The Photography Market Place (Bowker) provides a detailed list of North American universities with large photo departments and what they teach. The college photo arts department is excellent for the future generalist or the specialist.

The Wilderness, Wildlife, and Agricultural Specialist

Some sound knowledge is equally critical if you must shoot—as Grant Heilman does—"the fifty most common American weeds." Where are they? What are their names? Heilman and his staff must know; otherwise they couldn't write captions or even find the weeds. In the same sense, this agricultural specialist has shot, catalogued, and captioned (even in Latin) scores of beetles and other insects, practically every tree, and numerous rocks—all for his extensive stock file. His extensive outdoor collection also includes a whole zoo of cattle, chickens, turkeys, and other domestic birds, hogs, sheep, horses, forest scenes, and so on.

Many successful outdoor photographers are interested in conservation. They may expose the ravages of cutting down whole forests, of brutal tree harvesting, the damage done by snowmobiles, or the killing of nearly extinct animals. Many young hikers buy their first camera to express their views about the damaged environment. Or listen to how Boyd Norton, a former scientist, became a nature photographer. "My strongest driving force was the desire to nurture in people a sensitivity, care, and understanding of the natural world." Boyd Norton now considers it his mission to "help save our last wilderness." Norton's many published books back that theme.

How does a person get into this specialized field? Norton says:

In the early 1960s I discovered those marvelous books published by the Sierra Club. Like the Sierra Club photographer, I also wanted to grab people and to say, 'Look, this is what's so magnificent and beautiful about the natural world. But it won't stay this way if we don't work hard to save it.'

At that time I was still working as a nuclear physicist for the Atomic Energy Commission in Idaho, trafficking in neutrons, gamma rays, and other assorted and unhealthy things. One of my early breaks in publishing came when *Audubon* magazine published an early photo essay of mine. By 1969 I was pretty disenchanted with the AEC. I wanted to quit the physics racket. *Audubon* published a major photo essay and article of mine on Hells Canyon and the conservation battle to save it. The magazine spread had quite an impact and led to the introduction of legislation in Congress to save the area. Eventually, I was offered a contract by the Sierra Club for my first book, *Snake Wilderness*, about the Snake River country in Idaho.

Another wilderness voice comes from Myron Sutton and his wife Ann, who say: "We wanted to record the great scientific wonders and attractions of the natural world and use these images in books and classrooms." Sutton still lectures today.

The slide presentation was Galen Rowell's impetus, too, for his kind of freelancing. He explains:

I started out taking pictures of unusual places I visited in the mountains, then showing them with lectures or giving them free to small magazines and journals. Soon I had a growing demand for photos and texts, sometimes together, sometimes separately. I studied available books on photography, light, and color voraciously and asked a million questions of experts.

And the great David Muench, now among the foremost western landscape photographers, began by traveling with his father. "I soon discovered that nature was everything to me," he says. Muench has shared the scenic grandeur with thousands of readers via his big picture books. He stands on top of a freelance field that is no doubt the most competitive; because photographing outdoors is so enjoyable and healthy, there are more people who do it. The result

of the overpopulation: It is a difficult field for those who want to make a living in it.

Boyd Norton calls himself a wilderness photographer rather than a nature photographer. What is the difference? "In photographing wilderness country you're working under pretty remote and often rugged field conditions," Norton warns. "That has an important effect on your working technique and on the type and amount of equipment you can bring along. On the other hand, good nature photographs can be made without straying far from home; in parks or nearby woodlands, for example." Norton admits that his own field is "a lonely and not very lucrative one."

Is there room for women wilderness photographers? Yes, definitely. One prime example is Patricia Caulfield, author of numerous photo books. She explains how she entered it: "I had a great interest in natural history as a child, and it is this interest in subject matter which gives me the patience necessary for work in the natural history field." Ms. Caulfield warns that wilderness photography—particularly of animals—can be time-consuming. She once found some stilt nests deep in the Florida Everglades. She had to check these nests every day for about three weeks in order to be there when the eggs hatched. She says, "I got up at four, at 6:00 A.M. met a cooperative biologist from the Florida Game and Fresh Water Fish Commission who was working in the area. We went about ten miles in his airboat to photograph the hatching."

Pat Caulfield admits that not too many women relish the long weeks of roaming the wilderness. "Women who have children would find that kind of life impossible," she says. Many insiders claim that Pat Caulfield is the most successful female in her specialty.

Pete Czura, one of her colleagues, stumbled almost accidentally into the business. The Nebraska-headquartered Czura explains: "I did an article for an editor who asked me to submit four black-and-white prints to illustrate it. He offered one hundred dollars. With that lordly sum, I bought my first camera. This was in 1957. Since then wilderness photography has proved more profitable to me

than writing." In fact, Czura has photo-illustrated animal books, and sold over one hundred covers to national and international magazines. "I would have never chosen a photo specialty other than this one." What is in it? Czura can talk eloquently about his myriad fishing adventures (in sweet or salt waters) and his travels to every continent. In Kenya, Czura once found himself eye to eye with a lion. "I looked into my viewfinder and thought, my god, he's close, and he was right there, a few meters away, and coming closer!" On another African occasion, Czura and his cameras actually moved among elephants "covered with elephant dung so they thought I was one of them!" He agrees that the work takes patience and is often dangerous. To be good at it, a freelancer must "risk anything for a shot," Czura says. "No doubt about it. You must be able to take chances."

Most wildlife specialists take chances with their time, too. They shoot "saturation" so that they can come up with many pictures on the same subject. Editors often insist on forty to fifty views of the same animal.

Travel Photography

"There isn't a train I wouldn't take. No matter where it's going," wrote Edna St. Vincent Millay. There are fewer trains nowadays, especially in the United States, so travel photographers use their cars and jets. (On occasion, they also shoot from passenger liners, freighters, ferries, ostriches, or camels.)

Thanks to some connections with national tourist bureaus, airlines, and resorts, a travel photographer can move up to a hectic schedule. Manhattan-based Lisl Dennis, who shoots mostly for magazines, kept track of one particular six-month period. In April, an editor asked her to photograph a story on tulips in Holland. A month later, she was busy working in the United States. Within four weeks, she'd been in seven states shooting agricultural scenes and landscapes for a fertilizer company. In July Lisl and her writer-husband were on a mule safari in Switzerland, followed by a barge trip on London's waterways. In August, it was Paris, then Ireland in the fall.

Unusual? Not so. Dave Bartruff, a California freelancer, roams the world from Alkmaar to Amboanga and points in between. Bartruff's international assignments have produced covers for publications like *Travel & Leisure, Carte Blanche,* and *Bon Appetit.* Meanwhile Robert Wenkam concentrates on Hawaii. And Jack Fields has covered the South Pacific (including Micronesia) for decades. There are many good American travel photographers, most of them members of the Society of American Travel Writers (SATW).

With enough publication credits, the photographers get on lists for airline junkets; a national tourist bureau may pick up the rest of the tab. Resort hotels and convention bureaus invite these specialists. They often receive free accommodations in exchange for publicizing a hotel, resort, or city.

Most of the specialists also sell pictures to newspapers, hustle for advertising business, and deal with secondary or trade magazines. The photographer may add specialties such as ski photography, golf, recreation vehicles, camping, and so on. But even so, the travel specialist is the low person on the financial totem pole. Lisl Dennis considers her field "the underdog of the photo world." Most magazines pay poorly and—alas!—many amateurs travel with their cameras, too, competing against the professionals. As a result, the métier suits only those individuals who are inwardly compelled to travel, or the idle rich who can do so easily. Photography infuses their voyages with some purpose.

The topflight pros only work for the better-paying magazines or for ad clients, leaving the minor markets to others. Unfortunately, most publications pay for travel coverage on publication. This can be a year after turning in your transparencies. To make matters worse, many editors expect the travel specialist to write a story to go with the pictures. The average photographer is a visually oriented person, with only modest writing skills. Doing a story therefore adds a burden of hard work. And conversely, a professional writer cannot possibly know everything about camera techniques. Such a person's photographic output may therefore be a hit-and-

miss thing. Only a few people can photograph and write equally well.

There are some other pluses and minuses to be considered. Traveling for long periods can become strenuous. You live out of suitcases, get delayed or stranded at airports, sometimes sleep in noisy hotels. You must deal with bad food, putrid water, and impossible accommodations. When Dean Conger toured Russia, he found himself besieged by natives who insisted that he drink with them; he often had to swallow more liquor than he wanted to, lest he offend the Russians. "On the average day each of us consumed one-half bottle of vodka," he recalls. "Call it a form of primitive hospitality, mostly sincere. At other times, the booze masks the fact that they aren't really going to show you anything. So, if they get you loaded, you won't care."

One of Conger's colleagues speaks frankly of other adverse conditions. This reporter feels that almost everything is against travel photographers. Yet they persevere. The studio man leads a very organized, secure life. The wind doesn't come along and blow the food off the table while he's trying to do a still life. Rain doesn't soak his models to the skin.

Yet there are glorious creative possibilities. The alert, sophisticated travel specialist can bring his or her own vision to bear on a country or city. You can emphasize the changes; you can indicate what has happened to a place. You can truly illustrate Baudelaire's lovely two lines about the new and different Paris:

> Le vieux Paris n'est plus: la forme d'une ville
> Change plus vite, hélas! que le coeur d'un mortel.

> The old Paris is no more: a city
> Changes faster, alas, than the human heart.

The photographer only too rarely finds the kind of editor who accepts candor. In that case, travel-with-camera results in an honest comment on a local situation. Evelyn McElheny illustrated the air pollution over Denver, Colorado, along with the sign pollution and Denver's many porno shops. She photographed the graffiti

carvings made by youths on delicate aspen trunks at a national park. On the other hand, Bartruff considers himself a travel photographer who wants to show a city or country in its best light. "I go for tourist promotion, not journalism," he says. Most travel photographers are somewhere between exposing a situation or embellishing it. Let's say you travel in the French Alps, for instance. The assignment calls for depicting Chamonix. The competent travel pro will photograph its most glorious feature—the gleaming Mont Blanc glacier. In town there is Chamonix's mélange of old and new, rust and gloss, and the many building cranes at work. The specialist will always ferret out the most characteristic shot of a town or landscape.

The travel photographer lucky enough to illustrate books has the greatest chances for creative expression. Wenkam once drove onto the Hawaiian summit every day for a week. Finally, one morning, the light was just right and he got the shot he had visualized. He placed his tripod in position, screwed the Hasselblad into position, and pointed his 250mm telephoto lens. "The sun rose on schedule," he writes. "It was glorious. I had my favorite shot of the Big Island."

Photojournalism

When Bartruff says he is not a photojournalist, others insist that they are. And photojournalism has indeed returned with full force. The newsmagazines such as *Time* and *Newsweek* flourish. (Freelancers sell to both). *Life* is back (and works with freelancers). *Geo* magazine has joined a great number of newer and successful publications. Picture stories are bought by hundreds of markets that include newspapers. H. T. Kellner, an expert on picture sales, describes other opportunities: "The beginning photojournalist who specializes in children, teens, and people in general will find a ready market for his work at hundreds of the small (and not so small) religious publications in the lower range of payment. Photos of minorities are good sellers, too." Kellner's *Moneygram* newsletter overflows with names of editors who buy pictures.

While it is difficult to get hired as a staff photographer, maga-
zines are willing to consider your photo stories, and, after you
prove yourself, to send you out on an assignment. Likewise, news-
papers are overrun by applications for photographic staff jobs. But
a paper will welcome the freelancer who offers some unique scoops.

Not everyone is suited for the photojournalist's life. It takes
curiosity, a sense for news, a quick mind, wide interest in many
fields, persistence, and *chutzpah* or sang froid to keep shooting.
Instead of communicating with words like the writer, the photo-
journalist tells the story in pictures. A journalism school instructor
explains the work: "You're a reporter with your camera in the
midst of excitement when it happens. You get the picture of to-
day's news—the razor-sharp shots your news editor wants. You
make on-the-spot pictures of presidents, mayors, movie and tele-
vision stars, sports greats, weddings, disasters, crimes."

In his long career, *Time/Life/People* freelancer Carl Iwasaki
gave us memorable coverage in black and white of a mortally sick
American president in a wheel chair, of cattle being fed by airdrop
during a bad Wyoming winter, of a dynamited jetliner and the
FBI's legwork, and of another United States president taking a
tumble on skis. Photojournalists have captured that moment in
Jackie Kennedy's life when she acted with dignity during the Dal-
las assassination. The brutal murders at Kent State, the Guyana
excesses, and the deaths of *mafiosi* were all recorded by free-
lancers.

Some photographers begin in news and later move on to other
fields. Lisl Dennis, for instance, first worked for a Boston news-
paper; she was the only woman among twenty males. (Women are
no longer rare in newspaper photography.) Dean Conger first free-
lanced part-time for a Casper, Wyoming, newspaper, while still
going to school. Some photographers now start with a summer
internship.

How can you tell if you're suited for photojournalism? Iwasaki
claims that your interest usually shows up at an early age. The
future *Life* photographer himself already ran around with a thirty-

seven-cent box camera in grade school. Iwasaki began to take snapshots of other kids in high school; he volunteered his services for the school's darkroom, learned to develop film, shot activities for the yearbook. He began to work part-time for a commercial studio, developing pictures, making prints, and enlarging, all of which helped him later on as a photographer for a federal agency, and finally for the big American magazines. Iwasaki feels that the university photojournalism school still isn't absolutely necessary.

As a young man, advertising and annual report photographer Tom Hollyman joined the staff of the *St. Louis Post Dispatch*. It was his baptism of fire in a long career. Hollyman found it enjoyable. "I ran around with a Speed Graphic," he remembers. "I went whammo! whammo! What a life! I felt like Alice in Wonderland."

The situation has somewhat changed. Journalism schools now grind out candidates for the few staff jobs on magazines and larger papers. As a result, the leading dailies are overrun with applicants. Photo editor Ken Poli recommends that you try *small* newspapers and then step up the ladder. There are almost eighteen hundred daily papers in the United States, plus eight thousand or so weeklies, many of these in small communities.

Much of the freelance photojournalism work for magazines is speculative and ill-paid. "Forget about getting rich in the business," says Iwasaki. "And be prepared to beat the bushes for assignments!"

After thirty years, Iwasaki himself is in the lucky position to receive calls from editors. He no longer has to solicit work himself. Iwasaki suggests that a new photographer try to get published *anywhere*, and try for a steady flow of assignments to guarantee your livelihood. The situation on newspapers is much better; here the photographer gets a fair salary, thanks to the Guild. In addition, many papers allow their staff photographers to sell pictures on the side. The rookie photojournalist must be versatile and able to shoot all kinds of things. With patience, you might become a contract photographer for a magazine, which means a steady income. You may also be signed up for a string of assignments.

Photo reportage's most admired practitioners have provided pictures that can haunt us forever. Great photojournalism remains etched in the brain. But there are others in the profession who occupy its lowest and dirtiest rungs. They are the so-called paparazzi, those photographers who invade the privacy of celebrities and who molest rich and poor alike to get sensationalized shots, often for the gutter tabloids.

The best known of the paparazzi breed, Ron Galella, has been sued by his victims and was even bombarded outside a New York discotheque with garbage can lids. "When you face Galella, it's like being mugged," one woman has said. The privacy-invading, scoop-seeking breed of voyeurs are generally disliked by serious news photographers. "So they can earn $15,000 for the picture of a movie star?" says one magazine photographer. "I'm not impressed by the money they make. Paparazzi are vultures. Animals! I despise them!"

The statement may be a strong one. But the classic photojournalists always used their cameras as a tool to make social changes. One good example was Lewis Hine. His photographic commentaries of the early 1900s starkly illustrated the dark side of capitalism. He photographed eleven-year-old girls who had to slave in textile plants and twelve-year-olds who were forced to descend into coal mines. Hine's work led to the child labor laws. The photojournalist has become not only a social commentator but a historian as well. One of the most memorable photos to come out of World War II is of a mother seen holding up an old snapshot of her son to the returning column of ex-POWs who file past her. The anguish in the woman's face and the bitter, aging faces of the soldiers remain with me always. The picture was a strong indictment of war.

The late W. Eugene Smith, himself renowned in the field, knew about the impact of a photograph. It could drum up emotion and awaken the viewer. "Someone, or perhaps many, among us may be influenced to heed reason," Smith once said. "To find a way to

right that which is wrong. And to create understanding and compassion."

The Photo Artist

The documentary force of late W. Eugene Smith's pictures was more than photojournalism. Smith's thorough research, his selectivity, the accuracy of his portrayals, and a personal vision made him a photo artist as well. No one can quarrel with the statement that a classic collection of pictures, like those in the *Family of Man*, can be called art. Many photographs remind us of the Degas, Monets and Manets, Rouaults and Van Goghs. Such work has lasting quality. It is often innovative and imaginative. Some modern photo artists often match the sensitivity and originality of great painters. And the Museum of Modern Art in New York takes their work as seriously as Picassos or Chagalls.

Most of them shoot pictures to please themselves. They do not want to be considered "commercial" because museums wouldn't touch them; on the other hand, serious photo artists know that ad agency art directors get nervous at the sight of their work. Some of it portrays fantasies, or illuminates an inner struggle—often one of anger, fear, or pain. One illustration is of the late Diane Arbus, who focused on New York's seamy world with a great number of downbeat pictures; she eventually committed suicide.

In studying modern photography, you become aware of how these artists reflect the style of their times. They can go far out; they experiment wildly and often surpass the surrealists of the fifties. Or they venture where no one else trod before: into the massage parlors of Manhattan, down into the ugly New York subways, or prowling the slaughter houses of Chicago. Some of their work reminds us of Katherine Ann Porter's downbeat novel *Ship of Fools*. The technique cannot be faulted. But the vision is mostly negative. In some cases the photography is self-conscious or murky.

The pictures of these artists are made subjectively and judged subjectively, like paintings. This includes abstract montages and

assorted work that results from darkroom manipulation. Still other photos are purely experimental. One example might be a shot of a cyclist in white tennis shoes but sans legs.

Duane Michals, among the genuine originals in his surrealist field, got his start many years ago in a New York gallery. Michals called his first show "Sequences," a good enough title for an art form which he co-invented. The pictures were all black-and-whites and already bore his personal stamp, with bizarre double exposures, blurs, and dream visions. Indeed, his sequences proved no less imaginative and "different" than a Menotti opera, full of encounters in dark alleys, nude women reflected in mirrors, floating ghosts.

Michals's work jolted the public. Some people actually walked out of the show. But before long, the Museum of Modern Art had taken him on, and today, Michals speaks of a "route paved with good exhibitions." Indeed, his unique vision eventually traveled to Paris (where it got rave reviews, a rare thing then), Rome, and Frankfurt. Ironically, the shows became Michals's primrose path to *Vogue, Glamour,* and other magazines. He still reserves one day per week to commercial work. Michals also sells through galleries, with a limit of twenty five prints per negative.

Garry Winograd, an artist whose work is somewhat pessimistic, markets his photos of Los Angeles freeways and assorted gray suburban scenes through galleries, too. He was fortunate enough to get the backing of a New York museum curator for his controversial work. Winograd himself explains, "I've been lucky in the sense that I never had to think about what to photograph. I never had a plan. All I really do is keep my eyes open."

Stephen Shore, one of Winograd's arty colleagues, has not been equally lucky; a critic has called his work "utterly boring and totally trivial." Shore takes snapshots of motels, fields, and main streets. Dozens of such "serious" American photographers have received acclaim; they are often products of art schools, university photo courses, summer seminars, or photo teachers themselves, would-be painters and, sometimes, recipients of various grants.

Photo editor Ken Poli, who sees his share of portfolios, admits that some of the work is "incomprehensible"; Pat Caulfield, photographer, former editor, and teacher says that many photographs now regarded and sold as art were originally just documents or propaganda and now merely look trite. And Boyd Norton, another longtime photo instructor, agrees that grants often go to the "esoteric or trendy" work. Even Duane Michals agrees that it is easy to fake photo art. Unfortunately, there are a lot of poseurs, he says.

Nicholas De Sciose, a technically advanced glamour photographer, has studied some of the "art" with great care. "The photographers often hide behind the out-of-focus image," says De Sciose. "Or they just provide us with design projects."

Ron Adams also takes a dim view of the fakers. Direct as always, the San Francisco–based Adams says: "I see a lot of 'arty' photographers traipsing around Sausalito. The cameras with long lenses hang around their necks. They talk a lot about photography. But when the push comes, they really don't know some of our most basic techniques. So the 'arty' people exhibit? Well, they just luck out on a few pictures. Besides, what's socially important about an old trash can? Frankly, almost any competent professional photographer could go out and shoot the stuff. And faster, too."

A successful commercial photographer may actually indulge in spending a few hours each week to pursue personal images. One Manhattan superlancer, for instance, has been shooting from the roof of his office building for eight years now. "That's eight years on the same subject," he says. "I go up there in all kinds of weather to record the view, the light at different times of the day, and the pigeons."

Grants, Fellowships

Everyone agrees that it is nearly impossible to make a living as a photo artist, particularly when he or she is still a newcomer. Even the more recognized artist faces financial problems. "There are too many of us," says one man. So what is the solution? You

can try to get a job teaching. You can compromise by doing editorial photography. You can send a first-rate portfolio to one of the photo magazines and hope for publication. Some young photographers have also lucked out by *schlepping* their more outrageous (or banal) work to an avant-garde type gallery, or visited the curator of a local museum and actually succeeded in getting some of their photos displayed.

It is true that nowadays few art museums want to get caught without some photography alongside the modern art. Your exhibited pictures may be reviewed by the local newspapers. This gets your name before the public and such reviews can be sent to editors. Naturally, even being part of a group at some of the better-known halls of art—the Art Institute of Chicago, New Orleans Museum of Art, International Center of Photography, or the prestigious Museum of Modern Art in Manhattan—is the ultimate high for a creative photographer. But such ego trips are reserved for only a few rare names.

In recent years, an increasing (but still minute) number of talented photographers have also received grants. "Don't go after one until you have decided on a serious project," advises Ken Poli, of *Popular Photography*. "Judges insist on the photographic worth of your project." (Among portfolios awarded grants are one on retired vaudevillians and another on New York prostitutes.) Boyd Norton, who has helped many photo students, points out that most grant applications (including several of his own) end in failure. Norton applied to the National Endowment for the Arts on several occasions. He was invariably turned down although he had already done significant conservation photography. Likewise, a respected *National Geographic* pro never succeeded in getting a grant for a worthwhile project.

Peter Gold, who directs the Lightworks Workshop in Minnesota, explains the odds against the grant seeker. "Competition is about as tough as can be," says Gold. "All the major artists compete, so you have to be really very good. You'll be among eighteen hundred yearly entrants who apply for the thirty-five to fifty grants of

$3,000 and $10,000" from the Photographers Fellowship Program of the National Endowment for the Arts. (Duane Michals got a grant of $7,500 in 1976.) In addition, the Guggenheim Foundation will include photographers among its art fellowship awards.

Some moneys are available from other sources, too. A complete list with addresses appears in the yearly *Photography Market Place*, a book published by the R.R. Bowker Company (see bibliography).

One type of professional rarely asks for a grant. The talent of these specialists is generally ignored by museum curators. They are the "people photographers." Their clients are the sitters.

The next chapter deals with some of these specialists and their careers.

People Photographers

A Morning with Francesco Scavullo

THE STUDIO IS QUIET except for his Nikon. Click! Click! Click! Sunlight erupts: Flash! *Flash!* He handholds the camera, first kneeling on a piece of foam rubber, then standing free. He moves quickly, sleekly in his black shoes, black socks, a black silk shirt. *Click! Click!* Two assistants flank him, bend down toward the low stool on which the Master now sits. They hand him a second loaded Nikon, take the other camera, and remove the film. One assistant works the battery of strobes. A devastatingly beautiful black model remains still throughout. No one speaks.

The photographer is Francesco Scavullo, no less. Scavullo smiles as he shoots; it is the bright smile that swayed Barbara Walters, Jacqueline Bisset, and Joan Sutherland. Scavullo is model Lauren Hutton's photographer. Scavullo made Barbra Streisand look significant when she still worked in a delicatessen. He has

shot *Cosmopolitan* covers for years, and regularly appears in *Esquire* and in *Vogue*. At five thousand a portrait, this is big business; it take place at Scavullo's brownstone on East 63rd Street in Manhattan. Tight security protects the Master and his visiting celebrities.

He needs to concentrate on his sitters, whom he directs with great skill, making them try various poses, encouraging them, and always smiling brightly. The smile itself flashes like strobe in a smooth face, topped by slicked-down hair. (Scavullo is in his forties but looks younger.)

In watching him at work for a morning, I became aware of how well he handled his subjects. He could be suave, cheerful, quiet, or loquacious, as the occasion demanded. And Scavullo has the kind of charisma that draws the famous and rich to him. Like all great portraitists, he has the ability to bring out the best in his subjects. "Every woman who steps in front of my camera is the most beautiful woman on earth," he once said. Scavullo's knowledge of hairstyle, makeup, and clothes is as thorough as his psychological insight. Equipment? "The eye is more important," Scavullo says. He shoots with Nikons and Hasselblads. He never touches a roll of film or the lights. His assistants do it, so that Scavullo can concentrate on the essentials.

What is the secret of this people photographer's success? His self-analysis should give you a clue to what he considers desirable characteristics for the future Scavullos. He considers himself an optimistic, positive, helpful person. He is alive, enthusiastic, capable of giving applause to his sitters, a sincere people pleaser. (He told me that "liking people" is perhaps the most important trait for the portraitist or fashion photographer.) If you want to emulate him, you must be affable, able to give strokes, yet be totally committed to your craft.

Scavullo's involvement as a photographer becomes clear as you watch him at work. Nothing else counts. One day he decided that he should learn Italian. He wanted to live up to his name; besides, the American-born photographer often travels to Italy. An Italian

tutor soon settled down with Scavullo in the small *salon* above the
studio. Unfortunately, the photographer's mind kept traveling
downstairs where the action was. No way. He had to let the
teacher go.

Scavullo can only concentrate on his profession. This includes
several photo books (see bibliography). In both of them, he focuses
on portraits, on people, and on beauty.

What You Can Learn from Other Portraitists

It is considered chic to be photographed by certain names. And
the public not only wants to read about the famous sitters but
wants to know what they look like. The well-known portrait pho-
tographers—Scavullo, Avedon, Karsh—fulfill that need. Unlike
the paparazzi in the back alleys, the portraitists have perception,
taste, depth, and their images survive the sitters.

Styles vary, of course. Scavullo makes people beautiful. Ave-
don's people pictures are considered somewhat cold. And Karsh,
who enjoys gimmicks like painting a camera white, has his own
special style.

Portraitists only get to the top if they possess an above-average
knowledge of psychology. Karsh's famous story of removing
Churchill's cigar—to get the right bulldog expression in the prime
minister's face—was pure psychology. And anti-Semitic poet Ezra
Pound was provoked by Avedon, who cracked, "I'm a Jew!"
(Avedon once claimed that people come to be photographed "as
they would [go] to a psychiatrist or a fortune teller—to find out
who they are.")

To become a good portraitist, you don't necessarily have to stir
up someone's anger, as in the above stories. But you definitely need
rapport with people. You must often erase their self-consciousness.
All this takes charisma on the photographer's part, or at least a
flair for handling individuals.

You make more money if you're willing to create idealized ver-
sions of your clients; this is also essential for the commercial studio
photographer. (One of Avedon's critics accused him of seeing

"ugliness when he should see beauty! Insight is better than insult!")

There are other useful traits. Industry, for instance. In Chicago, famous Victor Skrebneski gets turned on by work. He seldom varies his routine: Rain, shine, or a Chicago blizzard, Skrebneski drives to his studio every morning. He gets there before most citizens reach their offices. "This is a business," he says. (Apart from photographing celebrities, Skrebneski also does the lucrative Estee Lauder ads.)

He suggest to young photographers that they apply themselves; industry, he says, is an important ingredient to get ahead. Hard work must be matched by professionalism. For instance: Skrebneski's staff sets up lights and props *before* the arrival of his busy sitters.

Gear? Many new freelance portraitists overrate equipment, it seems. Skrebneski shoots with a thirteen-year-old Hasselblad. Yet his portraits look like paintings; they are set against a stark black background.

One leading New York portraitist also claims that you can succeed if you are able to build up the right image. Good looks help, too. "Image and handsomeness are often more important in this business than talent!"

Fashion Photography

Fashion photography is closely related to portraiture. Both are competitive, of course. Fashion is especially hard to get into. And the requirements—even on the lower rungs of the profession—are much greater than one suspects. That is perhaps why the field attracted some great photographic names such as Edward Steichen and Irving Penn, whose works now hang in museums.

• You need a fascination with clothes, other people's and yours. (Avedon grew up with a father who owned a clothing store.)

• You must keep up with the fashion of the times, since you're recording it. This means an infallible sense of what is chic right now and what is not.

• You require a lot of technical knowledge: how to find and

handle models, hire a stylist, set up props and studio lighting. You must deal smoothly with department store personnel, magazine editors, models (who hire you to shoot *their* portfolio pictures), with labs, and ad agency staffs.

You must be able to work within the confines of fashion. This can be restrictive; even with great imagination and savoir faire, a photographer can only do so much with a model.

Robert Farber, who is considered one of the leading fashion specialists, recommends that the newcomer buy good 35mm cameras, plus the following lenses: 50mm (normal), 28 or 35mm (wide angle), 105 or 135mm tele for head shots, plus about fifteen hundred dollars worth of studio strobes. One of Farber's colleagues says that good equipment impresses clients and models.

Farber sees himself as "an artist first and a technician only out of necessity. . . ."

Apprenticeships: The Value of Assisting Other Photographers

How do you get to be a Robert Farber? Or a Vic Skrebneski, an Avedon or a Scavullo? Farber's route was unusual; originally interested in painting, he entered fashion by exhibiting artistic photos in galleries. Eventually, art directors drafted him. Skrebneski, who is now reputed to be a millionaire, went to the Institute of Design in Chicago. Avedon had the good sense to take a class from Alexey Brodovich, who happened to be the *Harper's Bazaar* art director just then. Brodovich saw the potential and gave Avedon his first breaks.

Scavullo went the apprenticeship route. Instead of going to college, he went to work for *Vogue* photographer Horst. He learned fast; he quickly became a wunderkind of the industry by doing a *Seventeen* magazine cover at age nineteen.

Along the way, Scavullo was helped and influenced by Alexander Liberman, Marvin Israel, and Sean Byrns. Scavullo feels that an apprenticeship is also right for fashion. His peers in the glamour field—Nicholas De Sciose, for instance—totally agree. De Sciose, now an important *Playboy* photographer, went to see Irving Penn and had the nerve to ask for a job. He never got it.

But he worked for another skilled people photographer. De Sciose considers an apprenticeship the best training you can get.

Apprenticeships are not all peaches and cream. You are expected to tag along on location, carrying the master's heavy equipment. You do all the mechanical work, such as setting up strobes and loading Nikons at record speeds. (You are not yet allowed to *use* the camera.) The pay is modest, the hours are long. And the top people photographers have ten times as many applicants knocking on their doors than jobs. Some beginners are hired on a freelance basis for special occasions; others manage to get on the staff of a name photographer. Either way, it is harder work than most young Americans are prepared to do.

Glamour and the Nude

And now meet Nicholas De Sciose, a "beauty photographer" who specializes in nudes. American-born, grandson of a Neapolitan, he has a studio in an old red-brick converted fire station in the midst of Denver's Italian churches and grocery stores.

De Sciose is one of the leading *Playboy* photographers, longtime contributor to *Oui,* and a perfectionist with a life story that should inspire the upcoming professional. He gets daily phone calls from amateurs ("How did you do it? How can *I* do it?"). He is envied by some pros for his diversification: De Sciose shoots sexy Lange ski boot posters, Samsonite luggage ("They pay me to make anything look beautiful!" he explains), and Head Skis (a big-name firm).

At this moment, he has a session with a delicate-looking, fully dressed, flat-chested girl whom he selected from thirty models; the resulting full-length portrait goes into the glossy *American Showcase,* as an ad for De Sciose himself. (The magazine is read by art directors.)

It took him two days to find the girl, two hours for her makeup by his stylist, and two more hours until he is satisfied with the prop (a simple bar stool).

More time passes until she holds the handkerchief as De Sciose

wants her to. "You have lovely hands," he whispers. "Move the left one. Up. Just a little bit. Yes, that's it. You're not a model now. You're a woman!" He cajoles, begs, praises. "Part your lips, please. Good. Fine. Turn your chin, please. Slightly. Slightly! Oh, terrific! Freeze!" De Sciose might be a motion picture director (his assistant applies a Karo syrup tear to the girl's cheek), but he is also (like Scavullo or Karsh) the innate psychologist. The work demands that you be a technician who knows lighting, a fashion expert (who must supervise the stylist), and a producer who later bears sole responsibility for it all.

The studio phone rings. The color of the phone seems symbolic. Gold. De Sciose's freelancing brings about one hundred thousand dollars a year, plus almost that much in reimbursed travel expenses. He has reached the zenith of his profession.

His story contains some lessons for new photographers.

It begins during the mid-sixties when young Nicholas was still in high school. He was shy, so he took speech classes. He already knew he was a photographer, so he shot prom queens for the high school yearbook. This was followed by various apprenticeships with other photographers. (A route which he recommends, too.) Finally there were long risk-taking periods when De Sciose invested in setups for *Oui* and *Playboy*. He got many rejections, then acceptances that never appeared in print, and finally *the* center spread. It elicited much reader response.

De Sciose advises beginners to take chances with their time and money, and to hang in there until they finally click.

Rent a studio? Not yet. Start outdoors. Use beaches, swimming pools, mountain glades. Then borrow friends' and acquaintances' apartments.

His most important piece of advice: Find a girl who also wants to take a risk. "Find one who trusts you or loves you," he says, "or one who is ambitious."

De Sciose thinks that a young photographer should not just do nudes but should "get a feel for many things." It is possible to glamorize a building, an old woman's face, a glass of beer, a pair

of skis, even an aluminum tripod. The nude is the ultimate challenge, of course. (The power of De Sciose's *Playboy* images is so strong, so painfully titillating, that some men read the articles but barely look at the pictures.)

Like his big-name colleagues, De Sciose has all the right personal characteristics: He is amiable by nature, comfortable with others, and sensitive to their needs. De Sciose treats his models with respect and tact.

Is there a chance to make some money until the jackpot comes in? According to many beauty specialists. a big market exists for model photography, even in medium-sized cities. Your clients are young (or mature) women (and some men) who hope to earn money as models. You can find prospects by placing ads in local newspapers or via charm schools and modeling agencies. You contact local actresses and actors via theaters; the clients will need pictures for their portfolios. Other income source possibilities include offering your services to small retailers—clothing stores, jewelery stores, beauty salons, among others—who need glamour photos for local ads.

Lastly, magazine publishers still hunger for pictures of nudes which are known as "cheesecake." While sexist and exploitative, such photos remain the mainstay of the cheap men's magazines. Stock agencies clamor for layouts and covers.

An executive of one photo agency gives some blunt guidelines: "Your model must be able to project beauty with her face and body. These may include making love to the camera (that is, the reader), being candid and unaware of being observed, and showing a certain interest in parts of her own body (a hint of masturbation). Her mood may range from pensiveness to abandon, exuberance, or overt sensuality. Whichever situation you choose, it must be planned, controlled, and stylized for maximum effect rather than 'hit and miss' and still *look* natural.

"The ideal model is beautiful from head to toe: colorful, shiny hair; intelligent face; large eyes; sensuous lips; firm bosom, small waist; well-rounded buttocks; long legs, etc., with all other parts of

her body well shaped and well proportioned. For the American market her breasts should be big, the bigger the better."

The artistic Nicholas De Sciose naturally takes a dim view of such requests.

"I photograph beautiful nudes," he says, "not just naked women."

The High-class Big-city Portrait Studio

De Sciose's road to the top included a long and valuable period as an assistant to Kurt Jafay, then one of Denver's best and most expensive portrait photographers. The apprenticeship began while Nicholas was still in junior high school and lasted till he was twenty and took over a studio of his own. In between, the future *Playboy* regular learned to understand the essence of glamour. "You learn about gracefulness, about making a woman—any woman!—beautiful, about making a male business executive happy with his portrait."

Jafay gave his apprentice the first clues on handling the city's carriage trade, and how one photographs a Miss America. The most flattering view, the best use of props, lighting, exposures, composition, printing, contact sheets, how to handle a customer ("I learned to say thank you") all proved invaluable later on. Many photographers agree with the route. "Start at bottom," says one. "Get a job sweeping up in your city's best portrait studio! Learn all you can; ask to handle the cameras. Then set up a studio of your own and make money!"

Many pros agree that the first-class portrait studio is extremely lucrative. Lou Jacobs, Jr., who has trained hundreds of freelancers in California, and then watched their careers, puts it this way: "I consider high-class portraiture the most lucrative and least competitive of all photo categories." Phoebe Dunn, famous for her work in the field, points out that "good portrait photographers are universally needed. Equipment can be simple, subjects endless."

The experts also agree on some other points:

- You *must* work in a portrait studio full-time (or at least part-time) before you set up one yourself. *Experience* is essential.
- You will only succeed if you have business sense.
- Consider learning portraiture in a commercial school of photography. Choose one which does not promise you "an easy road to riches" and "almost no investment."

In fact, how much capital do you need for a major portrait studio? A more elegant one in the large metropolitan city may cost more than a two-chair dental office. Naturally, the choice of the city—and your clientele—also determines how much money you need. New York is more expensive than Kansas City or Seattle. And a large portrait studio which aims at a clientele of politicians and bank officers means a higher investment, of course.

Most experts estimate that it takes a minimum of fifty thousand to one hundred thousand dollars—not necessarily all at once, of course—and perhaps partial financing by the Small Business Administration or a bank loan. It is also important that you have enough funds to survive while waiting for your business to succeed.

One expert estimates that there are now about twenty thousand portrait studios in the United States. Many of these operate in smaller communities as well.

The next section takes a closer look at some of the opportunities.

The Small Photography Studio

"If I were starting out today," says one editorial photographer, "I wouldn't try to work for magazines. Much too competitive. I'd settle in a small but growing middle-American—or Canadian—town and open a photo studio. I'd be a generalist. Not just portraits but babies, weddings, IDs, some commercial stuff. The works."

The above opinion makes sense. Opportunities do exist for the one-person studio, or better still, for a man-and-wife team. Such photographers are often revered in a small community; they are

always part and parcel of the community itself. And these studio people can be called freelancers, too. They are self-employed, and like other freelancers, they never know what the next day will bring. Their income depends on their own skill, ability, and resourcefulness.

What does it take to do well in a studio situation? A Small Business Administration (SBA) survey zeroes in on the requirements.

The operator of a one-person studio must have:

• A thorough knowledge of camera optics, film and paper emulsions and speeds, photographic chemistry, the proper handling of studio lights, ability to read light-measuring instruments, and a knowledge of darkroom techniques and projection equipment.

• A working knowledge of color materials, since an increasing number of persons want color photography. Color films and papers have far less exposure tolerance than their black-and-white counterparts, and the developing periods are much longer.

• Enough artistic ability to see—and photograph—individuals and objects in an appealing manner.

• A knowledge of the merchandise—frames, albums, and so on —sold in a studio.

• A knowledge of business management, especially a working knowledge of advertising, promotion, and recordkeeping.

A studio requires a sizable investment in equipment that must be constantly upgraded and repaired.

The minimum space requirements call for an office or reception area, a dressing room for clients, a shooting room at least fifteen feet by twenty feet, a work area which can also double as a storage area, and a darkroom.

Even the simplest setup should be air-conditioned for the comfort of your clients. During the summer months, air-conditioning holds the temperature of chemicals to proper tolerances for developing and printing.

In addition, the SBA has worked up an excellent quiz to determine if a photographer is ready and capable of opening a one-person studio. Here are the test questions you should ask yourself:

• Think about *why* you want to own your own studio. Do you want to badly enough to keep you working long hours without knowing how much money you'll end up with?

• Have you worked in a business like the one you want to start?

• Have you worked for someone else in the photo field?

• Have you had any business training?

• Do you know how much money you will need to get started?

• Have you counted up how much money of your own you can put into the business?

• Do you know how much credit you can get from your suppliers—the people you will buy from?

• Do you know where you can borrow the rest of the money you need to start a studio?

• Have you figured out what net income per year you expect to get from the business? Count your salary and your profit on the money you put into the business.

• Can you live on less than this so that you can use some of it to help your business grow?

• Have you talked to a banker about your plans?

All the above adds up to a need for solid business sense. The latter also comes into play *before* you make the final decision to settle in a small community or before you pick a certain neighborhood of a large city. It would be unwise to commit your own savings and get a loan until you've analyzed the "territory" for your studio.

According to the SBA, many photographic freelancers never take a close look at their area. And many studios go out of business the first year.

There are a number of reasons for such failures. The photographers often underestimated the working capital, or overestimated the possible income. In many cases, their original market research

was superficial. In the end, they failed because they picked the wrong location or misjudged the potential clientele.

There are other reasons for bankruptcies, even of potentially profitable studios. For instance: The photographer refuses to operate alone and hires a full-time secretary and a lab assistant. The payroll then consumes all the profits. This happened to a wealthy photographer who set up a shop in a western mountain resort that would have supported him well. He personally didn't like to put in the extra hours, so he hired a staff of four. The overhead killed him. His studio went out of business in twelve months.

In the same sense, you can't start your operation until you've looked at your competition. SBA advisors have compiled these crucial test questions: How many competitive businesses are there within the market area of this business? Where are they located? What can be found out about them? From whom? How many competitive businesses have gone out of business or moved out of your market area within the past year?

An SBA analyst says: "If there has been a decline in the number of competitors, an attempt should be made to find out why. If the decline has been significant, it may indicate that there are too many businesses of that type for the potential sales volume. If other areas of the analysis tend to indicate a declining market, the exodus of competing businesses may help support those findings."

Ask yourself also: Is your community close to a large metropolis where discount stores, or department stores, promote cheap portraits? If so, you can expect competition.

H. T. Kellner suggests that you look ahead. "Will the population pattern change in your area?" asks Kellner. "Could your market shrink five years from now?" All this requires solid local research, of course. What with chain operations in shopping centers, and new technologies of large operators, the mom-and-pop businesses often get hurt, especially if the studio owners are not sales-minded or imaginative in getting new business.

A studio may also never do well because the photographer's personality isn't right for it. SBA analysts suggest these test questions:

1. Are you a self-starter?
2. Do you like people?
3. Can you lead others?
4. Can you take responsibility?
5. How good an organizer are you?
6. How hard a worker are you?

But let's assume that you have the right personality, attitude, financing, and location.

The prospective studio freelancer must now inquire locally what licenses are required. In some cases, you may have to apply to a city zoning office for a business license. You may have to get in touch with state offices to find out about sellers permits and state sales taxes. (A city sales tax may be payable, too.) Equally important, you should become familiar with IRS rules regarding your recordkeeping, accounting, and IRS income tax regulations. An accountant or CPA can be useful in such matters. The accountant will find a route through the labyrinth of state, city, and county taxes. Among these are also real estate taxes, personal property taxes, taxes on gross receipts of businesses, and unincorporated business taxes. A license to do business is also a tax even though some owner-managers don't think of it as such.

Once you're in business, you can only thrive (or perhaps survive) if you master merchandising techniques. You must know the ins and outs shown by questions like these:

- How do you attract customers?
- When do you make the sale?
- How do you sell large prints?
- Is the "holiday sale" or "special" an effective way to attract business?
- What type of advertising is most effective?
- How do you gain repeat business?
- Are your rates too low for profit? Or too high to attract people?

The above items also reflect on your experience as a photographer; if you've actually worked for someone else, even part-time, you are more likely to succeed on all levels.

Weddings, Babies, and More

Some prior experience will also help you function as your community's—or neighborhood's—wedding photographer. Pat Caulfield, who happens to be wildlife photographer and photo instructor, states that "weddings make for a stable business." A sign in your store window can bring in future marrieds; leads can also be secured via bridal shops, through the local newspaper, or from a minister. Like news photography, wedding photography requires that you are familiar with your own equipment; you cannot shoot the scene a second time. (By then, the couple are already on their honeymoon!) Wedding photography resembles portrait photography in that your customers expect idealized images of themselves. A photographer's nice manners, personal warmth, and good looks all help. And in the end, your photos must be good enough to make people happy. This is no small order.

The studio freelancer will also have to learn how to photograph babies and older children. An executive of the Hasselblad Camera Co. has some explanations:

Who wants pictures of children? Well, parents and relatives, of course. Pictures to paste in the family album or to frame for the mantelpiece. Most photographers of children aim for this market. They operate as portrait or all-round photographers and work with child subjects when commissioned by parents in need of a studio portrait. Child photography is a natural and essential part of the photographer's business. . . .

Photographing children can become a specialty, of course. One good example is of Phoebe Dunn, the Connecticut photographer, who started by taking pictures of her own children. She was so talented that neighbors commissioned candid portraits of *their*

youngsters. Phoebe Dunn has run her business for the past fifteen years with the help of her husband, who does the selling. The Dunns go beyond the studio situation: They not only photograph children inside for parents but also sell children's pictures to banks and airlines. Her work is superb and she has won several national awards.

Suzanne Szasz, another noted children's photographer, points out that you will first have to get acquainted with the child, and that you must basically love children. Moreover, you can only function well if you use your equipment "as the typist uses a typewriter, without having to think about it."

Part of your income will be from baby pictures. Ron Adams, a San Francisco studio owner, feels that baby pictures teach you a lot about your profession. "It's not hard to take an adult's portrait," says Adams, "but you'll have to move fast with babies. You must hold their attention. If you learn this, you've learned some very fundamental things."

The learning experience will also be useful for other studio work. You will be expected to photograph dogs and cats. Outside work may call for shots of retail stores, ad items, school proms, or athletic events. In short, the studio freelancer will never get bored. Variety!

Part-time People Freelancers

Some photographers have full-time jobs and do studio work only on a part-time basis, perhaps for someone else, or with the help of a mate. (The mate holds the fort during the day.) Photographers often set up a "studio" in the basement of their own house, or they have no studio. Instead, they use only outdoor locations. One California part-timer, for instance, finds young people who are about to get married; he persuades them to celebrate the wedding in a mountain meadow. The young photographer shows some prints of friends who got married that way. The minister in a white shirt, and the bridesmaids wearing little crowns made of fresh flowers. Naturally, in some parts of North America, such

weddings can only be recorded during the warm season. It is also true that June, July, and August are the peak months for weddings; at that time, it should not be hard to dig up enough assignments.

One fellow gets some of his business by placing classified ads in local give-away newspapers. The ad reads like this:

GETTING MARRIED? Professional wedding photographs. A specialty in custom color. Latest designs in albums and frames, interviews in the convenience of your home. Free portrait with all packages. Phone 420-2015

The photographer operates only part-time and manages without a studio. For such weekend freelancing, you still need business cards and a telephone.

There are many other ingenious ways to make money from people photography without much of an investment, and to do it whenever *you* have the extra time and feel like it.

• *Ski area freelancer.* You stand at the bottom of your favorite slope and photograph beginning, intermediate, or expert skiers, toddlers, old-timers, and visitors. Arrange to exhibit your pictures for the prospects at the base lodge. Ideal for ski bums!

• *Part-time sports freelancer.* Turn up at Little League games, on high school basketball courts, at local swim events, or during collegiate tennis matches. Take pictures. Hand out business cards. Tell the prospects where they can buy your output . . . and for how little.

• *Workshop photographer.* Obtain a list of your region's writer's workshops, summer art instruction workshops, sales seminars. Turn up and take pictures for the participants and staff. Extra sales can result for brochure use.

• *Seasonal freelancer.* Hightail it to your nearest department store at Christmas. Head for Santa Claus's personal domain. Photograph the little children in his lap. Sell the pictures to grateful parents. (A Polaroid camera has been successfully used for this and other part-time work). Other seasonal photography could deal

with Easter promotions (bunnies and children), New Year's parties, Election Day (politicians will hire you), and many others.

• *School photographer.* Get in touch with school principals or teachers and offer to take group photos of students. Such pictures could include special events and special groups such as cheerleaders. Graduation pictures at special schools (for nurses, to name one example) pay off, too.

• *Murals photographer.* What with businesses using more and more photography for decoration than paintings, a mural specialist can do well, particularly in a city which has many offices. Murals can measure 8×10 feet. Scenics are popular. Sales can be made via a portfolio. This is ideal for a part-time free-lancer who enjoys the outdoors.

• *Spectator events photographer.* Wherever people gather—at rodeos, bowling tournaments, basketball games, theaters, auctions, flea markets, sailing regattas, marathons, cross-country ski races, parades, dog shows—there should be some good prospects for pictures. At rodeos, it would be the riders themselves. At basketball games, you would sell to the players; at regattas, to the sailors; at dog shows, to the proud owners.

Opportunity awaits the ambitious freelancer.

7

A Livelihood in
Freelance Photography

Dealing with Art Directors

BECAUSE THE CLIENT'S FINANCIAL STAKES can be so high in certain kinds of photography—pictures for annual reports, for instance, or for national advertising—the ambitious pro learns how to interest, woo, and please art directors. This can be done in many ways. Ron Adams in San Francisco irreverently suggests that you begin by taking the prospect to lunch. "Make it the finest restaurant in town. Get the art director bombed. This way, he can't see anyone else that day."

Adams emphasizes that you must be competent, of course, as well as honest. And you can't be shy. Some top pros say frankly that to attract interest, you need to exude self-confidence, and that you may have to "flaunt your credentials and achievements."

You're up against competition; in fact, there may be some 4,500 advertising photographers in New York City alone.

The real drama begins after you have gotten the foot into the door of a $300-to-$500-a-day account. Will you be hired for one assignment? For more?

Okay, let us assume that the ad agency gives you a chance. They will try you on one job. According to the interviews with the superlancers, repeat business depends to some extent on your skill in asking the right questions. Query the art director. What is the purpose of the ad? Is it for a poster, a catalogue, a consumer magazine? A brochure? What is the client's image and theme? Who is the audience? How about the deadline? Does the art director (or the account executive) have certain props in mind? Or a model?

In some cases, you receive just a sketch or a complete layout. In other cases, it is all up to you, with the agency people allowing you total creativity and the use of *your* imagination. There may be previous ads you can analyze. If it is a new account, and the art director leans on you, the photographer, you are in a happy situation indeed. "The art director can now tell who is a pro, and who is an amateur," says Bruce Pendleton. "The pro has *ideas*."

In many instances, though, you will be face to face with someone who already knows what he or she (or the client) hopes to get from you. The cardinal rule at this point is to "Never argue with an art director," says Pendleton, along with most of his colleagues in New York. The top photographers apply the rule even to art directors who are "narrow-minded" or "have ghastly taste." Adams warns: "Never offend the client. Give him what he wants and needs. Shoot an alternate way. If you totally disagree with the agency's concept—if it really can't be done—you'll have to say so tactfully."

In some instances, art directors allow photographers a fine amount of leeway. In one intriguing case, an art director expressed great doubt that a certain shot would work. As he watched the photographer (fortunately an old reliable hand) in the studio, the

art director got more and more depressed. He just did not see the visual potential. The ad photographer gently suggested that the other man go back to the office. After a few hours, the photographer showed up with the Polaroids. The pictures were perfect.

Is it useful to have the art director (or client) in the studio during the shooting? Should the picture buyer be present in an outdoor location such as for ad pictures on a travel account? Most questioned pros agreed that the presence of the buyer is helpful.

Many art directors, ad account executives, or clients actually insist on being there to watch a shooting. And why not? They can help guide you. They can approve on the spot or make needed changes. The genuine pro accepts instruction. "Never tell an art director that you want to do your own thing," says one photographer. "It would be catastrophic for you. And always think of *him*. Make *him* look good." His presence prevents "do-overs," of course.

To be sure, the situation can become somewhat tricky if you're working with four people at the same time and all of them want to be chiefs. It is difficult to please all of them. In most instances, you deal with one boss, however. Herb Lubalin, one of America's best known and most brilliant experts in the graphic arts field, once shared his views with an audience of photographers:

An art director is like the director of a motion picture. He must, of necessity, be in complete command in order to insure a viable end product. There's a lot more to advertising and editorial communications than a photograph. First, there is concept, then words, design, typography and reproduction methods. And there is a client and his product or service. The art director is charged with all of these responsibilities. He is directly accountable to the client. He creates the end product. He, therefore, must control all the means to ensure a favorable consumer reaction. The photographer contributes only one of the means toward this end. So if you ask, "Why don't art directors mind their own business and let us create?" the answer is that what you create *is* our business.

Pros attempt to meet the buyer's expectations at all times. A Denver ad specialist was asked to photograph a mountain land-

scape in black and white. Although he did it well, the buyer was disappointed. He had expected more than standard-size glossies. "The pictures look so small!" the art director said. "I'll make them bigger," responded the pro. The next day, he returned with sheafs of 11×14 prints. The agency man was now delighted. Conversely, a newcomer lost a potential ten-thousand-dollar-a-year client because he gave the first assignment only a couple of hours. The result was unsatisfactory. The photographer, believing he'd invested enough time, made no offer to reshoot. The ten thousand dollar account wandered off elsewhere.

To maintain a good relationship with art directors, only your best work should be good enough. "Never submit junk," warns one photographer, who sells stock to ad agencies.

How to Remain Friends with Magazine Editors

"Establish contact with some good magazine editors," suggests Pete Czura. "Hopefully you will find some who appreciate you and recommend you. Business begets business."

But how do you secure the goodwill of picture editors in the first place? Technical ability is expected, of course. The top talents sway top editors by aiming for perfection. They care about lithography, layouts, paper quality. Nicholas De Sciose not only strives for flawlessness in his work but for good reproduction as well.

The superlancer's reliability is taken for granted in the editorial business. Once you make your living as a photographer, you are supposed to be reliable under all circumstances. This can be difficult at times. But it separates the valuable wheat from the disposable chaff. Unfortunately, amateurs seldom come through. Ken Poli, the seasoned *Popular Photography* editor, says it well: "The professional delivers what is wanted when it is wanted—and no excuses!" says Poli. "Anyone else is a dilettante, a fumbler, or an 'artist.'"

To deliver the goods on time takes some self-motivation and drive, of course. The full-time freelancer has learned to cope with deadline pressures. You may be asked, for instance, to shoot a

series of photos of a new discotheque at around midnight when the action reaches its peak. And so you do. But the magazine—a weekly—actually expects your contact sheets at 9:00 A.M. sharp. As a working photographer, it will mean staying up until 3:00 A.M. to meet the deadline.

Handling deadlines—and withstanding the tension associated with deadlines—is not the only requirement. The editor of an in-flight chain of magazines adds this tidbit: "On assignment, the amateur shoots what he wants. The pro shoots what the editor asked him to shoot."

Quality will be matched by quantity; those who make it in the business often do so because they give the buyer more than expected.

At the same time, editors also warn photographers against overselling and overextending themselves. Propose only those projects which you can actually handle. Be realistic. Ask yourself ahead of time: Do I own the proper equipment for that job? If I rent it, will I know how to use it? Do I really have enough experience? And the time to complete the assignment? Pete Czura, the outspoken outdoorsman, says bluntly: "Don't bullshit an editor. Stick to the facts. Make sure that you can produce whatever you offer." Czura, who has shot some of the most rapid fishing and hunting sequences for top publications, was once told to do an executive's portrait. Czura declined. "I'm sorry," he said to the editor, "I don't do portraits. I'm an action photographer." He earned the buyer's respect forever.

Of course, one can still blow a potentially good editorial contact despite honesty and excellence. It is possible to alienate a buying editor in various ways. Some of them are obvious. Ken Poli tells of an out-of-town photographer with the bad habit of calling up at 9:00 A.M. "I'm in Manhattan today. Can I come in to see you?" The freelancer would then be miffed if the busy editor couldn't see him. Another pro did not exactly endear himself to Ken Poli when he sold him a stunning color scene for a cover. The same month it was used, almost the same shot appeared on the cover of a com-

peting magazine, to Poli's embarrassment. The photographer had sold both at the same time and so had his name added to two editorial "no-no" lists for the future. While simultaneous offers of *ideas* are now customary in the magazine field, a sale should still remain exclusive, at least in the case of two competing publications. Poli says, "At the very least, if you have competitors considering the same work at the same time, tell both about it so they can decide with that in mind."

The editors' laments also include photographers who fail to communicate, right at the start, their aversion to a magazine's cropping one of their pictures. If this happens later, they raise a ruckus. "First lay down your ground rules; you can't initially stand mute and *then* scream," Poli says.

A photographer can commit other faux pas. Some of these can be hard to predict. A competent western outdoor photographer made a personal call on a middle-aged editor in a western city. Instead of coming alone, he also brought his extremely handsome girl friend. The freelancer showed her off, flaunting his sexual conquest and prowess to an aging editor who had just gone through a divorce and happened to be lonely just then. The dazzling girl made him feel even lonelier. He never bought another picture from the visitor.

The refusal to buy again can have many other reasons. Actually, even years of selling one magazine still doesn't guarantee you tenure. "You're only as good as your last assignment," says Lisl Dennis.

All the top freelancers insist that each batch of photos has to stand on its own feet. "Some pros let up," says David Muench. "They tend to quietly fall by the wayside. Only a few—Ernst Haas, for example—survive on their image alone."

H. T. Kellner sums up the problem:

No one can afford to enjoy "tenure" in this business; each new photograph is a passport to future sales and successes. Freelance photographers must forever keep fresh photos on the editors' desks.

The best way to stay on the good side of photo buyers is simply to

give them the kind of photos they want promptly and consistently. And always conduct yourself professionally: Crybabies and complainers cry alone.

There are exceptions, of course. One famous woman photographer has miraculously survived in the editorial field despite her personality. She is known to be pretentious and abrasive. She upsets her subjects and editors alike. *Esquire* magazine called her "boorish, spoiled, the pushiest person in America." Yet somehow, editors keep buying from her, partly because she ruthlessly gets and delivers what they need, and partly because they are intimidated by her. And one of the best known male photojournalists—a cigar-puffing Type A hustler in his sixties—never stops cursing or fretting. He cannot even look other people in the eyes. Yet he keeps working.

Examples like these may have provoked a *Wall Street Journal* editor's statement: "We actually don't use photos. That's fortunate, too. It means we don't have to deal with photographers."

In most cases, the reverse is true, of course. Editors and art directors happily deal with photographers. Some of them even become good friends.

Should You Have a Rep?

Some photographers are lucky enough; they don't have to sell themselves and their ideas. A personal representative, or rep, does it for them.

A rep should not be confused with a stock agent, about whom you read in chapter two. Stock agencies often have hundreds of photographers and several million pictures. By contrast a rep will represent from two to five photographers. Most stock agencies welcome beginners; personal representatives (or their cousins, the personal "assignment agencies") only accept big name photographers, or longtime professionals.

The beginner faces a dilemma, of course. When you need help most you just cannot get it; and once you do have enough assign-

ments, you may feel you no longer need representation. Especially when you consider the commission. The rep receives from 25 to 50 percent of your income.

Why do some photographers then insist on being represented? "I can be out shooting," says Bruce Pendleton. "I don't have to call on anyone. And my rep knows the markets inside out. She is doing it eight hours a day. She saves me a lot of time. She generates new business and makes me money."

Bruce Pendleton's rep is Ursula Kreis, a handsome, hard-working German woman, who has been in the field for almost twenty years. She handles only two photographers. New York City–based, Ursula knows corporate buyers, art directors, designers, and leading picture editors. She gets up to two thousand dollars a *day* for her photographers. She negotiates and obtains travel allowances and expenses. She gives both personalized attention to her buyers and to her photographers. As the go-between, she talks and makes slide presentations (she carries her own carousel and projector) and she listens to the needs of agencies. Because of her expertise, she is trusted by those to whom she sells. At the same time, her devotion to Pendleton and others is obvious. It includes holding some of her people's hands, and encouraging them when frustration or overwork gets them down. (This happens even to the best.) "You have talent!" Ursula told one of her clients who threatened to go into some other line of work. "Believe in yourself!" He did. He is on top now.

Ursula Kreis has also done much to help her photographers maintain a good image. She encourages top pros (and other reps) to produce good promotion pieces. She says: "Whatever you do, big or small, go first class! Impress! All the way through—no cheap anything. Don't print a slick mailing piece and then use a cheap wrapper. Your best work deserves the best printer, the best paper."

Many good reps are women. A typical one is vivacious Audrey Hollyman; she handles her husband Tom Hollyman and several others. She is known as an ace in the annual report and fashion field. Julia Scully, a photo magazine editor, has watched agents at

work. "Personal reps are very useful," she says, "especially for photographers with little business sense."

In addition, a freelancer with enough credits and experience can approach an "assignment agency." Unlike the impersonal, super-market-style stock agency, the assignment agent only handles a dozen to fifty pros. The agent keeps them working.

Some of the assignments are in advertising, audiovisuals, PR, annual reports, or ads. Much of it, however, is in the editorial field for book, magazine, and newspaper publishers. Guy Cooper, an insider, warns that "you must be available, frequently at very short notice, to travel and work. If your agent has spent half an hour singing your praises to a picture editor and has succeeded in get-ting you a three-day shooting job in Quebec leaving this afternoon at three, he is not going to be pleased if you can't because of a dentist appointment or a dinner party."

Some agencies concentrate on news photography. Certain agents —like one who represents Robert Farber—go in heavily for fashion; others handle glamour or food photographers or other specialists.

Naturally, not everyone needs, likes, or manages to get a rep. Suzanne Szasz, who is so well established now, says that no one wanted her when she was on her way up. Now she gets along fine. Duane Michals has no rep, and will not have one again. "I had one for two months and she drove me crazy," Michals recalls. "She kept calling me. She kept trying to change my style. She wanted me to ape Avedon. And the extra money she got for me? Well, she kept it in commissions."

Ron Adams had only one brief eye-opening experience with an agent. Adams was living in Hawaii at the time. "The agent sold a lot of glamour stuff for me," Adams says. "Lots of girls at the beach. He took 40 percent. A high fee, I think. By chance, I once had to go back to the mainland. A magazine cover caught my eye at a newsstand. The cover photo looked familiar. Well, *I* had shot it! In fact, practically every picture in that publication was mine. I had no idea that the agent sold these pictures. What with such glamour magazines' schedules, the agent must have made the sale

a full year ago. He'd never told me about it. Or paid me. So I
called him. He said, 'Oh, I didn't tell you about that sale! It was to
be a surprise!'

"It so happened that the particular magazine wasn't distributed
in Hawaii where I lived at the time," Adams says. "If I hadn't
shown up in California I would've never known about it. In short,
he tried to rip me off to the tune of four or five thousand dollars."
Adams insists that the particular agent must be the exception and
not the rule. But it is something to think about.

To be sure, the personalized two-to-five client rep, or the well-
known houses like The Image Bank and others are all 100 percent
ethical. Still, there are just too many photographers and too few
agents with clout, who in turn have too few extra hours. One
assignment agent says confidentially: "Some agencies can become
a quicksand for the freelancer's ideas and material. Sometimes
even for their morale. So a photographer is often better off to slug
it out alone."

Still interested? Some addresses follow:

Contact Press Images
113 Central Park West
New York, New York 10023

Ursula Kreis
63 Adrian Avenue
Bronx, New York 10463

Audrey Hollyman
300 East 40th Street
New York, New York 10016

Magnum
15 West 46th Street
New York, New York 10036

The Image Bank
88 Vanderbilt Avenue
New York, New York 10017

Photo Researchers
60 East 56th Street
New York, New York 10022

Vincent J. Kamin Associates
42 East Superior Street
Chicago, Illinois 60611

Reports Internationale
Box 4574, 1350 Santa Fe
Denver, Colorado 80204

For a complete list, see *The Photography Market Place* (bibliog-
raphy).

Ethics

Are there high ethical standards in photography? Superlancers
consider them important. The subject is a big one. But it can

be summed up simply. Nicholas De Sciose says: "Just use tact, honesty, and common sense." The lack of tact emerges in a story told by Jack Fields, who frequently visits Pacific islands. One day in Micronesia, he learned that the natives were being hassled in their own homes by camera-carrying tourists. No professional would do this, of course. When in a foreign environment, a pro would always ask for permission to photograph. One good rule for non-news: Never photograph any person if they ask you *not* to. Tact also applies to your dealings with people on an assignment.

Nicholas De Sciose, who works for *Playboy*, warns that a photographer cannot cause embarrassment to an employer. "You'd quickly lose a magazine's trust if your conduct became unprofessional."

A male glamour photographer can never make passes at his models. This would not reflect well on the publication. (De Sciose: "Sex is actually throttled in our business. Your head has to be full of camera and light technicalities. You're working so hard that you can't even think about anything else.") Studio photographers avoid the physical touching of a model or sitter, and nudes are rarely photographed without the presence of a third person.

Advertising specialists are also concerned with picture ethics. A picture shouldn't misrepresent a product and cannot be faked.

The magazine photographers' ethics include the keeping of promises: If Guravich promises to show a Southern gentleman the picture shot for an oil magazine, Guravich intends to show the picture. It is considered unethical to use photos for other than the intended purposes. The black-and-white of a pretty girl with cigarette in a ski lodge scene for a magazine cannot later be used in a book that describes the medical horrors awaiting chain smokers. Nor can the pictures of an attractive child, first done for a book, later be shown to illustrate an article on child abuse. Likewise, a professional photographer will deem it unethical to reuse the five-year-old news pictures of some New York prostitutes. They may be married now or in another occupation.

Ethics in photography apply to the buyer, too. Examples? Some full-time freelancers claim, for instance, that they've submitted picture story ideas to art directors who said no, thanks, and then

sent another person to shoot the same idea. In one instance, a Big Name in the winter sports field received a phone call from a West Coast cartel of airline in-flight publications. Could he furnish enough winter scenes for a whole magazine issue? The photographer culled his color stock files for two full days. "I sent them four hundred pictures. They bought two," he says.

To counter such problems, one long-established pro now charges a "research fee" plus an advance to magazines that ask to see a great many slides. The in-flight situation could have been avoided if the editor had admitted that many other photographers were being contacted, too. Superlancers also claim that buyers often do not keep promises, which makes some of the burned freelancers distrustful. A West Coast insider who was an agent for many years puts it this way: "The paranoia of the photographer is well-matched by the arrogance of some editors." This insider consoles those who have suffered disappointments: "This is a very subjective business. The next editor will accept your ideas."

Expanding Your Livelihood: In the Corporate Vineyards

Personal reps usually have the inside track to the juiciest work of all—corporate photography. Audrey Hollyman thus secures assignments for her husband Tom Hollyman from the oil giants, national tourist agencies, and prestigious banks. Ursula Kreis gets Bruce Pendleton and Bill Farrell jobs to do annual reports and sleek corporate magazine photography. This kind of activity pays from seven hundred fifty to fifteen hundred dollars a day, plus perks like all your expenses. A beginner in this field can expect five hundred dollars. The prestige attached to doing IBM's (or Xerox's) annual report is tremendous, and your color photos should impress both the corporation's stockholders and *your* future prospective employers who look through your portfolio.

It is not easy to break into the corporate field. First impressions count here. A photographer would be wise to dress right, too. "Don't show up in elegant conglomerate offices in casual garb. It may work elsewhere but not here," says one old pro.

According to annual report photo experts like Tom Hollyman, you have reached the top if you get hired by one of the leading corporations. The latter often give you unexpected artistic freedom. In advertising, someone generally looks over your shoulder; in corporate photography, the established big-timer is let loose to photograph what he or she wants.

Superlancers say that the big corporate magazines—especially those of the wealthy oil companies—are a joy to work for. Publications like *The Lamp* or *Exxon USA* have enormous budgets. They pay the photographer several thousand dollars per story. Some of the work may be in far-flung Finland or in the Caribbean or Scotland. Naturally, the corporation's executives and its products must look good between the magazine pages.

Annual reports are meant for stockholders, prospective investors, and the public at large. The report is presented in slick magazine format. The photographer may be hired by the corporation's marketing department, its PR or ad agency, or by a specialized design firm which prepares annual reports. Wherever the work comes from, you are expected to please everyone. Your work must please the top executive brass as well as the designer.

According to Hollyman, multimillion-dollar corporate work is more demanding than any other. Only a few freelancers have what it takes. It begins with your personality; this rules out all except the most polished, amiable, tactful, and articulate people. It takes diplomacy and political savvy to deal with business leaders; insight becomes crucial at all management levels. Hollyman points out "that you must read people accurately and be aware of *their* world and the world at large. This takes curiosity, intellectual aliveness, book knowledge." Hollyman and his colleagues also stress that you need self-reliance; the corporate photographer often works alone. This means first-rate equipment (some of which can fail), technical know-how, solid prior research, and double-checking of arrangements.

Imagination is a must, too. The corporate subject matter can be dull. How do you, for instance, make a supermarket look interest-

ingly different? How do you add some romance to a sterile factory office or to a mountain of cement pipes? Professionals find a way; they aim to please the client. "The talented photographer somehow creates excitement," says one art director. "For instance: The pro might crawl into one of the cement pipes and aim the camera at a hard hat looking in the open end. He becomes the designer. He makes people in the clean room look like visitors from outer space."

Naturally, the corporate names have a fine ring to them. De Sciose has done annual reports for Motorola. Lou Jacobs, Jr., often contributes to the internal corporate publications of Western Electric, General Motors, and Automation Industries, among others. Phoebe Dunn does corporate photography for Hasselblad Cameras and many other clients.

Where does the average freelancer start? Hardly with the Fortune 500 corporations. Instead, go to some local companies. Show your portfolio. Tell them that you want to contribute to their house organ (the internal magazine). Ask if they need someone to photo-illustrate their yearly financial statement. They may say yes, and you are on.

Branching Out—Book covers, Record album covers, Audiovisual firms, Encyclopedia companies, Posters and greeting cards, Calendars

No pro can allow himself or herself to stand still. You must find new clients to take the places of those who drop out. You must enter some new fields so that you don't go stale.

Opportunities beckon. Among them:

• *Book covers*. Get in touch with the art directors of major publishers and show your portfolio. Some books feature photos instead of other artwork on the dust jacket. Assignments are sometimes available, especially if you live in the New York City area. Or you may be lucky enough to sell stock shots by mail. Most publishers are located on the eastern seaboard, on the West

Coast, and in the Chicago region. But you will find it worthwhile to check the Yellow Pages in your hometown for leads.

• *Record album covers.* The art directors for this country's major recording companies often search for appropriate pictures to illustrate album covers. The work is well paid and competition is lively. You can obtain the names and addresses from your nearest public library. Ask to see *The Photography Market Place* (see bibliography).

• *Audiovisual firms.* AV firms represent a hungry market for your existing (or to be shot) 35mm color transparencies. Scattered all over the country, the companies produce slide shows for various clients. Among them are schools, libraries, associations, manufacturers, hotels, in fact, any business you can think of. In many cases, the art director may also hire an experienced, capable freelancer for a specific job. For the addresses of AV firms, see the *Photographers Market* (see bibliography). AV firms pay by the photo, the set, or the day. Rates are modest in comparison with advertising.

• *Encyclopedia companies.* Ask your librarian to dig out the names of the various publishers and their art directors. Encyclopedias have a voracious appetite for all kinds of photo illustrations.

• *Posters and greeting cards.* Another big, but somewhat crowded, market is posters or greeting cards. De Sciose has received lordly sums from the Lange Ski Company for two ski posters. Both showed pretty girls in a minimum of clothes. Visit a stationery store (or other shops) to see what kinds of posters are for sale and who publishes them.

The greeting card market can be researched in the same way. Ideally, transparencies here should measure 4×5 or larger, and the sharpness of your picture is paramount. What are appropriate greeting card topics? Just listen to one typical company's requests:

We are interested in seeing examples suitable for the following subject matter: Christmas, Thanksgiving, Halloween, Jewish Holidays, New Year's, Valentine's Day, St. Patrick's Day, Easter, Graduation,

Juvenile Birthday and Convalescent, Baby Congratulations, General Religious, Masculine Still Lifes, Feminine Still Lifes, Convalescent, Bon Voyage, Wedding Anniversary, Birthday, General Scenics, Animals, Humor, Baby Photos.

Surely, some of those subjects fit *your* stock files?

One stock agency adds one additional great need: "We are receiving many calls for soft-focus couples and nudes. Any combination of dressed, seminude, and nude couples or individual models is needed. All models should be young (15–25) and attractive. These must be mood shots—pastel colored, soft, and very romantic. They can be taken either outdoors in beautiful landscapes or indoors in bedrooms decorated in a romantic manner—for instance, antique furniture, lace bedspreads, and a bouquet of beautiful flowers."

• *Calendars.* Wall calendars and weekly engagement books gobble up a great amount of large-size color photography, too, along with some 35mm. The topics cover the waterfront, beaches, and mountains. Indeed if you name a subject, country, state, province, town, or hobby, you can be sure that a calendar already exists, and someone is looking at photos for next year's product. If this sounds promising, you might consider the limitations and anxieties. Some successful calendar enterprises may hang on to your photos for two years and then return them. For certain well-known products—the Sierra Club calendars, for instance—as many as eighty thousand submitted pictures vie for two hundred accepted ones. (The art director therefore warns: "Sending huge numbers of transparencies is not in the best interests of your work and really slows us down. Between ten and one hundred is optimum.") If you should be so lucky to place in this "contest," the Sierra Club only pays you on publication, which is one year away.

One stock agent also warns: "Your transparencies must be needle-sharp and taken at the correct exposure. By eliminating fuzzy, over- or underexposed subjects, you save time and shipping expenses. The calendar firms demand exceptionally bright colors,

especially reds, yellows, and blues. In landscapes (all seasons), rich blue skies, not gray or muddy. In models, flesh tones should be true to life; proper model releases are required. Most pictures are made more appealing by introducing red or other warm colors in a natural way."

A calendar agent stresses that you do best with photos that can be "read" instantly from a distance. "Each subject should have only a few well-chosen elements, be strong and simple in composition. Trying to put too much in a picture makes it "gingerbready" and weakens its pictorial impact. All props and other details must be correct and authentic, whether fishing equipment or flower arrangements."

A stock agency will tie up your work for five years, without guarantees of a sale. In fact, you may see neither any money nor your pictures again.

An aggressive photographer might therefore ferret out some new markets. Call on local firms: Would they let you put together a calendar for them? Talk to a wholesaler or to an association. Do they want to finance a calendar? Or invest some of your own money in printing, as one photographer did. He personally designs a calendar and sells it to the retail outlets in his city—with *his* pictures.

Selling to Federal and State Government Agencies

You can also increase your income by trying to get some business from your city, your state, and from a federal agency, or even an international prospect, such as a foreign tourist bureau in the United States. You might start by contacting the nearest chamber of commerce. Do they need any publicity pictures of the city? Do they know anyone who does? Show your best work to the mayor's office of a large metropolis. Ask if they know of a city agency in need of photography.

You will find an even more fertile soil in state government. Every state (or Canadian province) has an Economic Develop-

ment Department (or tourist organization) to attract visitors. Such tourist departments need photography for PR kits, brochures, and magazines. Call on the person in charge. He or she can also refer you to the state's magazine, which is another likely buyer.

How about the federal government? H. T. Kellner has some good advice:

The best way to get to do some work for federal agencies is to get on the General Services Administration's list. Photographers may write to GSA, Washington, D.C. for more information. As an independent contractor you will be in a position to bid for jobs in every conceivable aspect of photography. Photogs may also visit federal agencies and talk to PR "Directors of Publication."

Lou Jacobs, Jr., suggests that you "solicit such clients by researching them first. The United States Communication Agency (formerly the USIA), for instance, and the U.S. Department of Agriculture both give assignments to freelancers." And Boyd Norton recommends that you do a lot of legwork for both federal and state work. He says: "Talk to the director of public affairs for various agencies, but do so only with some firm projects in mind. Documentation of air pollution problems, for example. Or suggest an in-depth treatment of social or urban problems that the agency can use for public awareness programs. Be prepared for a lot of time spent on paperwork—proposal writing. Is it worth the hassle? Only you can decide that. For a one-day job, it may not be. But for a job lasting several months, it is definitely worth the time and effort."

Naturally, it does help if you are a minority. Uncle Sam wants to work with blacks, Spanish-speaking Americans, Orientals, and women.

How about foreign tourist agencies? You can get the addresses of American-based foreign tourist councils, national tourist bureaus, airlines, and railroads by writing to the various embassies. Then send them a letter or visit them when you are in the neighborhood.

Business Matters: Written Assignments and Billings

Since photography is no longer a hobby but your livelihood, all the above efforts should lead not only to work but to checks as well.

Some photographers are artistic enough, but they have no mind for business. Not even for some of the basics.

One: Get all assignments in writing. Make sure that all the conditions—from the number of pictures to your pay, expenses, and deadline—are spelled out by the buyer. In many cases, you may have to ask for a purchase order, too.

Two: Find out how you will be paid. Via their purchase order? Or automatically? Or are you expected to send a bill?

Three: Determine in advance how long it will take to get paid. In certain fields, it may take sixty to ninety days because an ad agency has to collect the money from the client first. Magazines nowadays pay for photos on or after publication. Find out, and be forewarned.

Four: You are entitled to the fairly speedy return of your "outtakes." These are the unsuitable pictures of your accepted shipment. Many editors, art directors, and agencies fail to return the outtakes because the staff is too busy, or too careless. You can't go wrong by writing a polite letter to the culprit. Here is an excellent one from a photographer in Alaska:

Dear Mr. _____:

Last October, in response to an inquiry from you, I sent you a number of 35mm slides for consideration for use in your book the X. All but eight were returned.

I'm checking to find out whether my slides are still under consideration. If so fine—if not I'm anxious to find out their current situation.

I'd appreciate your forwarding this to your publisher if the slides are no longer being considered so that they can be returned.

Thank you.

Unfortunately, many photographers are afraid of picture buyers lest they offend them. When a packager for book publishers held hundreds of valuable 35mm pictures from an assemblage of international pros, only a handful wrote to the packager. In questioning the others, I was told, "Better not rock the boat. Better keep mum."

According to Boyd Norton, this is an unprofessional attitude. "I get on the phone after six weeks," Norton explains. A similar lesson can be learned from Photo Researchers, a photo agency in New York.

The back of the agent's delivery memo spells out the terms. It starts with two conditions: (1) Photographs or transparencies may be held for fourteen (14) days approval; (2) Photographs may not be used in any way, until submission of an invoice indicating recipient's right to use same, or purchase of the photographs outright.

The next chapter looks at pricing, rights, and the legal side of your profession.

The Financial and Legal Side

The Financial Rewards

A WEST COAST FREELANCER likes to say that "photography may be the second oldest profession. First you do it for fun, then for your friends, and then for money."

Professional photographers only work for money. Freelancers are not hobbyists; if they want to make a living, they must be practical at all times. They must get paid, and if at all possible, well paid. Pros have overheads; they invest time for developing new business, for correspondence and travel, so they may actually wield their cameras only 100 to 150 days a year. "Never give photographs to anyone who can afford to pay for them," goes one freelancer's justified slogan.

The question is, of course: How much do I charge? How does the photographer keep pace with the galloping inflation of the 1980s? Boyd Norton reminds the pro to keep the steadily increas-

ing costs in mind. "Be on your toes," he says. "You must charge more than you did ten years ago."

In certain photographic areas—the editorial field, for instance—your editor or art director has the last word about rates. And rate structures vary in different parts of the country and with different organizations. For editorial use of black-and-white, inside, one-time, thirty dollars is a good starting point. Black-and-white covers should pay substantially more. But color is where the money is. A color cover (one-time) can bring three hundred dollars and up while inside use pays sixty dollars minimum at a fairly large publication. Small religious publications pay proportionally less.

Most periodicals—from the smallest to the best known—dictate their own pay scales; these are always fair for leading publications such as *Life, Look*, and others. *Life* pays from four hundred dollars up per page. Experienced pros set their own minimums for editorial use. Norton, for instance, considers $150 his bottom price for a color transparency; so when a minor-league backpacking publication offered him an "honorarium" of twenty dollars, Norton laughed in the editor's face. "I don't take pictures as a hobby," the photographer explained. "I'm in business."

Naturally, it is up to you to ask about fees in advance. If you happen to own some unique, or hard-to-get material, an editor can be enticed to increase his picture or page rate. You can expect better financial treatment if you are a top pro, or if you have sold a publication several times. Your stock sales always bring less than assignments, of course. In the latter case, you should also ask for expenses.

As you become better known and deal with better magazines, you will also have a chance to work on a per-diem rate. The minimum for the 1980s is $250 a day. Most publications pay $300 to $500, plus expenses. In addition, you may get a bonus for a cover photo. Naturally, all these details depend on your personal reputation, and on the importance of your assignment and the publication itself. At all times, insist that you receive a credit line. The latter is essential for your portfolio; besides, it is advertising

for your work and may bring further offers—including reprints—from other editors and art directors.

What do the noneditorial fields pay? Postcards, for instance? Or calendars, posters, and book illustrations?

In most instances, the buyer will tell you the rate. In some cases, you may be asked how much you want. This can be tricky; if your fee is too high, you price yourself out of the market. If it's too low, you lose money. "I always try to get the buyer to quote a rate," says Galen Rowell. "If it isn't up to snuff, I try to raise it."

Newcomers may keep some guidelines for color photos in mind. Postcards pay from as little as $25 by a low-budget firm to $200 apiece. The calendar publishers of the eighties acquire transparencies at $50, with the top limit at about $350 (unless you're Ansel Adams or Avedon, of course; then the ante goes up still further). A range of $150 to $200 is the average for calendar pictures, however. Posters? A De Sciose can get $1000. Most companies pay in the $200 to $250 range; a few pay from $50 to $100. Book publishers? The range is wide here; it depends on the number of transparencies you sell, on your fame as a photographer, and on the importance or rarity of the photo itself. Checks from book and encyclopedia publishers range from $25 to $250; book covers, or jackets, pay much more, of course. If you know the art director, and are asked for many pictures, you may also be able to wangle a day rate for your work.

The biggest photography money is paid by big-name national advertising agencies and for annual report work where even a color stock shot from your files may bring $250. (Naturally, small local agencies or companies cannot match these figures.) Most agencies pay experienced freelancers from $350 to $1,500 (and even $2,000 to $3,000) *a day.*

Rights: Who Owns the Pictures?

When a blue-chip corporation hires you at $500 to $1500 (and up) for a day's shooting, the buyer generally expects you to

sell the rights to the day's pictures. It means that you cannot resell the same shots to someone else without their permission. This situation also applies to assignments from certain top magazines; the editors would not take it lightly if you did not sell them exclusive rights, or while being on a day rate, shot some extra films for a competitor. In other cases, top magazines insist on so-called first magazine rights; after your pictures appear in print, you may resell them elsewhere (this requires prior discussion with the editor, however).

Some magazines demand "all rights" in exchange for a mediocre check. The photographer can refuse, of course, at the risk of losing the assignment.

Most photographic transactions are handled on the "onetime reproduction rights" basis. Seasoned pros insist on this; they explain that they do not sell their pictures; they *rent* them for onetime use. This is especially important in the case of stock. Rohn Engh, a photographer and publisher of *The Photoletter*, puts it this way:

> We encourage you to circulate your pictures and "rent" them continuously on a onetime publishing basis. We believe the rights to a good photograph should remain with the photographer. A picture should earn its full potential for the photographer or the photographer's family. We would encourage you to "rent" the same picture to local, regional, or specialized markets ten times at $25 rather than sell its ownership to one buyer for $250. By "renting" each picture, the photographer often realizes a greater income in the long run. And as a side benefit the photograph is given greater exposure and more of the public has the opportunity to enjoy it.

In the same connection, Engh warns against signing a buyer's document that your pictures are bought on a "work for hire" basis; it actually signifies that the company considers you an employee and owns whatever material you sent them. Likewise, a magazine or a book publisher may offer you one hundred dollars for all rights to a valuable picture. If you sign, the *magazine* can actually sell your output to book or encyclopedia publishers or anyone else

for that matter. To prevent such happenings, some photographers stamp their "onetime use" condition on the back of their black-and-whites or on the frames of transparencies. This will also ensure that you will be paid if the client uses your picture for a second or third time.

Unfortunately, some minor publications ignore a photographer's terms, and then cleverly dictate their own on the backs of checks. If you sign, you sign away "world rights" or "all rights." And all that sometimes for a mere thirty-five dollars per picture!

How do freelancers combat such exploitation? One anonymous photographer says: "Just sign and cash the check. Ignore the legend on the back of it. And keep selling the picture to other markets." Other pros advise that you return the check and ask for a new one, without legal traps. The return of a check may cause a publisher to return your pictures, however. Most people agree that it is not a good idea to cross out the legal language on a check since a bank may then refuse to honor it.

It is true that most publications won't object to your reselling your work to noncompetitors; in short, the portrait of an important woman which you sold to *Seventeen* Magazine can also be submitted to *Catholic Digest* or some specialized markets.

Professionals always spell everything out in writing. Here is a typical letter to a tourism board client by outdoor specialist Pete Czura:

Dear Mr. _____:

I am forwarding 72 various bass scenes which you asked to see. Any one of these pictures is available for onetime use for a $250 fee (plus credit line). The transparencies may be kept for 30 days and after that a holding fee of $1 per day per transparency is charged, unless otherwise arranged.

Holding Fees

The final sentence of Czura's letter illuminates an important point. After thirty to sixty days' waiting for acceptance or return,

the superlancer begins to charge "holding fees." This has become a common trade practice among pros and agents alike. Good firms willingly pay such fees. Some photographers do not charge them. And of course, you cannot unless you spelled it out in writing from the outset. Beginners are not expected to make such demands. The pros do though. And some photographers have gone so far as suing a publication or client for the holding fees.

One celebrated case was that of Dan Guravich versus the *National Geographic*. This top pro says he submitted two story ideas to the famous magazine. The *National Geographic* liked both, and Guravich supplied 110 transparencies for each story. According to the superlancer, the magazine held his work for six months, then sent their staff photographer to shoot *his* stories. Guravich sued for a holding fee of $38,000.

"Suing doesn't make any friends," one colleague admits. "But you must wonder if they were friends in the first place. They can't be if they treat you so callously."

Lost or Damaged Photos

The freelancer must also insist on his or her rights in the case of lost photos. (That is why registered mail or certified mail is important for your picture submissions.) Some photographers spell out their terms in a delivery memo; others use stickers on their vinyl sheets: "Notice of liability! In case of loss or damage, each picture is valued at $_____."

What's the value of a color picture? That depends on your background and the photo, of course. Galen Rowell considers that five hundred dollars for a quality photo is a fair sum; naturally, if you submitted twenty pix and the buyer lost the whole batch, you cannot get five hundred dollars for each slide.

One photographer was informed by the J. Walter Thompson agency that one of his pictures had disappeared. How much did he want? He asked for one thousand dollars. Within days a check came by messenger. It was for $1,000.

David Muench demands up to $2,000 for the loss of one of his famous landscapes, and Jack Fields once sued Finnish Air Lines for $28,000, a reasonable sum for losing eighty transparencies. (The airline had first offered him free roundtrip tickets to Finland in exchange for the lost pictures.)

Many top photographers say that prevention is better than billing or suing; Wenkan, for instance, recommends that you only submit duplicate slides. Myron Sutton suggests that you shoot "multiple originals" because "film is the cheapest item on your expeditions." If a multiple shot goes astray at the buyer's office, the photographer still has others on file.

Several freelancers also point out that pictures often get displaced or misfiled, perhaps even returned to the wrong person. According to Engh, the photographer may be at fault. Some examples are:

- No identification, or the identification blurred or unclear
- Return mailing information missing or unclear
- Picture mailed to a wrong address in error
- Failure to include return postage (SASE) when appropriate

In other instances disappearances of your pictures can be due to sloppy (or understaffed) editorial offices. Inquiries should be made of course. Photojournalist and instructor Lou Jacobs, Jr., says: "No loss should be ignored; otherwise publishing personnel will have a license to be even more careless." A photographic magazine once "lost" eighteen color slides submitted by Jacobs. The photographer recalls the details: "My editor professed not to have seen the slides. He next claimed that the pictures must have gotten lost when some office spaces were rearranged."

Jacobs made five phone calls from Los Angeles to New York. The editor was always in "a meeting," or unavailable when the photojournalist's name was announced. Jacobs recalls: "Finally, I visited him in New York and he admitted for the first time he *had* seen the pictures, and had turned them over to a subordinate who

misplaced them. I said I was sorry [but] I'd have to negotiate a settlement if they were not recovered in thirty days. The slides were found two weeks later, eight months after they were submitted."

Such stories are not unusual. Galen Rowell relates:

Just this year a magazine told me photos were in the mail back to me, but they failed to arrive in time for an important submission elsewhere. I figure I lost $500. I called the mag again, then received the photos postmarked the day after the call with a letter dated a month earlier. This kind of thing happens at least a couple of times a year. Sometimes late returns aren't even sent with the courtesy of a cover letter or registered mail.

These things can happen at offices that are too busy or plain careless. According to most pros, outright thievery is rare, however. But it has occurred, too. Gea Koenig, a respected woman travel photographer says that you had better count all returned pictures. "All too often, some of them are missing, and may have been used." (If so, send a bill.) Gea Koenig also recalls a strange case of piracy. She once submitted some color slides to an eastern Sunday supplement. Then she went on some of her long trips with her husband, a travel writer. When she came back to the States, she chanced into a stationery store. It was selling boxes of illustrated crossword puzzles. All the puzzle pictures were hers.

Many pros also say that clients nowadays return some of their slides in bad condition. Boyd Norton: "In the past year or so I have had some serious problems with damaged pictures. This has caused me to tighten my policies on picture liability. On everything sent out I now use a brief statement of liability which places a dollar value on the loss or damage of transparencies. For the very special, unique kind of pictures—such as my Alaska coverage that would be enormously expensive to replace—the liability figure is $2,500 per lost or damaged transparency. In my cover letters I ask editors to make a quick check and verify that they received the pictures without scratches or other visible damage. I also ask edi-

tors to warn their engravers and printers of this liability. I've had stuff come back looking like the whole Denver Bronco football team had stomped over them. I think all photographers must take a very hard-nosed stand on this situation. It's an area where there should be absolutely no compromise!"

The ASMP Policies

Many of the dollar figures in this chapter originated with an important organization known as the ASMP. It is the American Society of Magazine Photographers, a misnomer because many of its fifteen hundred or so members are also advertising, corporate, book, or newspaper photographers—or in other specialties.

ASMP has had a tremendous influence on industry practices; many photo agents and even nonmembers use the ASMP's "holding fee, or lost/damaged pictures terms. Likewise, many top pros (and some stock agencies) use the ASMP-devised delivery memo. It lists terms on the back. "Thanks to the forms, I've received $1,500 settlements for single losses. And so have countless others," says one pro. ASMP-type invoices and assignment confirmations are now routine among superlancers in the business.

The organzation is considered a guild by many pros; it pushes decent rates on behalf of its members and protects them against abuses. "Magazines don't walk over me now," says one photographer. Not everyone can join, though. You must prove professionalism; the ASMP demands to see your publications and you will need two sponsors who must be members. The advantages of belonging therefore include a certain prestige; the ASMP looks good on your letterhead and can bring referrals.

How about the ASMP's negative side? It now costs a three-figure sum to become a member, and the yearly dues are almost twice that of the ASJA, the most prestigious organization for professional writers. One photographer says frankly: "I was going to join, but the bastards doubled their initiation fee in between the time they sent me info and the time I responded. I gave up. Never became a member."

Like many associations in the United States, the ASMP has sleek headquarters in Manhattan (the offices are at 205 Lexington Avenue, New York, N.Y., 10016). Monies also go for the ASMP's (somewhat erratic) publications. Nor does inclusion in the membership directory guarantee you access to a uniformly friendly group. Several of its prominent members are chronically rude to other people. As a result, many eligible freelancers refuse to join. (An aside to students: The ASMP also has an "associates" category for developing photographers. The initiation fee is lower for associates.)

Collection Tactics That Work

The ASMP's firm industry stance is called for. Many new magazine editors are lax. Some are unfair. Large conglomerates ignore the just needs of individual photographers. Competition is tough and the artist will often be the last to get paid.

The climate of the eighties therefore calls for business know-how. In some cases, it is enough to be merely aware of a client's policies. Robert Farber, the fashion photographer, warns that slow payment has become common. He deals with ad agencies and department stores that may send their checks only after sixty to ninety days have elapsed. Dan Guravich states that "Magazines which pay page rates often keep you waiting until the layout has been made." This can take months.

The most ideal clients pay on acceptance, of course. One leading travel photographer points to one such person. "The client handed me an $8,000 check the same day I delivered my bill. This is the way it should be."

Unfortunately, such instances are the exception and not the rule. Advertising agents must often wait for funds from *their* clients. Magazines can be short on cash flow, and therefore wait for ad revenue before paying photographers. Department stores first take care of merchandise suppliers who give them a cash discount.

The well-established freelancer can afford to be selective and deal only with reliable clients. "I don't want to work for people

who don't have the decency to pay within thirty days," says Lisl
Dennis. "I actually dropped one such client. He was earning inter-
est at my expense!"

Some photographers or their reps have enough clout to demand
a check within ten days of billing, and actually charge 1½ percent
per month on the unpaid balance. Other pros wait patiently for
sixty days. In many cases, a firm's bureaucracy might be at fault;
after all, editorial or creative departments are separate from ac-
counting departments. Payment can also be delayed because of
inefficiency or a lost invoice/purchase order.

Pros deplore the all too common practice—particularly in the
magazine field—to settle with photographers *after* publication.
This is unfortunate. What if the magazine goes out of business
before your pictures get into print? What if an editor gets another
job and the new one does not like your (already accepted) work?
Or how about unavoidable editorial delays that will result in tying
up your pictures for six months or longer?

Lou Jacobs, Jr., the outspoken West Coast pro, cites one such
example:

About a year ago a publisher of several photographic magazines
asked me to do regular stories for him. I was happy to get started, and
then discovered the stories were being held months before scheduling.
I asked that each assigned story be paid for at half the anticipated space
rate within thirty days of delivery. The publisher refused, saying, "I
can't treat you differently than other contributors," which is specious,
and adding, "What are you complaining about? You always get paid,
don't you?"

I explained I would not supply him a free inventory, and he became
miffed and told his combined editors not to have anything more to do
with me. By acting unprofessionally and childishly, he did me a favor in
that I did not have to hassle any further. Payment on publication is
unfair—and unnecessary—and should be objected to!

It makes sense to inquire beforehand, of course; this allows the
freelancer to accept or reject an offer. Some pros stay away from
all "on pub" magazines; others avoid new magazines until these
have survived for several months. More pointers? Ask for an ad-

vance, payable on receipt of your photos (which you can some-times hand-carry to the editor). Or offer a 5 percent discount for prompt payment.

Unfortunately, many clients are casual about sending out checks. "The accountants don't care a hoot about *your* cash flow problems," says Boyd Norton. "And they may keep you waiting for months."

In such cases, a photographer should know some collection basics. How do the top pros handle these very real problems? Only one in a hundred ignores unpaid bills and actually writes off the client.

The great majority do not remain silent. "It's simple," says commercial photographer Ron Adams. "Call them! Ask where the money is!" "Use the phone," Ursula Kreis says. "Be assertive!" Both reps and seasoned pros like Tom Hollyman in New York suggest, however, that you *don't* call the art director or editor. Go to the business department instead. Ask for the accounts payable supervisor.

Other pros prefer the mail. Myron Sutton, the Wyoming-based book specialist, reports *his* approach: "I write repeated courteous letters, perhaps eventually to the head of the house, the chief executive officer of the conglomerate. Nothing kills like kindness.

Dear Mr._____:

Your check for my photos, due two months ago, must surely have gone astray, courtesy of the postal service. If you can tell me when it was mailed, perhaps I can start tracing at this end. . . . With every good wish. . . .

One of Sutton's colleagues employs an equally light touch:

Dear Friends:

Sorry to bother you . . . but when I turned in my social security number in late July, and when I talked to you, Paul, in early August, you mentioned that "the check" would soon be along, no longer than a week at the most. It has been two months now.

Please write me a little note on the attached, self-addressed post card. Do let me know when I can expect the $200.

Cordially,

Still another freelancer takes a stronger tack:

Dear _____ ,

As you may remember, I've sent this bill for the Worthington job twice before, and I know you turned it over to accounting, but unfortunately, I still have not been paid.

It's over ninety days now, and the picture story is about to be printed, but I still have not even been paid my expense money. I know you agree that this is a drag and unfair, and I'll appreciate any pressure you may bring to bear on the proper people. Tell them I don't want to hire a lawyer, but I will if necessary. And who needs that expense? Not XYZ magazine any more than I.

Thanks a lot for your understanding and support.

An attorney is only a last resort, says Lou Jacobs, Jr., and many of his colleagues. Likewise, pros wait for some months before they turn over the stubbornly silent fly-by-night debtor to the post office for a possible mail fraud investigation.

Despite their patience, however, the pros insist that they expect payment. And they are prepared to rock the boat for it. "The art director gets *his* pay check. So why shouldn't I get mine?" one freelancer asks. "I'll gladly stick my neck out and tell him so."

The Law and the Photographer: The Public's Right to Privacy

The Anglo-Saxon courts hold that any individual has a right to privacy. So it is easy to understand how a paparazzi-type—a woman in this case—was sued by a well-known actor after she rang his doorbell and then stormed into the depths of his house to shoot pictures against his will.

Most privacy cases are less blatant, but a portrait photographer can get sued by a customer for displaying the person's picture in the studio (without consent). A new commercial photographer faced a lawsuit from a mother for using her three-year-old daughter's black-and-white picture in a brochure for a day-care center. The photographer had never bothered to obtain the mother's permission.

It is true that you can take a picture for fun; you only get into trouble when you use it for profit.

The most critical privacy area is advertising. This also applies to people you know well. Even Aunt Emma could take you to court if you used her picture for an ad or other commercial (money-making) purposes. Anyone except a celebrity could sue you for running their picture on a book cover, in a greeting card, or on a poster *without their written permission.*

Pros know, of course, that this simply means getting a person's signature on a so-called model release. Experienced photographers always play it safe. Unless they shoot a straight news story, or a mass scene at a football game, or other crowd scenes, they generally obtain a model release.

The Model Release

The model release becomes crucial for any picture of any individual who is promoting a product or service. That includes the casual picture of a man and his wife getting off an airplane in Hawaii for a travel agency brochure.

Naturally, nude pictures cannot be sold without proof of a signed model release; the same goes for all professional modeling. (In the case of children, the guardian must sign the release.) It should be said that the signature on a release does not give a photographer the right to show the model in a derogatory manner, or in a way that might hurt the model's future.

Some pros protect themselves by paying not only a fee to a professional model but to any person who signs the release. Other pros protect the identity of strangers who happen to be in a ridiculous situation; they will shoot a struggling novice skier from the back, for instance. Fortunately, news photography is exempt from most of these problems unless the picture is used for commercial purposes. (But beware of misleading or derogatory captions for your news pictures!)

H. T. Kellner writes:

"For years many photographers have paid little attention to

model releases. As people become more inclined to run to the courts, this will be more of a problem in the future. It's a good idea to get model releases whenever possible. Many editors request them . . . even for editorial use."

"I even get a release from people whose houses, offices, or rooms I photograph," adds Ron Adams, San Francisco. "Today you're lucky *not* to get sued if you're careless."

What does a model release look like? Some corporations, magazines, or other firms—or individual photographers—use a very simple form.

Here's one by a major cruise ship company:

TO WHOM IT MAY CONCERN:

I am herewith authorizing the m/v (ship's name) and X Cruises to photograph me for story and publicity purposes.

I gladly cooperated with X Cruises' photographers and writers, and will not demand remuneration at any time.

Signed _____

Address _____

Suzanne Szasz's photo release is brief, too:

For valuable consideration and the sum of $_____ I hereby give my permission to _____ to use photo No. _____, taken by Suzanne Szasz of me and/or my child/children named: _____

_____ for the following purpose:

No names will be mentioned.

Signed _____
 (parent)
Address _____
Date _____ Witnessed by _____

Lastly, one corporation's form is equally simple:

MODEL RELEASE FORM

I hereby give my consent to Corporation of New York, its affiliates, assignees, and licensees to use my name, voice, verbal statements, and portrait or picture (motion or still) for advertising purposes, for purposes of trade, or for any lawful purpose whatever.

Full name (print)

Signature Date

Persons under twenty-one (21) years of age must have the consent of parent or guardian. I, the undersigned, being the parent or guardian of the above minor, do hereby consent to, and agree to be bound by, the above release.

Signature of parent or guardian Date

Naturally, some forms are more complicated. Professional photographers try to obtain a signature before or during a photo session, not days later. When editors request releases, you can send photocopies of your originals.

Copyrights

Here is a scenario with some twists and turns: A well-known glamour photographer shoots a series of sexy advertising pictures for a ski company. He is handsomely paid and his photos appear in the magazine ads for which they were shot. Later, however, the ski firm's marketing director gives one of the slides to a poster company. He feels that such a poster would be good publicity for his ski brand. The picture is promptly and innocently used for a dramatic poster. It sells thousands of copies.

The photographer tries to collect for the second use of his sexy

slide. But he seems to get nowhere with the ski company or the poster firm.

The photographer had made two mistakes. He had never told the ski people just what rights he was selling them. They assumed that his $600-per-slide charge meant all rights. And secondly, *the photographer failed to put a copyright notice on his pictures.*

Thanks to the laws that went into effect on January 1, 1978, more photographers now copyright their most valuable pictures. This can be especially important when you shoot important news pictures. A copyright notice © on the frame of a slide or the back of your black-and-white will tell the world about your ownership. According to the US Copyright Office (c/o Library of Congress, Washington, DC 20559), your handwritten or rubber-stamped notice should include:

- the symbol ©, or the word *copyright*;
- the year of first publication of the work;
- the name of the owner of copyright in the work, or an abbreviation by which the name can be recognized, or a generally known designation of the owner.

Such a notice applies only to pictures taken after December 3, 1977. The notice is free, and you are under no obligation to register your pictures with the US Copyright Office in Washington. Your photos are now protected from the moment of their creation.

Your © notice is good for five years. After that the pictures fall into the public province, that is, anyone can copy them.

Does your copyright stamp make it possible to successfully sue a possible picture thief?

The answer is yes *if you register your pictures with the US Copyright Office.* This can be done with groups of photos. The cost is ten dollars on each occasion. Ask the copyright office to furnish the proper forms and procedures.

Your registered copyright is valid for your lifetime plus fifty years. And no ad agency, magazine, book publisher, newspaper, or

other medium can publish your copyrighted picture without your permission. If they do, you can sue for infringement and win.

Rohn Engh, of *The Photoletter* has researched some infringement suits. Engh writes:

The owner of a registered copyrighted picture to which infringement has been proven may receive in addition to damages he has suffered (court costs, attorney fees, etc.), the amount in cash of the profits received by the infringer. If the copyright owner has to sustain the burden of proving the infringement he could receive as high as $50,000 if he or she wins. If the copyright owner asks only for statutory damages, and he wins the case, the award could be between $250 and $10,000. Now the bad news: If you do not register your picture and your picture is infringed upon, the court fight might not be worth the trouble and expense. Your legal remedies are limited.

Copyright protection is often registered by stock agencies or by magazines unless you have already secured the ©. In that case, everyone—including reprinters—must deal with you, as the owner. "I copyright all photographs in my name that are used in my books," says Robert Farber. On the other hand, well-paid advertising photographers sometimes have no choice but to let the agencies or clients copyright ad pictures in the client's name. There are numerous other ramifications to the copyright laws. Write to the US Copyright Office for details.

Taxes for the Freelance Photographer

This is a book about photo careers and photo marketing, and it would take an entire chapter to explain the freelancer's tax situation. But a few brief points should be made.

The IRS has strict rules about who can file and deduct expenses as a professional photographer. Nonearning, would-be freelancers are considered hobbyists and ineligible for the deductions. Occasional moonlighters who don't show a profit seldom make the IRS grade, either.

A CPA can tell you which expenses are legal, and also help you with recordkeeping. A tax accountant will know all about depreciation schedules for your cameras and other equipment, allowable travel expenses, and other permissible deductions. The CPA will also tell you when to file your tax reports and prepare them for you.

An Afterword

Whether you succeed hugely or just a little bit does not change your innermost life.

You are still a photographer.

You are the eyes of the world, commentator, documenter, philosopher. You take us to the milestones, the changes, the moments of truth, giving us evidence or showing us beauty. Or as Mary Lawrence Rubin has said, "You capture those subtle seconds you call your work and your pleasure."

Success is, therefore, not all. Sometimes, it is built on failure. And at all times a measure of success *can* be found by believing in your potential. Do not let anyone talk you out of your dream!

BIBLIOGRAPHY

MARKETS AND PUBLISHING

Balkin, Richard. *Writers Guide to Book Publishing*. New York: Hawthorn, 1977.

Henderson, Bill, ed. *The Publish-It-Yourself Handbook*. Yonkers, N.Y.: Pushcart Press, 1973.

Jacobs, Lou, Jr. *Freelance Magazine Photography*. Garden City, N.Y.: Amphoto, 1970.

Kellner, H.T. *Money in Your Mailbox: A Guide for Freelance Photographers*. Baldwin, N.Y.: Kellner's Photo Services, 1980.

Literary Market Place (LMP). New York: R.R. Bowker, annually.

McDarrah, Fred W., ed. *Photography Marketplace*. New York: R.R. Bowker, 1977.

Nicholas, Ted. *How to Self-Publish Your Own Book and Make it a Best Seller*. Wilmington, Del.: Enterprise Publishing, 1975.

A Photographer's Market. Cincinnati: Writer's Digest Books, annual.

Poynter, Dan. *The Self-Publishing Manual*. Santa Barbara, Calif.: Parachuting Publications, 1979.

Stock Photo and Assignment Source Book. New York: R.R. Bowker, 1977.

Townsend, Ken. *How to Produce and Mass Market Your Creative Photography*. Burlington, Ontario, Canada: Sinclair Smith Printing, 1979.

Writer's Market. Cincinnati: Writer's Digest Books, annual.

PHOTOGRAPHY TECHNIQUES AND SPECIALTIES

Dennis, Lisl. *How to Take Better Travel Photos*. Tucson, Ariz.: H.P. Books, 1979.

Farber, Robert. *Professional Fashion Photography*. Garden City, N.Y.: Amphoto, 1978.

Fundamental Photography. Los Angeles: Peterson Publishing, 1979.

How to Enter and Win Photo Contests. Los Angeles: Peterson Publishing, 1978.

Jacobs, Lou, Jr. *How to Take Great Pictures with Your SLR*. Tucson, Ariz.: H.P. Books, 1978.

Kodak Professional Photoguide. Rochester, N.Y.: Eastman Kodak, 1979.

Langford, M.J. *Basic Photography, Professional Photography*. Garden City, N.Y.: Focal Press, 1978.

Miller, Gary. *Freelance Photography*. Los Angeles: Petersen's How-to Photographic Library, 1975.

Perry, Robin. *Photography for the Professional*. Waterford, Conn.: Livingston, 1976.

Roberts, Howard R. *The Beginner's Guide to Underwater Photography*. New York: David McKay, 1978.

Schulke, Flip. *Underwater Photography for Everyone*. Englewood Cliffs, N.J.: Prentice-Hall, 1978.

Schwartz, Ted. *How to Make Money with Your Camera*. Tucson, Ariz.: H.P. Books, 1974.

————. *How to Start a Professional Photography Business*. Chicago: Henry Regnery, 1976.

Snyder, Norman, ed. *The Photography Catalog*. New York: Harper & Row, 1976.

Sussman, Aaron. *The Amateur's Handbook*. New York: T.Y. Crowell, 1973.

Szasz, Suzanne. *Child Photography Simplified*. Garden City, N.Y.: Amphoto, 1978.

————. *Modern Wedding Photography*. Garden City, N.Y.: Amphoto, 1976.

Editors of Time-Life. *The Studio*. New York: Time-Life Books, 1971.

SOME OUTSTANDING BOOKS BY CONTRIBUTORS

Adams, Ron. *Woman Times Two*. Sausalito, Calif.: Astarte Enterprises, 1975.

Caulfield, Pat. *The Everglades*. San Francisco, Calif.: Sierra Club Books, 1970.

Guravich, Dan. *Westward to Zion*. New York: Doubleday, 1980.

Michals, Duane. *Sequences*. New York: Doubleday.

————. *The Wonders of Egypt*. Paris: Deneul, 1978.

Muench, David. *Arizona*. Chicago: Rand McNally, 1971.

Norton, Boyd. *Alaska: Wilderness Frontier.* New York: McGraw-Hill, 1977.

———. *Backroads of Colorado.* Chicago: Rand McNally, 1979.

———. *The Grand Tetons.* New York: Viking Press, 1974.

Rowell, Galen. *In the Throne Room of the Mountain Gods.* San Francisco: Sierra Club Books, 1977.

———, ed. *The Vertical World of Yosemite.* Berkeley, Calif.: Wilderness Press, 1977.

Scavullo, Francesco. *Scavullo on Beauty.* New York: Random House, 1976.

———. *Scavullo on Men.* New York: Random House, 1977.

Sutton, Ann, and Sutton, Myron. *The Life of the Desert.* New York: McGraw-Hill, 1966.

———. *The Secret Places: Wonders of Scenic America.* Chicago: Rand McNally, 1979.

———. *The Wild Shores of North America.* New York: Alfred A. Knopf, 1977.

———. *Wildlife of the Forests.* New York: Abrams, 1979.

———. *Yellowstone: A Century of the Wilderness Idea.* New York: Macmillan, 1972.

Wenkam, Robert. *Honolulu Is An Island.* Chicago: Rand McNally, 1978.

PHOTOGRAPHERS AND THEIR MÉTIER

Arbus, Don, and Israel, Marvin, eds. *Diane Arbus.* Millerton, N.Y.: Aperture, 1972.

Avedon, Richard. *Portraits.* New York: Farrar, Straus & Giroux, 1976.

Cohen, Joyce, ed. *In/Sights: Self-Portraits by Women.* Boston: Godine, 1978.

Danziger, James. *Interviews with Master Photographers.* New York: Paddington Press, 1977.

Farber, Robert. *Images of Woman.* Garden City, N.Y.: American Photographic Book Publishing, 1976.

Jacobs, Lou, Jr. *Basic Guide to Photography.* Los Angeles: Petersen's How-to Photographic Library, 1974.

———. *Instant Photography.* New York: Lothrop, Lee & Shepard, 1976.

———. *Photography Today for Personal Expression.* Santa Monica, Calif.: Goodyear Publishing, 1976.

Karsh, Yousuf. *Karsh Portraits.* Boston: New York Graphic Society, 1976.

Lange, Dorothea. *Photography*. New York: Museum of Modern Art, 1967.

Editors of *Life*. *W. Eugene Smith: His Photographs & Notes*. Millerton, N.Y.: Aperture, 1969.

Rooney, Ed, ed. *The Nikon Image*. Garden City, N.Y.: Ehrenreich Photo-Optical Industries, 1975.

Rubinstein, Eva. *Photos*. Dobbs Ferry, N.Y.: Morgan & Morgan, 1978.

Steichen, Edward. *The Family of Man*. New York: Simon and Schuster, 1967.

Szarkowski, John. *Mirrors and Windows: American Photography Since 1960*. New York: Museum of Modern Art, 1978.

Szasz, Suzanne. *The Body Language of Children*. New York: Norton, 1978.

Editors of Time-Life. *The Art of Photography*. New York: Time-Life Books, 1971.

Untitled 14, Carmel, Calif.: Friends of Photography, 1978.

WRITING FOR PHOTOGRAPHERS

Casewit, Curtis. *Freelance Writing: Advice from the Pros*. New York: Macmillan, 1974. (Fourth printing 1978).

Gunther, Max. *Writing and Selling a Non-Fiction Book*. Boston: The Writer, 1973.

Strunk, William, and White, E.B. *Elements of Style*. New York: Macmillan, 1962, 1979.

Trimble, John. *Writing with Style: Conversations on the Art of Writing*. New York: Prentice-Hall, 1975.

MAGAZINES

American Photographer, 485 Fifth Avenue, New York, N.Y. 10017.

Industrial Photography, 475 Park Avenue South, New York, N.Y. 10016.

Modern Photography, 130 E. 59th Street, New York, N.Y. 10022.

Peterson's Photographic Magazine, 6725 Sunset Boulevard, Los Angeles, Calif. 90028.

Popular Photography Magazine, One Park Avenue, New York, N.Y. 10016.

Index

[183]